PIONEERS

― OF ―

RIVERSIDE

COUNTY

THE SPANISH, MEXICAN AND EARLY AMERICAN PERIODS

STEVE LECH

Charleston London

THE
History
PRESS

Published by The History Press
Charleston, SC 29403
www.historypress.net

Copyright © 2012 by Steve Leeh
All rights reserved

First published 2012

Manufactured in the United States

ISBN 978.1.60949.831.3

Library of Congress CIP data applied for.

CONTENTS

CONTENTS

PART I
THE SPANISH PERIOD

1

THE FAGES, PORTOLA AND ANZA EXPEDITIONS

In the course of the journey made today we have seen an improvement in the country in every way, and have concluded from its moisture that it may be suitable for seasonal crops and the planting of fruit trees, and that there are pastures sufficient for maintaining cattle.
—*Captain Juan Bautista de Anza, upon first encountering the territory that would become Riverside County, March 15, 1774*

Until 1772, the only people who had ever seen the varying terrain that would eventually become Riverside County as we know it today were the many different groups of Indians who had inhabited Southern California for thousands of years. With no names for their tribes, the people who eventually would be given names such as Cahuilla, Luiseño, Serrano and Gabrieleño generally lived what anthropologists call a hunter-gatherer lifestyle, obtaining their food from what the land offered without human-induced activities such as cultivation.[1] They lived in village-oriented groups, traveled frequently because of the changing food supplies and handed down their knowledge to subsequent generations in a manner referred to as oral tradition. In short, they had no written languages, just the patience to ensure that the stories of their creation, legends of their ancestors and spirits of beings who inhabited the earth around them, were passed from the old to the young, who would in turn pass them on as they aged.

The year 1772 began to change that. In that year, the territory that would some two hundred years later become Riverside County, California, was first

seen by a non-Indian—a person of European blood—and that person was Don Pedro Fages (pronounced FAH-hays). Fages and the expedition he was leading were only the beginning of what would become an onrush of several groups of non-Indians into the area known today as Southern California.

The first of these groups was the Spanish, who brought with them the beginnings of non-Indian development in Southern California. This period of Spanish in-migration is most often associated with the chain of missions and military presidios established throughout coastal California. Although none of the missions or presidios was ever located within Riverside County, their influence was undeniably felt and set the stage for later development within the county.

In the late 1400s, the pope divided most of the undiscovered portions of the world between Spain and Portugal. Spanish authorities immediately began dispatching explorers to the new regions to study and report on areas that could be colonized in the name of the king. By 1520, Hernán Cortés had wrested control of Mexico from the Mayas, and Francisco Pizarro had taken control of Peru. Fifteen years later, Cortés tried to establish a colony at La Paz on Baja, California, but was soon forced to abandon that plan because the area had such a hostile environment. At the time, California was believed to be an island, and in 1541, Francisco de Bolanos became the first to call that island "California."[2] For more than two hundred years, though, the area called California was virtually ignored by Spain, with the exception of a few coastal explorations.

Over the next two hundred years, the world changed greatly and affected Spain's colonies and its ability to hold them. By the mid-1700s, it was becoming apparent to officials of the Spanish government, both in mainland Spain and New Spain (i.e., Spanish North America), that soon they would have to colonize and develop the northern, generally unpopulated regions known as Alta California. If left unguarded, Spain could lose its colony lands to the Russians, who were coming down the coast of North America from Alaska; the French, who laid claim to the area called Louisiana in central North America; or possibly even the British, who had established a series of successful colonies along the eastern coast of North America. Officials in New Spain therefore decided that a party should be sent north with the idea of founding both military presidios and religious missions in Alta California to secure Spain's hold on its lands.

The aim of the party was twofold. One group would found presidios, which would give Spain a military presence within its lands. The second group would begin the establishment of a chain of missions along the coast

or slightly inland, with the aim of Christianizing the native population. By Christianizing the native Californians, they could be counted as Spanish subjects, thereby bolstering the colonial population within a relatively short time.

The party was led by Gaspar de Portolá and consisted of two groups; one would take an overland route, and one would go by sea. All parties were to converge on San Diego, which would be the starting point for the chain of Spanish colonies. What became known as the Portolá expedition set out on March 24, 1769. Portolá, who was very loyal to the crown and understood the gravity of his charge, arrived in what would become San Diego on July 1, 1769. Here, he immediately founded the presidio of San Diego. Leaving one group in the southern part of Alta California, Portolá took a smaller group and began heading north to his ultimate destination: Monterey Bay. Along the way, this smaller expedition gave us what is today the oldest non-Indian place name in our area. On July 26, 1769, they reached a large valley and camped near what is today the city of Orange in Orange County. To this valley, Father Crespi, a member of the expedition, gave the name *el Dulcísimo Nombre de Jesús de los Temblores* (the sweet name of Jesus of the earthquakes), due to the fact that they experienced a few of the earthquakes for which Southern California is so well known. Father Crespi also notes that the river that wound through the valley was called the *Rio de Santa Ana* by several of the soldiers in the group, due to the fact that July 26 is the feast day of Saint Ann. This name continued to be used for several years and survives today as the Santa Ana River. Continuing up the coast, Portolá established Monterey Bay as a Spanish possession on June 3, 1770, although it would take two expeditions to accomplish this task.[3] Having established the presidios at San Diego and Monterey, Portolá returned to Mexico.

During the first roughly four years of Spanish presence in Alta California, Father Junipero Serra, a member of the Portolá expedition and the Catholic leader of the new province, began establishing what would become a chain of twenty-one coastal missions in California. The first, founded concurrently at San Diego with the presidio, was the launching point for this group. During this time, four additional missions (San Carlos Borromeo de Carmelo, San Antonio de Padua, San Gabriel Arcángel and San Luis Obispo de Tolusa) joined the list.

Also during these first few years, Riverside County sees its first non-Indian explorer. Upon his return to Mexico, Portolá left Don Pedro Fages in command at San Diego. In 1772, Fages discovered that several soldiers of the garrison at San Diego had deserted and apparently headed east.

The Spanish Period

Leaving in pursuit of them, Fages went east through the mountains that characterize the eastern portion of present-day San Diego County until he ran headlong into the vast desert, nowadays in Imperial County. Deciding that the deserters probably had not attempted to cross the desert, Fages and his men headed northwest, remaining close to the foothills of the San Jacinto Mountains. This route took them through what is today Coyote Canyon on the southern edge of Riverside County and then into the Anza Valley, where they continued northwest through the San Jacinto Valley and toward Riverside. At some point, they veered north, probably through a low point in the hills to the north, and entered the San Bernardino Valley. Here, Fages "discovered" the Cajon Pass[4] and traveled through it to the Mojave Desert, eventually returning to his base of Monterey.

Life for the inhabitants of the early missions and presidios was precarious at best. Although the missions were known later for having huge orchards, vineyards, farms and other agricultural assets, this was not the case in the early years. Agriculture takes years to become established, and the mission fathers had to train the Indians in the ways of planting and harvesting. Therefore, the early outposts had to be supplied directly from Mexico. Ships were loaded with supplies in San Blas, on the northeastern shore of the Gulf of California, sailed around Baja, California, and unloaded at the ports of San Diego and Monterey. This method of supply was extremely costly to the Spanish government and very treacherous to the Spanish supply fleet. Before long, many officials, both government and military, began to theorize about the existence of an overland route from Sonora to coastal Southern California. One such person was Captain Juan Bautista de Anza, the military commander of the presidio of Tubac, in the northern Sonora region of New Spain.[5]

Anza had been interested in an overland route to Alta California for years. Seeing the great need for a road at present, he petitioned Viceroy Antonio de Bucareli in New Spain to allow him to lead an expedition. So confident and willing was Anza that he even offered to pay many of the expenses out of his own pocket. The Spanish government gave its consent, and Anza began his preparations.

On January 8, 1774, Anza and his party of thirty-four people, including soldiers, interpreters and servants, set out from Tubac, continued in a roundabout way to the confluence of the Gila and Colorado Rivers near present-day Yuma, Arizona, crossed the Colorado River and then proceeded south-southwest in an attempt to avoid the desert lands that are now the Imperial Valley. He reentered what is today California near Calexico and

headed generally north. This portion of the expedition had already been explored, and Anza was simply retracing the steps of Fathers Kino and Garces before him. However, once on the western edge of the Imperial Valley, he entered essentially uncharted territory.[6]

Coming up through San Felipe Creek and the Borrego Valley in present-day eastern San Diego County, Anza entered what is now Riverside County through Coyote Canyon, at the western foothills of the Santa Rosa Mountains. From Coyote Canyon, he climbed the ridge between Nance and Tule Canyons and overlooked present-day Terwilliger Valley and Anza Valley, the latter of which was named for him in the twentieth century. Luckily, Anza and others in his party kept diaries of the journey, and they are an excellent source for the modern-day local historian of how the area appeared more than two hundred years ago, starting with a description of the Coyote Canyon and Anza Valley area:[7]

TUESDAY, MARCH 15 —*Two hours before daybreak we set forth up the arroyo, which in general runs north-northwest, dividing the large mountain chain through which it flows. The floor of the valley is very even and of considerable width for four leagues, where in various places running water is found. Two more leagues were traveled where the valley is narrower, and then, leaving it at the left, we climbed a ridge which did not cause the animals the greatest fatigue, and at whose crest we camped for the night in a place with good pasturage and water—From Tubac to the Puerto Real de San Carlos, 227 leagues.*

Right here there is a pass which I named the Royal Pass of San Carlos[8] [today's Coyote Canyon]. From it are seen most beautiful green and flower-strewn prairies, and snow-covered mountains with pines, oaks, and other trees which grow in cold countries. Likewise here the waters divide, some flowing this way toward the Gulf and others toward the Philippine Ocean. Moreover, it is now proved that the sierra in which we are traveling connects with the sierras of Lower California. In the course of the journey made today we have seen an improvement in the country in every way, and have concluded from its moisture that it may be suitable for seasonal crops and the planting of fruit trees, and that there are pastures sufficient for maintaining cattle.

In the same transit we met more than two hundred heathen, extremely timid, and similar in everything to those farther back except in their language, which we did not recognize. It was laughable to see them when they approached us, because before doing so they delivered a very long

harangue in a tone as excited as were the movements of their feet and hands. For this reason they were called the Dancers. The few weapons which they use are not carried by the men themselves but by their women and children. The only thing of value which they were seen to have was a small net wound around the stomach or the head. They wear sandals made of mescal fiber, like all those from San Sevastian to here. The women cover themselves with the same fiber, or some of them use buckskin. Of all the tribes through which we have passed this is the one which has manifested the strongest desire to steal, at which they show as great dexterity with their feet as with their hands. For this reason they have not enjoyed our little gifts as have the others.[9]

At this point, the Anza party continued into what is today the Terwilliger Valley and camped at Dry Lake, which he called Laguna de Principe:

WEDNESDAY, MARCH 16—Because it rained and snowed, like the night before, we were not able to take up the march during the forenoon. But at two in the afternoon we set forth, immediately climbing some small hills, where a fair-sized vein of silver ore was found. From these hills we continued west for a distance of three leagues over good terrain, halting for the night, because it threatened to rain, on the banks of a large and pretty lake, to which we gave the name of El Principe. It is surrounded by flower-strewn and pleasant valleys and by several snow-covered mountains, by which it is filled with water. In the hills nearby were found several springs of very agreeable water, independent of the lake—From Tubac to the Laguna del Principe, 230 leagues.[10]

The next day, Anza crossed what is today the Anza Valley traveling northwest and camped at the southern end of Bautista Canyon, which he called San Patricio:[11]

THURSDAY, MARCH 17—Because it had rained and snowed during the night and part of this morning, we were not able to set forth until ten o'clock in the forenoon. We then started, marching northwest and north-northwest, through the valley which lies between two ranges. We followed it until it narrowed between several other hills, at the foot of which we halted for the night, having traveled three leagues. From these hills there is seen a very pretty little valley which within itself contains water and trees in abundance. We called it San Patricio.

In these hills another good vein of silver ore was found, and from it was taken a piece which shows this metal black and thick. We think that the same kind will not be lacking in all the hills between the Royal Pass of San Carlos and this place, for they seem to give indications of it—From Tubac to the valley of San Patricio, 233 leagues.[12]

On Friday, Anza traveled through Bautista Canyon and ended his day at the northern mouth of the canyon. At present, Bautista Canyon looks much like it did over two hundred years ago and affords the traveler along Bautista Canyon Road a glimpse of what the party saw. At the end of the day, Anza looked over the vast San Jacinto Valley, which he named San Jose:

FRIDAY, MARCH 18—Although morning dawned with very thick clouds, we thought because it had snowed and rained so hard during the night that we should free ourselves of these elements today. With this in mind, as soon as day dawned I sent a party of six men provided with axes, to clear out, if it was necessary, the road which we must follow down the canyon which we have close by. At eight o'clock in the morning, raising our train, we all set forth on the road, which we found favorable, for only for a league was it necessary to cut here and there a tree which impeded. After this the canyon, which we followed to the north and north-northwest, kept getting wider and wider, until we reached a broad and most beautiful valley, six leagues distant from the place whence we had set out.

Through this beautiful valley, to which we gave the name of San Jose, runs a good-sized river, on whose banks are large, shady groves. Likewise in the mountains where the river forms there are seen pines, oaks, and various other trees. All its plain is full of flowers, fertile pastures, and other vegetation, useful for the raising of cattle, of which species as many as one might wish could be raised. And in the same way one could raise good crops, which I judge would be produced with great advantage, for although this is the cold season, from the verdure and the shadiness of the leaves there is no sign of any frost here, either now or earlier. In this place where we are today we saw some heathen women, but they did not wish to come near us, although they were coaxed in the same way that has been practiced at other times—From Tubac to the valley of San Jose, 239 leagues.[13]

Next, Anza crossed the San Jacinto Valley to the northwest and came to a large lake he named in honor of the viceroy, Antonio de Bucareli. This is the intermittent lake that was called San Jacinto Lake for a while and is now

Juan Bautista de Anza's Trail
Through Western Riverside County

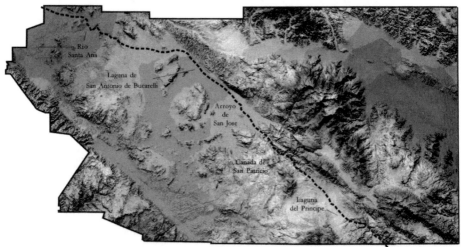

Puerto Real de San Carlos

called Mystic Lake. Although he did not see many of them, Anza believed the area to be well settled by Indians:

> SATURDAY, MARCH 19—At eight o'clock in the morning we took up the march down the valley toward the northwest. Its amenity and the beauty of its trees continued for three leagues, after which the trees came to an end but the amenity continued. We followed it for three more leagues, till we came to the banks of a large and pleasing lake, several leagues in circumference and as full of white geese as of water, they being so numerous that it looked like a large, white grove. I called this lake San Antonio de Bucareli. Today several heathen came to us here and along the road which we traveled, talking with us now with greater freedom than those farther back, but as soon as they were given presents they left us. There is nothing particularly noteworthy about them, for in everything they are similar to those last seen. In the crossing of the sierra I have not seen very many of them, but it is evident from their tracks and their dwellings that it is thickly inhabited by them—From Tubac to the Laguna de San Antonio de Bucareli, 245 leagues.[14]

13

At this point, Anza crossed what is today called Moreno Valley, entered Sycamore Canyon and traveled just south of downtown Riverside. He camped for the night and then crossed the Santa Ana River around Anza Narrows, just north of the present-day intersection of Jurupa Avenue and the Union Pacific Railroad:

> *SUNDAY, MARCH 20—At half past eight in the morning we set forth, going northwest for five leagues, keeping on our right a high, snow covered mountain, which drains into the lake mentioned. Having gone two more leagues to the west-northwest, we came to a valley similar to that of San José, which likewise has a good river, to which was given the name of Santa Anna. At the end of these two leagues another half league was traveled in seeking a ford, but not having found one or having any hope of finding one, I camped for the night near a place where there was a village of heathen like those mentioned before, and whose number would be more than sixty persons.*
>
> *At four in the afternoon, when we halted, we began to make a little bridge, as a means of taking over our train, and by nightfall it was completed.*

Mystic Lake area, 1890s. *Photo courtesy of the Riverside County Regional Park and Open-Space District.*

The Spanish Period

The heathen mentioned came to our camp tonight, some of them asking our native Californian, in the idiom of San Gabriel, if we came from the port of San Diego. They marveled greatly when they were answered in the negative, and were told that we were from the east, whence we had been traveling for three moons, and where there were more soldiers than they had ever heard of—From Tubac to Santa Ana River, 253 leagues.[15]

Leaving Riverside County, Anza continued through the plains that today are home to Ontario. He then traveled through the area near what is today San Dimas. Eventually, he knocked on the door of the Mission San Gabriel, to be greeted by a group of very surprised missionaries. Such was the state of supplies at San Gabriel that only a very modest celebration could be afforded Captain Anza. Having arrived at San Gabriel overland from Sonora, Anza left most of his party at San Gabriel and took a very quick trip to Monterey. From there, he returned to San Gabriel and, with the rest of his party, retraced his steps to Mexico. In Sonora, Anza and his party were considered heroes for opening the California settlements to an overland supply route. Thanks to Anza, the missions, pueblos and presidios could be furnished with the materials they needed to survive and flourish.

Eighteen months later, Anza was in command of another trek along the same route but this time with settlers instead of explorers and soldiers. Throughout late 1775 and into 1776, at about the same time the Declaration of Independence was being signed on the eastern coast of North America, Anza returned through Riverside County with a group of men, women and children who would become the founders of the Spanish colony at San Francisco. Anza took essentially the same route through Riverside County to San Francisco, where a presidio was established on September 17, 1776, and the mission on October 9.

For roughly the next four or five years, although records are scant, Anza's route was undoubtedly used by a few people traveling between Sonora and Southern California. However, in 1781, the Yuman Indians, in whose territory lay the key Colorado River crossing, revolted. They attacked and destroyed two of the mission outposts along the Colorado River and also attacked Spanish supply trains. Although Anza had taken great steps to ensure pleasant relations with the Yumans, they feared further Spanish intrusions into their territory. Rather than risk more trouble along the route, the Spanish government closed Anza's overland route that year to all travel. Thus, only a few years after its discovery, Anza's route to California was abandoned and virtually forgotten.

By the time Anza's route was abandoned, agricultural enterprises at the established missions had begun to flourish, thereby supplying the missions and neophytes with food produced locally. This enabled them to virtually end their dependence on supplies from Mexico. Therefore, when Anza's road was abandoned, it was abandoned permanently, and the mission system became self-sufficient.

In order to produce the food necessary for mission officials and the Indians, huge tracts of land were claimed for their use. These tracts, called ranchos, sometimes encompassed hundreds of thousands of acres and incorporated some of the choicest lands in California. These ranchos allowed each mission to claim the various native populations living on these lands, thereby assimilating the Indians on the "mission's lands," and also allowed them ample acreage to grow food and herd cattle and sheep. Ranchos and lands closest to the missions themselves were used mostly for farming, whereas the more outlying ones were devoted to pasturing the huge herds of cattle and sheep that the missions eventually established.

At this point, it becomes necessary to focus attention on the two missions whose influence and need for additional lands required that they encroach on what is today the greater western Riverside County area. The first of these is San Gabriel Arcángel, in present-day San Gabriel, and the other is San Luis Rey de Francia, in present-day Oceanside.[16] These two missions laid claim to most of the land within western Riverside County and established many names for areas that are still used today.

2

THE MISSIONS AND RANCHOS

MISSION SAN GABRIEL ARCÁNGEL

Mission San Gabriel Arcángel was founded on September 8, 1771, as the fourth mission in the chain. Known as the "Pride of the Missions," San Gabriel was the northernmost mission to be under the military auspices of the presidio at San Diego. Over the roughly sixty years in which it was a true mission, its land claims continually expanded out from the immediate area around the mission itself. The ever-growing need for more land for both agriculture and livestock drove the expansion, so that eventually, toward the end of Spanish rule in California, Mission San Gabriel lands encroached on the inland Southern California area and extended east to the periphery of the Coachella Valley. How were these mission ranchos established? An interesting description of how they were "claimed" was given by Pio Pico, a governor of California during Mexican rule, in 1852:

> When there was a piece of land suitable for placing a stock of cattle or sheep, they sent cattle or sheep with a herdsman to occupy the same and claimed the same as Mission lands: the extent of the tract was graduated by the ranging of the cattle or sheep.[17]

The latter days of mission rule in California saw the greater Riverside County area playing host to three ranchos that were established by the officials at Mission San Gabriel Arcángel: San Bernardino, San Gorgonio and Jurupa.

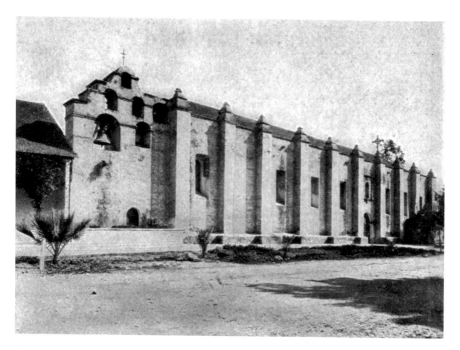

Mission San Gabriel Arcángel. *Photo from James,* Through Ramona's Country.

San Bernardino Rancho

Although not truly within the future boundaries of Riverside County, the San Bernardino Rancho was important because it became the center of mission activity in inland Southern California and influenced the expansion into Riverside County. Evidence seems to indicate that the San Bernardino Rancho was incorporated into the mission system on May 20, 1819, but given the area's location, mission officials at San Gabriel probably knew about it for years beforehand.[18]

San Bernardino's importance grew from the fact that, geographically, it was the gateway to two important inland areas into which mission officials hoped to expand their influence. The first of these was the upper desert region to the north, which was accessible via the Indian trade routes through the Cajon Pass. The second was the lower desert, toward the Colorado River. This was accessible from San Bernardino through the San Gorgonio Pass, which was later incorporated as the mission's San Gorgonio Rancho (see the next section).

The Spanish Period

Because of San Bernardino's potential to become a central location through which immigrant and trade routes would pass, it was only natural that mission officials made this rancho more than simply a stock-grazing area. Within the first few years of its dedication, the San Bernardino Rancho had several outbuildings, including a small, makeshift building for religious services and an adobe structure that served as an administration building, storeroom and sleeping quarters for the visiting padres.[19]

It was at San Bernardino that mission officials began to Christianize Indians who lived in the general vicinity and place them under Spanish rule. One method with which they tried to accomplish this was to begin small-scale farming near the mission outpost. Here, they planted several crops and irrigated their farms via a stone-lined canal (zanja) brought through the area from what is today Mill Creek. The Mill Creek Zanja is still mostly intact as a reminder of the efforts of mission officials.

From San Bernardino, it did not take mission officials long to begin expanding their landholdings to accommodate their ever-growing herds of livestock. Soon, not only was San Bernardino playing host to hundreds of sheep, goats and cattle but also these herds had expanded to the east and southwest. Because of this expansion, we see the influence of Mission San Gabriel extend into Riverside County.

San Gorgonio Rancho

The San Gorgonio Rancho was the easternmost extent of the lands claimed by the Mission San Gabriel Arcángel. Named for St. Gorgonius, this area encompassed the natural break between the San Bernardino mountain range to the north and the San Jacinto mountain range to the south, with the vast Colorado Desert extending farther east. Unfortunately, no record exists of what year the area was so named, but the date could have been March 10, 11 or 12 or September 9, depending on which St. Gorgonius was being honored.[20]

In all likelihood, because the San Gorgonio Rancho was farther from the San Bernardino Rancho, it was claimed later than 1819. In fact, the first mention of rancho seems to be in the Romero diaries of 1823, with another reference to it in the 1827 mission valuation.[21] However, one clue gives us an idea that the Spanish population of California knew about the San Gorgonio area at least as early as 1815, although it probably had not been named. According to early Southern California historian J.M. Guinn, although the

missions were self-sufficient by the second decade of the nineteenth century, one staple they lacked was salt, which still had to be imported from New Spain. Therefore, salt was a precious commodity. Through conversations with the Indian neophytes under their charge, the Spanish inhabitants of Southern California learned of the great salt flat on the desert (today's Salton Sea).[22] Starting in 1815, and continuing for roughly fifteen years, the inhabitants of Los Angeles and several of the closer missions sent yearly expeditions to the Salton Sea area. In the spring of each year, after the winter rains had subsided and before the heat of the desert became too oppressive, a caravan of Indians and Spaniards loaded ox-driven *caretas* (carts) for the month-long journey from San Gabriel, through the San Bernardino Valley, down the San Gorgonio Pass and onto the Coachella Valley, where they would camp along the Salton Sea salt flat. Here, they remained only long enough to gather enough of the almost pure salt to sustain the missions and the pueblo of Los Angeles for another year. These treks, termed the *Jornada para Sal*, or "Journey for Salt," were cumbersome and time-consuming and were not discontinued until the 1830s, when a saltworks called Las Salinas was established in a saltwater area in present-day Redondo Beach.[23] Because the early Spanish inhabitants apparently had to travel through the San Gorgonio Pass to arrive at the Salton Sea salt flats, they would have known of its existence, although they had not yet claimed the territory.

Once claimed by the Spanish, the San Gorgonio Rancho was used for grazing the ever-expanding livestock herds of the mission. Whether the padres of San Gabriel ever built any structures on the San Gorgonio Rancho cannot be shown definitively. No contemporary accounts mention any buildings on the rancho. However, Henry McAdams and others have speculated that Paulino Weaver, an early American settler in the Pass area, may have been able to use the ruins of an existing adobe building for his home when he settled there in the 1840s (see chapter 3). If this is true, then in all likelihood, the ruins were of a building used as an outpost by the mission overseers.[24]

Jurupa Rancho

The Jurupa Rancho lay directly southwest of the San Bernardino Rancho and would have been a logical progression of Spanish development considering that it also lay along the Santa Ana River. The Santa Ana River was a natural road allowing people to travel from San Bernardino

southwest to connect with either the Anza road leading back to San Gabriel or continue toward the coast. The Jurupa Rancho had the distinction of having an Indian name rather than a saint's name. Why the Indian name was used over a saint's (as was the custom) is unknown. The 1827 mission valuation for San Gabriel names "Jurupe" as an Indian rancheria within the lands claimed by the Mission San Gabriel Arcángel. Like the San Gorgonio Rancho, the Jurupa Rancho was used strictly for grazing livestock controlled by Mission San Gabriel and would have been named late in the Spanish period, shortly before or after the San Gorgonio Rancho.[25]

Near the western boundary of the Jurupa Rancho, in the vicinity of the Cucamonga wash outlet, lay a series of springs the Indians called Guapa. This series of springs was one of many Indian rancherias in the area and was important not only to the Indians but also to the Spanish, who used the springs on their trek to San Bernardino. In the earliest days of travel from San Gabriel east, the usual route led through the San Gabriel Valley to about present-day Pomona. From there, the road led south to the vicinity of what is today the southernmost extent of Euclid Avenue, generally where the Chino Hills come in proximity to the Santa Ana River. Once along the banks of the Santa Ana River, travelers headed northeast until arriving in San Bernardino. By using this route, they were never far from grass or water.[26] The springs of Guapa also became part of the Mission San Gabriel's lands and were usually mentioned along with both the San Gorgonio and Jurupa Ranchos. Although Guapa has been mentioned as a separate mission rancho by some, it was simply incorporated with the Jurupa Rancho.[27]

MISSION SAN LUIS REY DE FRANCIA

Mission San Luis Rey was founded in June 1798 as the eighteenth mission in the chain. Known as the "King of the Missions," San Luis Rey was the result of a tour taken the year before by a scouting party consisting of Fathers Lasuen and Juan Santiago of the Mission San Juan Capistrano. They departed on October 2, 1797, trekked through the mountains to the east, entered southwestern Riverside County near Lake Elsinore and continued south through the Temecula Valley until arriving in present-day Oceanside, where Mission San Luis Rey was eventually established. The diary kept by this group gives the first description of the area:

We climbed and descended an undulating terrain and with much difficulty descended a very long hill, very stony and overgrown, and then, when night had already fallen, we reached an ugly little sandy valley that had scarcely any pasture and only a little puddle of water.

On the third, at sunrise, we set out from that place, journeyed eastward along roads that were worse than those of yesterday, and around one in the afternoon reached Temeco [Temecula]. As we continued, the water of that canyon appeared in pools, and in a very long lake which flowed as in a furrow; and in the middle of the water we could occasionally see bare rocks. We tasted the water and it was brackish. We later came upon a good stretch of fresh water and there we rested, around two in the afternoon, in the neighborhood of a rancheria that had in all about fifty people. There we slept.

On the morning of the fourth, we investigated the other side of the canyon, following a creek that had its source in some marshes, and we found that there was no advantage to be gained, for the entire terrain was excessively alkaline.

At midday or a little before, we followed an easterly course along roads that were ever worse than the preceding ones, and for purposes of necessary communication cannot be regarded as roads.[28]

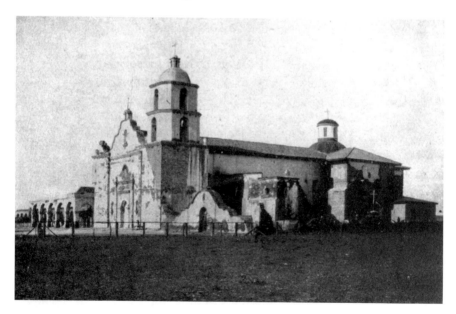

Mission San Luis Rey de Francia. *Photo from James,* The Old Franciscan Missions of California, *frontispiece.*

Obviously not too impressed by the area to become Riverside County, the party continued on to Pala, eventually recommending the valley of San Juan Capistrano Viejo as the new mission site.

As soon as the Mission San Luis Rey was established, it too began to incorporate neighboring tracts of land into its purview. Of the many Mission San Luis Rey ranchos that eventually characterized the "King of the Missions," two were located within Riverside County: Temecula and San Jacinto.

Temecula Rancho

Named for the primary Indian village in the region, the Temecula Rancho consisted of today's Lake Elsinore and its valley, the Temecula Valley, and the Long, Wolf and Pauba Valleys to the east. It too was used for grazing cattle, but at Temecula, apparently some agriculture was practiced. The crops grown were mostly wheat and corn. Soon, the Temecula Rancho became a necessary supplier of food for the mission and its Indians, as well as one of the padres' valuable tools for teaching the neophytes the ways of agriculture and "civilization."

Unlike their counterparts at Mission San Gabriel to the north, the padres at San Luis Rey constructed buildings on many of their ranchos, including the two in what would become Riverside County. According to B.E. McCown, who excavated the mission buildings at Temecula in the early 1950s, these structures consisted of a small, two-room building and a warehouse. The two-room structure, which measured 18 by 35 feet, was probably the *mayordomo*, or rancho overseer's, residence. The other room may have housed visiting priests, a small chapel or both. This structure was likely built around 1800, or just after the Mission San Luis Rey was completed. The second building at Temecula was a warehouse structure, measuring approximately 200 by 63 feet and shaped like an elongated L. It was used for storing grain and hides produced at the rancho. This second building was probably built later, closer to 1820. Both of the structures were located at the head of Temecula Canyon, on a point just south of the Santa Margarita River.[29] From that vantage point, most of the Temecula Valley could be seen, and it would have offered mission officials ample opportunity to view the vast holdings of the mission and survey the farms and herds that called the Temecula Rancho home.

SAN JACINTO RANCHO

The San Jacinto Rancho took its name from St. Hyacinth and was probably founded on August 16, because that is the feast day of St. Hyacinth.[30] In all likelihood, the year was 1819.[31] San Jacinto, the largest rancho within Riverside County, comprised more than 130,000 acres, stretching from Temecula north to the Badlands north of present-day San Jacinto, westward to the Woodcrest area southeast of Riverside and eastward to the foothills of the San Jacinto Mountains. Here in the northernmost hinterlands of Mission San Luis Rey, there was no agriculture, only the grazing of some of the massive herds of horses, cattle and sheep that belonged to the mission.

In order to better oversee the extensive San Jacinto Rancho, mission officials established an outpost compound on what later became known as Casa Loma Hill, near the present-day intersection of the Ramona Expressway and Warren Road. The compound consisted of a small rooming house for the mayordomo, several granaries to hold the harvests of barley and wheat and, of course, a small chapel. These buildings combined took on the familiar L shape of many mission building compounds and had the advantage of being on a slight elevation so that most of the mission grounds could be seen. When completed, the chapel at San Jacinto served as a stopping place for the roaming priests of San Luis Rey to say Mass. San Jacinto, Temecula and two other ranchos now in San Diego County all shared one priest.

Another feature constructed by mission officials in the area of the San Jacinto Rancho was the Corral de Pilares, or the "basin corral," located on the west side of the San Jacinto River against the hills that compose the eastern portion of today's Lake Perris. This Corral de Pilares consisted of an adobe structure and a four-acre pen surrounded by an adobe wall. Apparently, the herds of cattle were brought to this location for branding, which makes sense given its location on the far northern reaches of the San Luis Rey lands. By 1853, this area had fallen into disrepair, and today, nothing of it remains.[32]

As one might imagine, traveling to and from the various ranchos was a priority for mission officials. Therefore, when the two main San Luis Rey Ranchos were established, at least two roads were charted to connect the two holdings. One of these roads began east of the Temecula Indian village and ran north-northeast through a little valley north of present-day Butterfield Canyon. De Portola Road traces this road through much of its southern portion. The road headed north-northeast to a spring named

Santa Gertrudis by mission officials and continued through the low hills and valleys until coming into present-day Diamond Valley, where today, the Metropolitan Water District has constructed its newest reservoir. From here, the road headed northeast around several hills until it came to the adobe rancho house of the San Jacinto Rancho. The other road started farther east, near Aguanga, and headed almost straight north along what is today Sage Road. At the confluence of this road and today's Tucalota Creek was another Indian rancheria that would be renamed San Ignatio by the priests. From San Ignatio, the road continued north and entered the San Jacinto Valley at its most southern point. From there, it would have been a straight and easy journey north to the outpost at San Jacinto. Of these two roads, probably the former was used more often simply because of its proximity to Temecula. However, both continued to be major links between the two areas, as we'll see in subsequent chapters.

Many people confuse the more massive mission ranchos of the Spanish period with those of the Mexican elite, who would characterize the population of California toward the middle of the nineteenth century. Spanish authorities did have a system whereby individuals could solicit large grants of land to be used for pastoral purposes. However, because there were few non-missionary individuals willing to settle in California, this system was rarely used. In fact, during the entire period of Spanish rule in California, no more than twenty of these Spanish ranchos were granted. Of these twenty, none was within Riverside County. The one that came closest to our area was the huge, seventy-five-thousand-acre Santiago de Santa Ana grant of Jose Antonio Yorba. Yorba received this grant on July 1, 1810, from Governor Arrellaga. To use today's geographic nomenclature, the Santiago de Santa Ana grant encompassed virtually all of the Santa Ana Canyon area of eastern Orange County, as well as much of northern Orange County and Newport Bay. It has been speculated that this grant may have extended into the extreme western portion of Riverside County, but it did not, going only as far east as present-day Gypsum Canyon.[33] But in the days when the human population was sparse and boundaries were fluid, Yorba's herds probably did graze in areas later encompassed by Riverside County.

Within a few years of Yorba's grant, and in roughly the same proximity, Riverside County acquired its first non-Indian resident. His name was Leandro Serrano, and he came at the behest of the Mission San Luis Rey. Born at the presidio of San Diego to one of the soldiers of Father Serra's first expedition, Serrano had been affiliated with Mission San Juan Capistrano and later served as mayordomo of the Pala Asistencia of Mission San Luis

One of Serrano's tanning vats. *Photo courtesy of the Heritage Room, Corona Public Library.*

Rey. In his travels in these capacities, he became familiar with the local Indians north of San Luis Rey. Because the Mission San Luis Rey padres feared attacks or other unrest from these Indians, Father Peyri at San Luis Rey asked Serrano if he would settle in what is today the Temescal Valley to help establish a presence there and quell potential problems with the Indians. Serrano obliged, and in 1818, he was given a permit to graze in the Temescal Valley, which meant that he had temporary use of the lands for livestock purposes. He settled on these lands at a "big cienega," approximately one mile north of where Glen Ivy Hot Springs is now located, and built a small adobe home there.[34]

Serrano's first order of business was to organize hunting expeditions to eliminate the many bears and mountain lions that roamed freely throughout the hills surrounding the Temescal Valley. Having accomplished that objective, he imported a small herd of cattle and sheep into the valley. The Serrano Tanning Vats, a Riverside County historical landmark located along Temescal Canyon Road, were part of the Serrano settlement and were probably tanning hides as early as 1819.

This indicates that Serrano was busy in the early years orchestrating the building of an adobe house, the eradication of the bear and wildcat predators and the slaughter of cattle for hides. It is estimated that in May 1824, Serrano moved himself and his family to Temescal on a permanent basis.[35] The Serranos continued to live in the Temescal Valley for several years, and their story will be continued later.

Through the years of Spanish rule, the California missions grew in both area and importance, and so did New Spain. By the second decade of the nineteenth century, officials in both places were becoming eager to reestablish an overland route connecting the two spheres of Spanish influence. However, by this time, most officials had either forgotten the route Anza had discovered or wanted a better one. In 1821, with officials wanting to establish a mail route between Tucson and San Gabriel, the military commander in Tucson hired Jose, the chief of the Cocomaricopa Indians, to take mail between the two points. Jose used a more northerly route that was well known to him and had served as an Indian trading route for centuries. This route would later become known as the Cocomaricopa Road. Jose and several others set out in 1821 from Tucson and completely avoided the Yuman Indians to the south by crossing the Colorado River in the vicinity of present-day Blythe. They traveled through the somewhat mountainous terrain of the Chuckawalla Valley, through the Chocolate Mountains and entered the Coachella Valley. This led them to the San Gorgonio Pass, San Timoteo Canyon and then the San Bernardino Valley until they finally reached San Gabriel. Although this route was used several times to transport mail by Indians hired for that purpose, it was not a practicable route for pack trains or similar-sized convoys, mainly because of the terrain and insufficient water along the road. Still, the mission padres hoped that it would become a regular mail route between Sonora and Southern California.

At the same time a new overland route was being introduced through the eastern portion of Riverside County, events happening in the west would give us the first descriptions of some of the places that would become focal points in the further development of Riverside County. One such event focused on Father Payeras, who was a senior official with the mission system. In 1820, it was his firm belief that the Spanish missions should begin to expand into inland Southern California instead of into the northern portions of California. He was pleased that the Mission San Gabriel had, just one year earlier, established the San Bernardino Rancho, and he strongly advocated building a mission there. In order to further his cause, he enlisted the aid of Father Jose Sanchez, who would later become the priest at San Gabriel. The

Cocomaricopa Trail

Through Eastern Riverside County

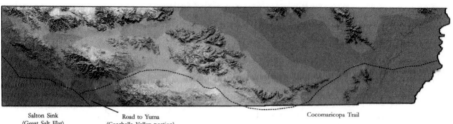

| Salton Sink | Road to Yuma | Cocomaricopa Trail |
| (Great Salt Flat) | (Coachella Valley portion) | |

two of them, along with eight military personnel, set out on a round-about trip from San Diego to San Gabriel, all the while taking stock of the mission holdings and ostensibly looking for locations for potential new missions. One of their stops took them to the *asistencia* at Pala, right near the present-day border of Riverside and San Diego Counties. Here, they recommended that the asistencia be upgraded to a full mission, provided a full-time missionary could be found.[36] They then traveled through Temecula and, on September 24, went north through the San Jacinto Rancho:

> SEPTEMBER 24—*At daybreak we left the lower canada for the west. The soil is very much saturated with alkali. The water ditch is apparently useless for irrigating because the land lies higher. On the right hand there are some small springs. After wandering toward the north for about a league, we encountered a spring which is not very large and which is called by our people San Isidro. Continuing in the same direction, we discovered another called Santa Gertrudis. Proceeding in the same direction we stopped at Jaguara, so called by the natives, but by our people San Jacinto. This is the rancho for the cattle of San Luis Rey, distant from Temecula about eleven or twelve leagues. On the whole stretch there are no trees. The soil is very good; but on reaching San Jacinto, its lands, though used for pasture, proved to be of little value on account of the alkali. From this little elevation where the enramada is situated, north to south, there are springs. The arroyo which runs from here east to south is covered with* alamos *for*

about two leagues. In front of the enramada, *toward the northeast, is a spring of tepid water. Not far away is fine timber. In fact it is a very extensive locality; but according to observations, it lacks sufficient water. In my opinion, it can serve only for a rancho.*[37]

From San Jacinto, Fathers Payeras and Sanchez skirted the Badlands to the north and crossed them probably where present-day Reche Canyon leads from Moreno Valley toward the San Bernardino Valley. Here, they would have had a short walk to the San Bernardino Rancho.[38] They spent five days at San Bernardino, at which time they departed in a rather circuitous route that took them west along the Santa Ana River:

> OCTOBER 1—*About four in the morning we set out toward the west by the road that leads to San Gabriel. About seven in the morning we arrived at Jubuval* [Jurupa] *on the bank of the Santa Ana. Continuing our journey we reached Guapia* [Guapa] *about nine-thirty. We ate and at four in the afternoon we…proceeded to San Gabriel where we arrived about eight o'clock in the evening, having traveled about twenty-one leagues from San Bernardino.*[39]

This route from San Bernardino, going west then southwest along the river, kept them in contact with a good water supply. It crossed the Anza route, which continued to San Gabriel.

Although the grandiose plans of Father Payeras met with the approval of many, including Narciso Durán, the father-president of California, events much farther south would preclude any new plans for mission outposts. Even as late as 1837, well after Spain's control of California had been wrested from it by new leadership in Mexico City, Father Duran wrote about the possibility of making Santa Ysabel and Pala full missions and even upgrading San Jacinto's status in the chain. However, that was not to be, because a new government, with new ideas and new settlers, had more ambitious aspirations for the missions and their holdings.

As we've seen in the previous pages, the beginnings of Anglo settlement in what would become Riverside County involved at first exploration and later domestication of the land. Juan Bautista de Anza traveled through the region in search of an overland route to San Gabriel and in the process described in glowing terms the areas through which he rode; he spoke of their possibilities for additional settlement. These sentiments were echoed years later by mission officials at both the San Gabriel and San Luis Rey

Missions, who claimed much of what would become western Riverside County for the use of their missions. By the end of the Spanish Period in California's history, Riverside County already had many of the place names known to us today, along with a land-use system that, to some extent, can still be recognized in the present day. As far as settlement in our area is concerned, though, while the Spanish Period ushered in non-Indian settlement, the pace of that settlement would drastically increase in subsequent years, which will be the theme of the next several chapters.

PART II
THE MEXICAN PERIOD

3
MISSION SECULARIZATION AND LAND GRANTS

S tarting with the Grito de Dolores in September 1810, New Spain would spend the next eleven years embroiled in a series of increasingly bloody, brutal battles from within. The turmoil ended in 1821 with the Convention of Cordova. With this act, all of the Spanish colonies of New Spain became part of the new land of Mexico, and a new phase in the development of California, and Riverside County, was begun.

The new government in Mexico quickly realized that something would have to be done about the sparsely populated region of Alta California because they faced an even greater risk of losing those colonial lands than the Spanish had. By the 1820s, the French had sold their vast Louisiana Territory to the rapidly expanding United States of America, and it appeared as though little stood in the way of the United States from claiming most, if not all, of North America as its own. Reluctant for that to happen, the Mexican government decided that a greatly accelerated plan of settlement and development of Alta California was necessary to ensure that California remained Mexican.

One major obstacle to this plan was the lack of a good road between central Mexico and California. As seen previously, the Anza route was discovered early but was abandoned almost immediately due to problems with the Yuma Indians en route. One additional possibility for a road had been "discovered" only recently by the Spanish—the Cocomaricopa Trail, which had just been opened for use by the mail. To ascertain its viability as a route for overland travel, the Mexican government arranged an expedition along the Cocomaricopa Trail.

The man ordered to conduct this expedition of the desert was Jose Romero. Romero already had been in Tucson and came to California by a circuitous route down the Colorado River, across and through Baja California and then to San Diego. By mid-December 1823, Romero had arrived at San Gabriel and, having received his orders, was preparing to embark across the desert. He was joined in this effort by Jose Maria Estudillo, who would be the diarist of the expedition; several soldiers; and a large accompaniment of horses. On December 17, they reached the San Bernardino Rancho, and on the twenty-fifth, they entered a region

> *full of obstructions, and rocky. The mountains were bare of large trees, and there was no pasture. Such water which was available, was only in small pools and of such small amounts that the horses were unable to drink therefrom. Twenty-eight horses that could not continue were left at this rancho.*[40]

The rancho to which Estudillo referred was the San Gorgonio Rancho, the first time a reference to it was printed. From San Gorgonio, they traveled through the Coachella Valley and met the Cocomaricopa Trail at Dos Palmas. January 2, 1824, saw the party camping on swampy land in the desert, owing to the fact that it had just rained. Their Indian guides told them that from their location, they were but two days' travel from the Colorado River. At this point, though, their main guide, Salvador, either became confused or wanted to lead the party astray. Having led them through numerous small canyons to dead ends, he declared he was lost. Romero then had to decide whether to turn back or tackle the rest of the journey without guides. Many of his animals, though, were in poor shape, and several had died. With little water and virtually nothing to eat, Romero decided to return to San Gabriel. Camping at a location in the vicinity of today's town of Thermal, Romero wrote to his superior, Don Antonio Narbona, of his condition and indicated that he would be returning to San Gabriel (see Appendix B). By the time he arrived back at San Gabriel on January 31, he had lost almost all of his animals in the desert. Later research has shown that Romero and his party were but a half-day's trek to the Colorado River when they turned back.[41]

While he was recuperating from the first trip, Romero soon received orders to try again, this time with fewer animals and more men. This expedition would be different, though, because Jose Cocomaricopa himself would be the guide. Delayed for nearly nine months due to Indian troubles and the summer heat, Romero's second expedition departed from San

Gabriel on November 28, 1824. This time, he made the trek to Tucson with few problems.

Leading a small band of soldiers across hundreds of miles of desert is hard enough, but leading a wagon train or a caravan of settlers across it is even harder. Therefore, when Romero successfully traversed the Cocomaricopa Trail, he wasted no time relating to his superiors that the trail was worthless, in his opinion. It was Romero's belief that the government should instead try to reopen the Anza trail farther to the south. Taking Romero's accounts into consideration, authorities in Sonora sent a detachment of soldiers to do just that. This new group retraced Anza's steps throughout Sonora and the southeastern California desert, but when they came to the confluence of the San Felipe and Carrizo Creeks in present-day San Diego County, they continued in a more northwesterly direction up Carrizo Creek instead of the San Felipe, as Anza had.[42] From Carrizo Creek, the group headed northwest through the hills and valleys of today's eastern San Diego County to the Valle de San Jose. Two important ranchos were located there: the San Jose, of Mission San Diego, and the Agua Caliente, affiliated with Mission San Luis Rey. In this valley, the party came to the eastern end of the road, which led from there to San Diego. Continuing northwest from San Jose, the party entered what is now Riverside County at the San Luis Rey Indian rancheria of Aguanga, near where Tule Creek flows into Temecula Creek.

At this point, the trail led west from Aguanga along Temecula Creek to the expanse of the Temecula Valley. Along this route, they passed the Indian village of Temecula, located on a bluff on the south end of the creek, in the vicinity of present-day Highway 79 and Redhawk Parkway. From Temecula, the party followed the trail to the north-northwest, through the Alamos groves and then to Laguna Grande (today's Lake Elsinore). Laguna Grande, a natural water source with an abundance of hot springs in the vicinity, became a major landmark and stopping place along the route. From there, the road led farther through the Temescal Valley, with a stop at Serrano's rancho. Continuing northwest from Serrano's, the route led to the Santa Ana River, which also served as a stopping place. From there, it left Riverside County, headed through Mission San Gabriel and ultimately reached the pueblo of Los Angeles. This "new" (to the Mexican government) road was immediately heralded as the better overland route to Southern California. In its earliest stages, it was known as "El Camino Real," a name given to almost any main road connecting the missions, presidios, asistencias and other Spanish outposts. It would later be known by several names: the Sonora Road,

the Los Angeles to Yuma Road and the Colorado Road (because it led to the Colorado River).

With the advent of this new road, Riverside County—and Southern California in general—began to experience its first large-scale influx of people. In time, it would become the custom for many people to purchase land or otherwise settle along such roads. These people established homes that became way stations along the route, serving as an outpost general store wherein travelers could obtain extra food and/or provisions for themselves and their horses, among other things. The availability of such goods depended on the season and the number of other travelers who had traded beforehand. Because many of the early roads crisscrossed the region, in later years, Riverside County would have many such outposts.

Who were the people coming to the area to settle? Mainly Sonorans from northwest Mexico, and later, little by little, Americans from the eastern United States. A series of decrees, such as the Colonization Act of 1824 and the *Reglamento* of 1828,[43] and other undertakings by the Mexican government, attempted to bring people north to the California frontier. In 1826, the Mexican government decreed that the Sonora Road was to be the official mail route for correspondence between Mexico and California. This decree brought several disparate groups of people to California along the route. The first of these were government officials traveling to Monterey and couriers carrying the mail. A second group to come north began in 1830, when Mexico began using Alta California as a penal colony, sending its "undesirables" north to the frontier. A third group of people began going north during the spring of 1842, when the discovery of gold at the San Francisquito Ranch near Mission San Fernando in present-day Los Angeles County drew hundreds of people in search of gold. Thus, by the time Mexico ceded California to the United States, several thousand miners, criminals and others had used the road to travel to California.

A fourth group of people, and the most important, were ordinary settlers. Many of these settlers came at the behest of the Mexican government, which needed to populate California due to the foreign threats. Although they had the route to travel, namely the Sonora Road, what the Mexican government lacked initially was an incentive to entice prospective settlers north on their own. There was little desirable land in California that had not been already incorporated into the mission system. Throughout the 1820s, the missions continued to grow both in influence and area, claiming most of the desirable lands in California. John Dwinelle, writing in 1863, sums up the material wealth of the missions at that time:

At the end of sixty years, the missionaries of Upper California found themselves in possession of twenty-one prosperous Missions, planted upon a line of about seven hundred miles, running from San Diego north to the latitude of Sonoma. More than thirty thousand Indian converts were lodged in the Mission buildings, receiving religious culture, assisting at divine worship, and cheerfully performing their easy tasks. Over four hundred thousand horned cattle pastured upon the plains, as well as sixty thousand horses, and more than three hundred thousand sheep, goats and swine. Seventy thousand bushels of wheat were raised annually, which, with maize, beans and the like, made up an annual crop of one hundred and twenty thousand bushels; while, according to the climate, the different Missions rivaled each other in the production of wine, brandy, soap, leather, hides, wool, oil, cotton, hemp, linen, tobacco, salt and soda.[44]

However, by the 1820s, the vast riches enjoyed by the missions were considered more desirable for their ability to attract potential settlers. True, the government had passed the Colonization Act in 1824 and the accompanying *Reglamento* of 1828, both of which liberalized land policy and made other concessions to prospective settlers. However, because the missions still occupied most of the worthwhile lands in California, people had little incentive to leave their homes to settle in the north.

Bearing this in mind, in 1826, California's governor, Jose Maria Echeandia, proposed that the missions be secularized, turned over to the secular clergy and used as a basis for Indian village settlements. This proposition led to lengthy arguments regarding the missions and their holdings. Seven years later, after much debate, the Mexican government passed the Secularization Act in August 1833. Instead of relinquishing the mission holdings to the Indians, this act effectively closed the missions and remanded their vast tracts of land over to the California governor for dispersal as he saw fit. Beginning with the Secularization Act's implementation in 1834, and continuing until the end of Mexican rule in 1846, several successive governors divided former mission lands into approximately seven hundred Mexican land grants, called ranchos, which were given to friends, relatives, political cronies, wealthy citizens and others who wished to have a piece of California.

These ranchos became the basis of Mexican settlement in California. In order to obtain title to a tract of land, a person had to file a petition with the governor.[45] This written request showed that the applicant was a Mexican citizen, either by birth or naturalization; contained a description of the area petitioned; and included a declaration that no part of the sought-after land

36

was occupied by anyone else. In addition, a hand-drawn map, called the *diseño*, accompanied the petition and showed the boundaries of the request, the rough topography of the area and any necessary geographic features, such as mountains, valleys, rivers, etc. Also included were the boundaries of neighboring ranchos, if any.

After reviewing the petition, the governor sent the information to the district official of the area in question, who was charged with verifying the information. If everything was in order as described on the petition, the governor issued a formal grant to the petitioner, and all of the information pertaining to the grant was combined into an *expediente* and filed in the government archives.

Once the petition was accepted and signed by the governor, the new owner could take possession. Usually, the first action taken by the new owner was to have the rancho surveyed. This was a process steeped in ceremony, and although it would make present-day surveyors cringe due to its highly unusual nature and lack of precise surveying methods, it was nevertheless a completely legal account of a huge tract of land done in an era in which land was so plentiful that pinpoint accuracy was quite unnecessary.

To begin the survey, the surveyors gathered at a predescribed point and thrust a long pole into the ground, to which was tied a long leather strap. A surveyor on horseback then took another pole, to which the opposite end of the strap was tied, and rode along the line of the rancho until the strap became taut, whereupon he would drive the pole into the ground. The first pole was removed, and the other surveyor then rode past the second until the strap was again taut and drove the pole back into the ground. This process was repeated until all boundaries were defined. Once all the measurements were taken and recorded, the grantee of the rancho walked over a portion of the land, uprooted some grass, broke branches off trees, scattered dirt and performed other tasks until it was understood, and the local government officials proclaimed, that he was the true owner of the grant.

Having secured his grant, the rancho owner could begin stocking his land with herds of animals. He would usually construct a large adobe home for his family and several other buildings for the army of workers required to maintain the large rancho. The beginning of these rancho grants in 1834 ushered in what has been called the Golden Age of California history, romanticized as the "Days of the Dons," since it was generally the Mexican elite who received ownership of the California ranchos. For a roughly thirty-year period in Southern California, under both Mexican and U.S. rule,

the large and ever-growing cattle herds of the rancho landowners roamed almost unhindered throughout the area.

Life on the ranchos during the "Days of the Dons" was not unlike that of the medieval English manor. The household was run by the patriarch of the family, the grantee of the rancho, who lived there with his wife and children, some of whom had their own families living there as well. Indians were employed as *vaqueros*, or cowboys, as well as domestics and other ranch hands. Their numbers ranged from just a few to several hundred, depending on the size of the rancho, family and herd. Out of necessity, each rancho became virtually self-sufficient, owing to the fact that California was still a frontier area and lacked any major means of supply. These ranchos facilitated the main economic pattern in Mexican California: that of livestock raising. With the large amount of acreage afforded to each rancho, livestock could roam virtually unchallenged throughout Southern California. Livestock was prized not for meat, but for hides, which supplied a vast leather market in those days. Annual roundups of cattle afforded a spectacular, multi-day festival hosted by the *ranchero* (rancho owner) that involved not only his own family and personnel but those of several neighboring ranchos as well.

Within Riverside County, sixteen of these large Mexican land grants were awarded to various people. Two others were never recognized by the Mexican government. Spanning the entire length of time that ranchos were deeded to private citizens, the ranchos within Riverside County generally can be classified, with only a couple of exceptions, according to the Spanish mission lands to which they once belonged. These groupings include the northwest portion of the county, under Mission San Gabriel Arcángel, and the old Temecula Rancho and San Jacinto Rancho grants of the Mission San Luis Rey de Francia.

4

DISPOSITION OF THE RANCHOS

FORMER MISSION SAN GABRIEL RANCHOS[46]

Jurupa Rancho

In 1838, four years after the Secularization Act went into effect, Juan Bandini, a dashing fellow known for his social graces and ability to dance, was appointed administrator of the Mission San Gabriel Arcángel by California governor Juan Alvarado. In this capacity, Bandini became the overseer of the mission and all its holdings. Wasting little time in claiming some of these holdings for himself, Bandini sent a petition in early 1838 to Governor Alvarado requesting ownership of the Jurupa Rancho. He was granted the Jurupa Rancho on September 28, 1838, and this land grant became the first officially recognized Mexican land grant within Riverside County.[47]

The Jurupa Rancho consisted of seven square leagues of land, or roughly thirty thousand acres.[48] It also included a small former mission property called Guapa, on the extreme west end. This gave Bandini a huge area bounded by the Jurupa Hills to the north, the Santa Ana River to the south and east and the Chino Rancho to the west.

In accordance with the rules governing rancho grants, Bandini began stocking his land with his herd and built a small adobe house for himself and his family. The location of the Bandini home has been described as being situated

Mexican Ranchos of Riverside and San Bernardino Counties

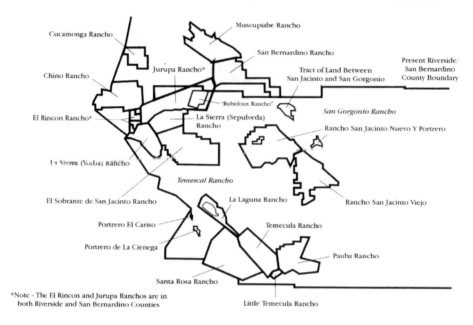

Muscupiabe Rancho

Cucamonga Rancho

San Bernardino Rancho

Present Riverside/
San Bernardino
County Boundary

Chino Rancho

Jurupa Rancho*

Tract of Land Between
San Jacinto and San Gorgonio

"Rubidoux Rancho"

El Rincon Rancho*

La Sierra (Sepulveda) Rancho

San Gorgonio Rancho

Rancho San Jacinto Nuevo Y Portrero

La Sierra (Yorba) Rancho

Temescal Rancho

El Sobrante de San Jacinto Rancho

La Laguna Rancho

Rancho San Jacinto Viejo

Portrero El Cariso

Temecula Rancho

Portrero de La Cienega

Pauba Rancho

Santa Rosa Rancho

*Note - The El Rincon and Jurupa Ranchos are in
both Riverside and San Bernardino Counties

Little Temecula Rancho

on a bluff approximately one thousand feet west of present-day Hamner Avenue, about a half mile north of the Hamner Avenue Bridge over the Santa Ana River. The Bandinis lived in this house for about two years, and although no trace of the home is visible today, it was visible as late as 1928.[49]

El Rincon Rancho

From Bandini's home, he could look to the west and see a higher bluff with better potential for a larger house for his family. This land lay outside his Jurupa grant. Therefore, in 1839, he petitioned the governor for the new area, which had been called, alternately, El Rincon (the corner) and Bolsa (pocket). On April 28 of that year, he received the one-square-league rancho, which bordered the Jurupa Rancho on its extreme southwest corner. Eventually, he settled on the name El Rincon Rancho, and Bandini soon began building a larger home on the land for his family. In order to secure wood for his

home, he again petitioned the governor, this time to allow him to cut and haul timber from a tract of land in the San Bernardino Mountains directly north of Jurupa/El Rincon. This too was granted, and Bandini went into the lumber business for a while, supplying lumber both for the foundation of his new adobe home and for many other projects in the area.

Although he took possession of both ranchos and built two homes, it was not long before Bandini began subdividing his property and selling some of it to others. On May 6, 1843, Bandini sold approximately 1.5 leagues of land to Benjamin David Wilson, an American who played a large part in early Southern California and for whom Mt. Wilson is named. This area was in the eastern portion of the Jurupa Rancho, on both sides of the Santa Ana River. Concurrent with the sale was the donation of the northernmost portion of the Jurupa Rancho to Lorenzo Trujillo and the Agua Mansa settlement (more later). Sometime in the next couple years, Wilson sold half of his land to Isaac Williams, owner of the neighboring Chino Rancho. On May 8, 1848, Wilson sold the other half to Louis Robidoux. A year and a half later, Robidoux bought Williams's portion, giving him approximately 6,750 acres, upon which today sit the community of Rubidoux, downtown Riverside and much of the Wood Street area of Riverside. The two halves together later constituted what was termed the Jurupa (Robidoux) Rancho.[50]

Bandini's other possession, El Rincon Rancho, was sold to a series of owners beginning in April 1843. Bandini sold El Rincon to David Alexander, who then sold it to Isaac Williams, who in turn sold it to Bernardo Yorba, owner of the La Sierra Rancho (see below).

San Gorgonio Rancho

The San Gorgonio Rancho is one of two unofficial ranchos within Riverside County. It is considered unofficial because apparently it was never officially granted by the Mexican government; no records of it exist, and as such, claim to it was not upheld by the Mexican, or later, U.S. governments. However, that did not mean people did not try. The early history of the San Gorgonio Pass is thus more a history of early settlers than of a formal rancho.

The Pass's first non-Indian resident was Daniel Sexton, a miner, farmer, timber man and jack-of-all-trades who came to the San Gorgonio Pass from the San Bernardino area in 1842 to cut lumber in the hills. Sexton, by his own admission, is said to be the first person to raise the American flag in Southern California, doing so on July 4, 1842, at an Independence Day

celebration he threw to show the local Indians that white men celebrated special occasions.[51]

At about the same time, another gentleman, Powell Weaver (alternately called Pauline or Paulino Weaver), arrived in the Pass area. Weaver, described as a frontier trapper, explorer and guide, came from White County, Tennessee, and settled on a plot of high ground situated on the west bank of San Gorgonio Creek. His home, later known as the Weaver Adobe, could have been the Mission San Gabriel outpost described in previous chapters. It seems likely, given that at least part of the mission outpost would have been standing, and Weaver could have rehabilitated it and used it for his residence.[52]

Three years later, in 1845, Weaver, together with Isaac Williams of the Chino Rancho and another man named Wallace Woodruff, petitioned then-California governor Pio Pico for the San Gorgonio Rancho. No records of this grant exist, although early Pass historian Jessica Bird indicates that all of the papers regarding the grant were lost in transit to Washington, D.C., probably in the mid-1870s.[53] Regardless of what happened to the title for the San Gorgonio Rancho, Powell Weaver began selling portions of it in the 1850s.

San Jacinto y San Gorgonio
(The Tract of Land Between San Jacinto and San Gorgonio)

Looking at the north-central portion of Riverside County, it seems logical that someone would have asked for a grant of what is today called San Timoteo Canyon, and in fact, someone did. That person was Santiago Johnson, born James Johnson, a native of England. Many Anglos who settled in California during the Mexican period became Mexican citizens for various reasons, one of which was to obtain land. Therefore, when he petitioned the governor for a grant of land, Johnson described himself as a resident of Mexico for twenty years who had a Mexican wife and numerous children. What he requested was

> the Cañada situated between San Jacinto and San Gorgonio, bounded by the first on the West and by the second on the East, and by San Timoteo and Jurupa on the north, in extent from North to South one league, and from East to West one mile.[54]

42

In addition, Johnson asked to have the Cañada of San Timoteo, as it was known then. When he received the final grant on March 22, 1843, Johnson discovered that he had been given the tract between San Jacinto and San Gorgonio, in the southernmost portion of the Cañada de San Timoteo, but not all of the Cañada. Even so, this small grant amounted to about one square league, approximately 4,400 acres in size. Regardless of his grant's size, Johnson held the property for only a year; in April 1845, he sold this tract to Louis Robidoux.

FORMER MISSION SAN LUIS REY RANCHOS: THE TEMECULA RANCHOS

Temecula Rancho

Unlike the other mission ranchos within Riverside County, the Temecula Rancho was used to some extent by the officials at San Luis Rey to raise wheat and a few other crops. This made it especially desirable to many people. In fact, the Temecula Rancho was the first of the Mexican land grants to be petitioned within Riverside County.

In September 1834, just a few months after the Secularization Act had begun to be enforced, Jose Antonio Estudillo requested virtually all of the Temecula Rancho that had been claimed by the Mission San Luis Rey. This included the large Laguna Grande and all of the Temecula Valley. His application stated that,

> *being the owner of a considerable number of cattle, horses and sheep and needing a place, suitable for their increase, in order in this way to secure the support of my numerous family, I pray your Honor to please grant me the place named Temecula, bounded by the Mission of San Luis Rey, which Mission has at this time some stock upon said land.*[55]

Just five months later, in February 1835, Jose Antonio's request was granted by California governor Figueroa. Within a few months, Estudillo, apparently in the belief that all necessary work to obtain the rancho had been or would be completed, began stocking his newly acquired rancho with some of his herd. He did this even though the last of the necessary approvals—that of the Committee on Vacant Lands—had not been

granted. When the local Indians learned that Estudillo had been granted the land they considered necessary for raising their own crops, they protested to the government in Monterey. Bearing in mind the protests of the Indians, the committee never endorsed Estudillo's grant, and he never received title to the Temecula Rancho.

As a result, the Temecula Rancho was still available for petition, and two more Mexican citizens requested it. In 1840, the Pico brothers, Pio and Andres, requested a larger grant, which included the Laguna Grande area, the Temecula Valley and the valley east of it through which ran the Sonora Road. Pio Pico, at that time the administrator of the San Luis Rey Mission (and who would soon become governor of California), was detested by the mission's Indians, who accused him of neglecting them and using them as slaves. William Hartnell, an Englishman appointed by California governor Alvarado to report on the conditions of the Indians, reported:

> On the ninth [of August 1840], *168 blankets or shawls were distributed to the Indians; and later Pio Pico spoke to the Indians, telling them that the government had given him the place Temecula, notwithstanding they had always opposed him; that they should appoint four men who, empowered by them, should go to Monterey; and that he, too, would go there and show that the Mission does not need said place. All the Indians replied that they would not appoint anyone.*[56]

Despite more protests from the Indians, and this time, the padres of Mission San Luis Rey, Pico was given title to the rancho later that year, subject to paying remuneration to the mission for the lands. Appeals continued on both sides until the next year, when Pico, apparently tiring of the Indian problem at Temecula, petitioned for and received clear title to the Santa Margarita Rancho, in present-day San Diego County, and formally withdrew his application for Temecula.

It was not until 1844, near the end of Mexican rule in California, that the Temecula Rancho was officially granted to one citizen. In the summer of 1844, both Jose Ortega, of the San Luis Rey Mission, and Felix Valdez, an army officer living in Los Angeles, petitioned for the rancho. In December of that year, the Temecula Rancho was officially granted to Valdez, although its size had diminished substantially. By the time Valdez received title to the Temecula Rancho, it contained only the flat portion of the Temecula Valley, not Laguna Grande or any ancillary areas. This may have been due to the protests of the Indians and missionaries or because

44

Henry Sandham sketch of the Temecula Village. *Photo from Jackson*, Ramona.

the proposed rancho under the original petition was simply too large. Regardless, Valdez took possession of the land in 1845 and sold it a year later to Luis Vignes, also of Los Angeles.[57]

Pauba Rancho

Early Temecula historian Horace Parker writes that when Nahachish, the great early leader of the Temecula Indians, brought his people to the Temecula Valley, he found a good spring near the end of what is today called Butterfield Valley.[58] The spring flowed with clear water, although at the time of Nahachish's discovery, it had small bits of matter floating in it, indicating that it was recently disturbed by strangers. Seeing this as an ideal location for a settlement, Nahachish declared that "this place shall be known as Paum Pauba," or the spring of the strangers.[59]

Jane Davies Gunther indicates that the word *Pauba* is a Luiseño word meaning, roughly, "traces of strangers."[60] That epithet is rather accurate,

given the Pauba Rancho's location. Located east of the Temecula Valley, and encompassing the Indian village of Temecula and the arroyo through which Temecula Creek passes, the Pauba Valley was the gateway to the Temecula Valley along the old Sonora Road.

It was strangers with whom Vicente Moraga was concerned when, sometime in 1844, he petitioned for the ownership of Pauba Rancho, stating that "this rancho will...be of some service by interfering with the robbers who are accustomed to having their lurking places in these mountains."[61] Described as six leagues of land between Temecula and the Portrero of Aguanga, the Pauba Rancho was granted to Moraga by California governor Manuel Micheltorena in November 1844. The strangers whom Moraga had mentioned in his original petition must have overwhelmed him, because just over a year later, in January 1846, Moraga submitted another petition, this time asking that another person, Luis Arenas, be given half ownership in the Pauba Rancho. In part, Moraga's second petition indicated that

> at this time if Your Excellency please, I find it necessary to have another person with me on said place, as a protection against the Indians in the neighborhood of said place, this place being far within the mountains.[62]

Moraga's troubles with the Indians may have stemmed from the fact that his rancho completely encircled the Indian village of Temecula, located on the south side of Temecula Creek on the bluff overlooking the valley. Regardless, eighteen months later, Moraga and Arenas sold the rancho to Juan Manso, who in turn sold it in January 1848 to Luis Vignes, owner of the Temecula Rancho.

Santa Rosa Rancho

Directly west of the Temecula Rancho, the Santa Rosa Rancho encompassed the much higher terrain overlooking the Temecula Valley. Characterized by rolling terrain interspersed with deep arroyos and wide, flat areas that still house some of the few remaining vernal pools in California, the area that would become the Santa Rosa Rancho had been used as grazing land by the Mission San Luis Rey. In April 1845, Juan Moreno submitted his petition and all other necessary documents to Governor Pio Pico to obtain ownership of the area. Pio Pico, who remembered his troubles at Temecula,

immediately granted the rancho on a tentative basis to Moreno, making it official in January 1846.

Moreno immediately inhabited the Santa Rosa Rancho and built a four-room adobe home for himself and his family. This building, reduced to only one room by fierce storms in 1884, still stands today on the Santa Rosa Rancho and is one of the oldest, if not the oldest, remaining building in Riverside County. In 1855, Moreno sold the Santa Rosa to Juan Machado, who in turn built a larger, three-room adobe nearby. These two buildings together give a good indication of what life was like during that period of California history.

Lands in the Valley of Temecula (Little Temecula Rancho)

The Lands in the Valley of Temecula, or Little Temecula Rancho, as it is often called, has the distinction of being one of the few California ranchos, and the only one in Riverside County, to be granted to an Indian. Pablo Apis was an early convert at Mission San Luis Rey. His dedication to the mission, his acceptance of Spanish ways and his leadership capabilities among the Temecula Indians soon made Apis prominent among the mission authorities and a leader among his people.

In 1843, during one of the short periods of time in which control of the former Mission San Luis Rey reverted back to mission authorities, the head of that mission, Father Zalvidea, began "granting" small portions of the former Temecula Rancho lands to distinguished neophytes so they could have some land for themselves. Apis requested one of these, and on July 9, 1843, Superintendent Juan Ortega (the last administrator of the Mission San Luis Rey), acting as Father Zalvidea's representative, granted the use of the area around the village of Temecula to Apis. Just one day later, on July 10, Apis took that grant and tried to formalize it with Mexican authorities by writing to Governor Pio Pico to obtain formal recognition for the land. Finally, on May 7, 1845, Pico granted the rancho to Apis, and at least for the time being, Apis and many other Indians were able to remain at Temecula.

La Laguna Rancho

Lying in the northern portion of the vast Temecula Rancho was the La Laguna Rancho, granted to Julian Manriquez on June 7, 1844, by California

governor Manual Micheltorena. The La Laguna Rancho was a relatively small land grant, encompassing the large lake we call Elsinore today and a small radius of land extending from the lake in all directions. Manriquez seems to have done little, if anything, with his grant during Mexican times; settlement at La Laguna would not begin for another fifteen years.

FORMER MISSION SAN LUIS REY RANCHOS: THE SAN JACINTO RANCHOS

San Jacinto (Viejo) Rancho, San Jacinto Nuevo y Portrero Rancho

The story of the subdivision of the San Jacinto Rancho of the Mission San Luis Rey is the story of the large and proud Estudillo family of Baja, California, and, later, San Diego. Jose Maria Estudillo, the patriarch of the family, came to New Spain in 1787 at the age of fifteen. He enlisted in the army and rose to the rank of lieutenant, spending several years in that capacity as *comandante* of the Monterey presidio. By 1827, he had been promoted to captain and transferred to the presidio at San Diego. There, his family took full advantage of the soon-to-be instituted Mexican land grant system.

Jose Maria's son, Jose Antonio Estudillo, was the first member of the family to acquire land. In 1827, at the age of twenty-two, he and his brother-in-law, Juan Bandini (see Jurupa Rancho), were given a tract one hundred *varas* square (approximately 1.75 acres) just outside the presidio of San Diego. On this plot was constructed the Estudillo adobe, which became the center of the family's existence for the next forty years. Today, the Estudillo adobe is the centerpiece of Old Town in San Diego.

The Estudillo family was not content with its holdings at San Diego. A few years later, in 1835, Jose Antonio became the first person to petition for land in what would become Riverside County (see Temecula Rancho). In 1840, after spending the previous twelve years in service to the Mexican government, Jose Antonio was named administrator of the former Mission San Luis Rey, a post he took over from Pio Pico. Jose Antonio wasted no time trying to secure lands for himself and his family. On August 9, 1842, Jose Antonio filed a petition for four square leagues of the San Jacinto Rancho. His petition stated that

it is absolutely vacant...The land petitioned for contains an indifferent house covered with earth, ten varas in length, and of a corresponding width, which is however in a ruinous condition, and also an old corral which is useless, all constructed by the Indians, who sometimes live there, at which times they also make some small gardens.[63]

The "indifferent house" mentioned by Estudillo was the Casa Loma building of Mission San Luis Rey. The corral also would have been associated with the Casa Loma. Estudillo's petition further stated that only three Indians lived at San Jacinto and that they wanted Estudillo to be granted the area and settle upon it.

During the fall of 1842, government authorities reviewed Estudillo's petition and found that not only was the desired area vacant, but it had also been that way for a while. Therefore, on December 21, Estudillo was granted the San Jacinto Rancho. The grant, however, was for more than eight square leagues of land, the additional land probably given to him by California governor Manuel Jimeno for his exemplary service to the government. Such a large grant must have overwhelmed Jose Antonio, because in 1845, his son-in-law, Miguel de Pedrorena, filed a petition that divided Jose Antonio's holdings. The petition showed the large original grant cut in half, with Estudillo's portion to the southeast named San Jacinto Viejo (Old San Jacinto) and Pedrorena's portion on the northwest named San Jacinto Nuevo (New San Jacinto). In addition, Pedrorena also asked for a small, relatively flat area called the Portrero that lay north of San Jacinto in the Badlands. Therefore, when it was submitted to the governor, the entire petition by Pedrorena was dubbed San Jacinto Nuevo y Portrero, which was, in effect, a petition for surplus lands of the old San Jacinto Rancho.

As we saw previously, a road had been established during Spanish times to connect Temecula with San Jacinto. This road was still in use in Mexican times, but with the influx of people, more roads began to lead to and from San Jacinto. Most notably, a road was laid out from San Jacinto leading northwest along the Badlands, through what is today Moreno Valley, to Box Springs Mountains, around the southern and western edges of the Box Springs Mountains and to the spring for which the area is named. From this spring, the road led down into the plain on which Riverside now lies, where a traveler could then head to Jurupa, Guapa, Chino, Cucamonga or even Los Angeles to the west or north to San Bernardino. This road essentially opened the interior portion of what would become western Riverside County to immigration.

El Sobrante de San Jacinto Rancho

Whereas the San Jacinto Nuevo and San Jacinto Viejo Ranchos occupied most of the easternmost portion of the original San Jacinto Rancho, the westernmost area still lay unclaimed until the end of Mexican rule in California. At that time, Jose Antonio Aguirre petitioned for the El Sobrante de San Jacinto Rancho, literally "the remainder of the San Jacinto Rancho." On May 9, 1846, the grant was confirmed to Aguirre's wife, Maria del Rosario Estudillo de Aguirre, who was a daughter of Jose Antonio Estudillo. One source indicates that beginning in 1844, and continuing for several years, Maria Estudillo de Aguirre had no fewer than nine hundred head of cattle on the El Sobrante Rancho.[64] However, during this time, nothing more is known of her.

OTHER RANCHOS

Temescal Rancho

The Temescal Rancho is the other unofficial rancho within Riverside County. As we saw previously, Don Leandro Serrano was the original settler on the Temescal Rancho, having come there at the behest of the Mission San Luis Rey in 1818. When he settled there, he was given what was described later as a "paper," which was merely a license to graze his herd. During the time of Mexican rule, Serrano tried to make title to the Temescal Rancho official by appealing to Governor Echeandia for a full grant of the rancho. However, the governor never responded to Serrano's request. But Serrano knew that under Spanish law, undisputed possession of property for thirty years or more meant that he would get title to the land, so he never again petitioned for title from the Mexican authorities. He kept the land for the necessary length of time but never gained official title to it, which eventually caused tremendous problems for his heirs once the Americans took control of California.

Portrero el Cariso, Portrero de la Cienega, Portrero Los Piños

These three small ranchos represent the only lands of the Mission San Juan Capistrano to be located within Riverside County. As shown

previously, the missionaries of Mission San Juan Capistrano apparently thought they had use of the Temescal and Temecula Valleys but never used them. When Mission San Luis Rey was established, the missionaries there began using the land almost immediately, and the missionaries at San Juan Capistrano protested.

In any event, after secularization of the missions, John Forster, also known as Juan, petitioned for and received the three "Portrero" ranchos from Governor Pio Pico in April 1845. Forster, an Englishman who had become a naturalized Mexican citizen under the various colonization acts of the 1820s, was well connected; his wife was Isidora Pico, Pio Pico's sister. In addition, he was the nephew of James Johnson, who was granted the Tract of Land Between San Jacinto and San Gorgonio.

The three small grants are located in the mountains west of Laguna Grande. The two smaller grants, el Cariso and la Cienega, are within present-day Riverside County, whereas the larger one, Los Piños, is in present-day Orange County. We can imagine how these places must have appeared at the time by their names: el Cariso (which is actually spelled Carrizo) means "bunch grass," which was endemic to Southern California at that time; la Cienega means "a marsh," which would probably have been one or more vernal pools that dot the area; and Los Piños means "the pines." Forster apparently did little with these lands, as he owned several other pieces of land in Southern California.

The La Sierra Ranchos

The La Sierra Ranchos do not fit into the category of a former mission land grant because they were never claimed by any of the three area missions. Their existence is due mainly to the large Santiago de Santa Ana land grant in Orange County and the Yorba family's quest for even more land.

As mentioned previously, in 1810, Jose Antonio Yorba received the massive Santiago de Santa Ana land grant in what is now northern and eastern Orange County. By 1825, two of his sons, Bernardo and Tomas, were pasturing their herds on flatter lands directly east of their father's massive grant. In order to incorporate these lands into the family, Bernardo applied for and received the Cañon de Santa Ana Rancho, which today encompasses the area including Yorba Linda, and another brother, Teodocio, received the Lomas de Santiago Rancho. Both of

these grants were just east of the original Santiago de Santa Ana and very close to what is today the westernmost boundary of Riverside County. The grants themselves did not stop the Yorba herds from moving even farther east, and they continued to move into an area to which Bernardo and Tomas gave the name La Sierra, probably because of the series of hills and mountains visible from it. Although the Yorbas' use of the lands dated perhaps from 1825, they did not file a claim for the La Sierra lands until it seemed as though Mexican rule would end in California. By that time, though, Don Tomas had died, leaving his brother to file the claim. On October 18, 1845, he petitioned Governor Pio Pico for the La Sierra Rancho, stating that

> *for more than twenty years, having been in possession of the place called La Sierra on the River…it is necessary for me to ask for…the said Sierra, and as I have never obtained a formal title for the same, I make this petition to Your Excellency…the extent of the tract being four square leagues.*[65]

This petition, though, angered his sister-in-law, Vicente Sepulveda, Tomas's widow. She obviously felt as though the land, or at least a part of it, should be hers. Therefore, just nine days later, she, too, filed for a portion of La Sierra in order to benefit herself and her children. Governor Pico deliberated and decided on June 15, 1846, to split the rancho in half, the western portion being given to Don Bernardo and the eastern portion to Vicente Sepulveda. In either case, they each received approximately 17,500 acres of land. Since that time, the two ranchos have been termed La Sierra (Yorba) Rancho and La Sierra (Sepulveda) Rancho, respectively.

As can be seen, the ranchos of Riverside County were granted throughout the entire period of Mexican rule. Some were granted with much fanfare, and some were granted in haste due to the encroaching Americans. During these years, settlement on the ranchos and in Southern California in general occurred more quickly than in Spanish times, yet nowhere near the pace of settlement during the ensuing period of American control. This population increase, along with the subsequent increase in livestock, played a major role in the development of a pair of new settlements in the San Bernardino Valley, the latter of which would eventually spill over into the very northwestern corner of Riverside County.

The Mexican Period

Politana and Agua Mansa/La Placita de los Trujillos

During the period of the great Mexican ranchos, all was not as peaceful as later accounts have made it to be. Especially in the inland areas, along the periphery of settlement, some of the rancho owners were harassed almost constantly by horse thieves and marauding Indians from the Mojave region, who would travel the Cajon Pass almost at will, steal livestock and then return virtually undisturbed. Because of its proximity to the mouth of the Cajon Pass, the San Bernardino Rancho, under the ownership of Jose del Carmen Lugo, was especially vulnerable. Although Lugo seemed to bear the brunt of this dilemma, he was not alone. Tiburcio Tapia, grantee of the Cucamonga Rancho, and Juan Bandini of the Jurupa Rancho, were similarly harassed and lost many valuable animals. Determined to counteract this thievery as best they could, the three men sought methods to end the raiding.

One idea was to station someone in the Cajon Pass. The surrounding rancho owners banded together and helped Michael White, a naturalized Mexican citizen generally known as Miguel Blanco, receive title to the El Cajon de Muscupiabe Rancho, which encompassed most of the Cajon Pass. White believed that his presence there would help the situation and give him a chance to further his own small herd. Instead, within a few months, his entire herd had been stolen, and he abandoned his home for safer environs.

Luckily, though, one other plan to combat the stock stealing met with better success. The Lugo family had been negotiating with several families and traders from what is today New Mexico to settle on a part of the San Bernardino Rancho in exchange for acting as vaqueros and helping to defend the herds.[66] Juan Bandini also made a similar offer for lands of the Jurupa Rancho, but the group accepted Lugo's offer instead. The New Mexicans, under the leadership of the three earliest settlers—Santiago Martinez, Hipolito Espinosa and Lorenzo Trujillo—established their new settlement along the Santa Ana River and called it Politana, after Hipolito Espinosa.

By late 1842, the population of Politana was approximately fifty. The settlers had established farms and had been involved in several skirmishes with raiders from the north. The relationship with the Lugos, however, was short lived. Two years after the village was established, Lugo constructed an arena near the northern end of the New Mexicans' fields. Lugo's cattle broke out of the arena and destroyed many crops and some of the irrigation system. In addition, Vicente Lugo, son of Don Jose, settled near Politana and often withheld irrigation water for himself.

Doubting that the harassment would cease, the citizens of Politana appealed to Juan Bandini for land so they could resettle. Bandini wasted no time giving them the very northeastern portion of the Jurupa Rancho, the area that became known as the Bandini Donation. At the time Bandini was making the donation, he was negotiating with Benjamin David Wilson for a portion of the Jurupa Rancho, which Wilson wanted to purchase. This portion was just south of the Bandini Donation and consisted of 6,750 acres that stretched from the Santa Ana River to the rancho boundary on the east and south to Pachappa Hill. As a condition of sale, Wilson insisted on protection against horse thieves and the raiding Indians. Fortunately for all involved, Lorenzo Trujillo and his people accepted the challenge right when Wilson hoped to buy that portion of the Jurupa Rancho.

In late 1844 or 1845, the people of Politana moved their homes, families and possessions a few miles west and established two separate communities. Agua Mansa, meaning "gentle water," lay on the north side of the river (in present-day San Bernardino County), and La Placita de los Trujillos, meaning "the Trujillo's place," was on the south side of the river (mostly in present-day Riverside County). As the name implies, Lorenzo Trujillo became the leader/spokesman for what was generally known as La Placita.

With the founding of the dual communities, and no harassment from Juan Bandini, the area flourished. The settlers planted farms and herded cattle, sheep and their own horses. One person who visited the area several times was Major Horace Bell, the gold miner, ex–Texas Ranger and Los Angeles newspaper publisher. In his monumental book about Southern California during those times, *Reminiscences of a Ranger*, he wrote of Agua Mansa:

> *About half way from Jurupa…and San Bernardino was situated the most beautiful little settlement I ever saw. It was called Agua Mansa, meaning Gentle Water, and was composed entirely of immigrants from New Mexico, numbering some two hundred souls—simple, good souls they were, too, primitive in their style of living, kind and hospitable to strangers, rich in all that went to make people happy and content, never having been, up to that time, vexed by the unceremonious calls of the tax collector, owing allegiance to none save the simple, kind-hearted old priest who looked after their spiritual welfare. With peace and plenty surrounding them, the good people of Agua Mansa went to make as contented and happy a people as could be found in the universe.*[67]

By 1852, the Catholic church had established a parish around the two communities and named it San Salvador. Soon afterward, an adobe church was constructed on the La Placita side. However, on November 13, 1852, just as the building was being completed, it collapsed due to the fact that it was built on an older portion of the Santa Ana River that was mostly quicksand. Therefore, the church was moved to Agua Mansa to the north.[68]

Throughout the 1850s and early 1860s, both communities continued to grow. Farms matured, families grew and the citizens of Agua Mansa and La Placita engaged in several skirmishes with marauding Indians, bears and others who tried to steal from the main rancho herds. Life in the two communities continued in this manner until the winter of 1862. There was a very heavy snowfall throughout December, followed by approximately fifteen days of warm, snow-melting rains. Both the Santa Ana River and all its tributaries soon swelled to well past their normal levels and began flooding the entire valley. The climax came on the night of January 22, 1862, when the severe flooding brought, by one account, approximately 360,000 cubic feet of water *per second* past the little village.[69] Father Borgatta, the priest at San Salvador, heard the commotion caused by the torrent and began to wake everyone by ringing the church bell. Although all the residents escaped the flood and no lives were lost, some of the last people to leave had to swim.

What was left in the flood's wake was utter devastation. The only building still standing was the church, which had been built on higher ground after its predecessor collapsed. All the fields and buildings and most of the herds had been obliterated, carried down the river and replaced with a thick layer of silt and debris that seemed virtually useless as farmland. Writing in early February 1862, Judge Benjamin Hayes reported:

> *I visited Agua Mansa on the 6th. A dreary desolation presented itself to my eye, familiar dwellings overturned, or washed away; here only a chimney, there a mere door-post or a few scattered stakes of a fence, lofty and stout trees torn up, a mass of drifted branches from the mountain cañons, and a universal waste of sand on both banks of the river, where a few months before all was green and beautiful with orchard and vineyard and garden, the live willow fence enclosing every field and giving a grateful shade for the pleasant lanes and roads. Here during many years a simple, frugal, and industrious population had lived, with a considerable measure of prosperity, to me always appearing a happy race, certainly hospitable, kind, and joyous when I met them, whether at the iglesia, the baile, or the social hearth. They were all or nearly all from New Mexico, and some of them Indians of the*

pueblos of Taos. I do not remember any American, of late years, residing among them, although visits of Americans were continuous, for diversion, or in the course of travel from Los Angeles, or of business, and I never heard anyone complain that he was not received with a most gratifying courtesy and attention.[70]

The people of Agua Mansa/La Placita were determined to rebuild after the floods. Many of them found immediate work in San Bernardino or on other ranches, and eventually, most of them resumed farming. However, the communities never regained the richness they possessed before. La Placita was moved to higher ground immediately east of the old location, although many of its former residents moved to Agua Mansa. Troubles began anew for the residents of the communities when, in the 1870s, Juan Bandini tried to take back the Bandini Donation. This led to several years of court battles involving suits, countersuits and appeals. Eventually, ownership of the Bandini Donation by the Agua Mansa/La Placita settlers was upheld in court, but by that time, it was too late. Many former residents had moved into the rapidly developing towns around the area, and by the early 1900s, little was left of either Agua Mansa or La Placita.

5
END OF THE
MEXICAN PERIOD

During the 1830s and 1840s, California began to see an influx of Americans into the region, which would eventually lead to the armed conflict called the Mexican-American War. The Mexican-American War of 1846–48 was quick and relatively bloodless, and it resulted in Mexico ceding all of its northern provinces to the United States. Although Riverside County was still too far inland to host any major events in the war, several of its residents played a role in what has been termed the Battle of Chino. Similarly, in the southwest portion of the county, the Temecula area saw the bloodiest conflict of the war. This conflict, called the Temecula Massacre, was an indirect result of the defeat at San Pasqual suffered by U.S. general Stephen Watts Kearny.

At the outbreak of war, Commodore Robert F. Stockton at Los Angeles asked Benjamin Wilson, then owner of a portion of the Jurupa Rancho, to follow General Castro of the Mexican army to ensure that he was leaving California. Wilson took several armed men and followed the general along the Sonora Road to the desert. Satisfied that the general was leaving, Wilson returned so that he could continue to watch the movements of the Mexican army while ostensibly on a hunting trip. While on this trip, he and several other Americans in the region received a request to return to Los Angeles from the authorities there. Over the next few days, many Americans began to converge on the roads to Los Angeles, and several rendezvoused at Isaac Williams's home on the Chino Rancho.

While this was occurring, on September 26, 1846, General Flores of the Mexican army sent a contingent of approximately fifty men under Serbulo Varela from Los Angeles to intercept the Americans under Wilson.[71] Varela and his men found the Americans at Chino. At the same time, another smaller group of Californios, as the Mexican citizens of California were called, joined Varela's contingent at Chino. This group was under the command of Jose del Carmen Lugo, son of Antonio Maria Lugo, the grantee of the San Bernardino Rancho. At Chino, the Californios asked the Americans to surrender, but they did not. The Californios attacked and were driven back by the Americans. A second attack ended with the Californios setting fire to the thatch roof of Isaac Williams's ranch house. Seeing little hope in continuing, Williams and his small children walked out of his house and surrendered. However, the Americans were still in danger of losing their lives. Because one of the Californios had been killed (not by gunfire but because his jumping horse had landed on him), most of Lugo's party wanted to execute the Americans. Familial ties kept that from happening,[72] and the party of Americans (including Isaac Williams, Benjamin Wilson, Louis Robidoux, John Rowland of the famed Rowland/Workman Party, David Alexander, Joseph Perdue, William Skene, Isaac and Evan Callaghan and Michael White) were escorted by Lugo to Los Angeles, where they became prisoners. At Los Angeles, the Americans spent many days unsure of their fate. Several Californios wanted to execute the Americans, but others, such as Ygnacio Palomares,[73] believed otherwise, reasoning that because an American victory seemed likely, executing the prisoners could have dire consequences for the Californios. Obviously, had hotter tempers won the day, the history of the northwestern portion of Riverside County, and especially the city of Riverside itself, would have been quite different (for the account of the Battle of Chino as told by Louis Robidoux, please see Appendix C).

On December 6, 1846, the American forces suffered their greatest defeat of the war when General Stephen Watts Kearny was overcome by Mexican forces under Andres Pico at the Battle of San Pasqual in present-day San Diego County. Kearny had marched his men over the Sonora Road as far as Warner's Ranch and then took the southern route toward San Diego when they met Pico's lancers. At San Pasqual, twenty-one of Kearny's men were killed, and Kearny retreated quickly. In the aftermath of the battle, eleven of Pico's men were resting at the Pauma Rancho, north of San Pasqual and near Warner's Ranch. During one of the nights between December 8 and December 12, a contingent of local Indians under Manuelito Cota gained entry to the rancho house and kidnapped the soldiers. The Indians

took them to Agua Caliente, in the vicinity of Warner's Ranch, where they brutally tortured and eventually murdered them. This incident became known as the Pauma Massacre, and it shocked the Californio community. Many Californios then believed the Indians in the eastern areas were rising against them, just as the Californios were trying to repel the incoming Americans. In fact, the Indians responsible for the Pauma Massacre had moved northwest to Temecula after the incident, which added credence to the rumor. In response, General Flores at Los Angeles ordered Jose del Carmen Lugo to take a contingent of men, suppress the Indian uprising and avenge the deaths of the eleven soldiers.

Lugo left Los Angeles with fifteen men bound for the Temecula area. Recruiting volunteers along the way, he arrived at his reconnoitering point at the Santa Gertrudis Creek with a force of twenty-two men. Once there, Lugo sent a few of them to get an estimate of the size of the Indian force. They found the Indians camped along the trail between today's Butterfield Valley and Aguanga. All of Lugo's available information indicated the Indians had a large force that could easily overcome his, so he asked for help from San Diego. A few days later, Ramon Carrillo arrived with eleven more men.[74] Still believing his force too small, Lugo appealed to the Cahuilla leader Juan Antonio at Jurupa, who was loyal to him (they were neighbors). Juan Antonio added a group of several dozen men to the party. With a force now approaching respectability, Lugo devised a plan wherein most of his men and all of Juan Antonio's would conceal themselves within the low-lying hills around what is today Vail Lake and create an ambush of Cota and his Luiseño Indians. On a morning in January 1847, Don Ramon Carrillo and a small force of men showed themselves to the camped Luiseños, who immediately pursued them. Riding as fast as they could toward Butterfield Valley, Carrillo and his men passed the ambuscade, rode toward the end of the valley and turned to face the oncoming Luiseños. At that point, the trap sprang—the Luiseños were ambushed and systematically slain by well-placed, vengeful forces under Lugo and Juan Antonio. Few of the Luiseños escaped, and most of those were pursued and killed. Two noted survivors of the incident, however, were Manualito Cota himself and the young Pablo Apis, the stepson and namesake of the Little Temecula Rancho grantee.

In pursuing the fleeing Luiseños, Lugo left about twenty prisoners in the care of Juan Antonio. When he returned, Lugo learned that Juan Antonio and his men had slain the prisoners, believing that had the situation been reversed, the Luiseños would have done the same.

M.E. Gover sketch of the Temecula Cemetery, 1891. *Photo courtesy of the Ramona Pageant Association.*

Various accounts of the Temecula Massacre differ in the number of dead reported. It was somewhere between forty and one hundred. Regardless, many Luiseño warriors lay dead in the area between Temecula and Aguanga. Right after the incident, the famed Mormon Battalion, under the leadership of Philip St. George Cooke, traveled along the Sonora Road on its way to Los Angeles. While camped at Warner's Ranch, the Mormons were asked by a few of the Temecula Indians if they would protect the Indians while they buried the dead of the Temecula Massacre. St. George Cooke agreed, but as his men entered the Temecula Valley, they were met by a contingent of mounted Temecula warriors that stretched across the valley. A standoff ensued, each group believing the other to be a detachment of the Mexican army. However, once the error was discovered, they met, and throughout the evening of January 25 and the morning of the 26, the Temecula Indians buried their dead in a new cemetery that would become known simply as the Indian Graveyard or Cemetery along current Highway 79 near Redhawk Parkway. After resting, the Mormon Battalion changed course and went to San Diego, having received orders to do so along the way.

The Indian Grave Yard — Temecula

On January 13, 1847, either just before or just after the Temecula Massacre, the Capitulation of Cahuenga was signed by the U.S. military commandant of California, Lieutenant Colonel John C. Fremont, and Andrés Pico, commander of squadron and chief of the National Forces of California. The capitulation ended the shooting war, and a year later, on February 2, 1848, the two countries signed the Treaty of Guadalupe Hidalgo, which formally ended the war and ceded Mexico's northern provinces to the United States. With the signing of the two treaties, California and Riverside County entered another major period of development, one that would give Riverside County many of the landmarks familiar to us today.

PART III
THE EARLY AMERICAN PERIOD

6

CALIFORNIA COUNTIES
AND SAN BERNARDINO

The first two decades of American rule in California saw development occur at a more rapid rate than before, with an increasing number of people arriving who had their sights set on gold, agriculture, land or speculation. For the first ten to fifteen years after the Mexican-American War, life in Southern California was a continuance of what it had been during the days of the Mexican ranchos. This lifestyle, though, was coming to an end with the decline of the rancho economic pattern. Over the years, the ranchos and their owners had incurred enormous debts. Starting in the early 1860s, Southern California experienced a severe flooding episode followed by years of drought that decimated the cattle herds. Desperate to raise cash, the rancho owners put huge tracts of land onto the market at a time when Americans were beginning to take an interest in Southern California as a place to live, not just to pass through on the way to Northern California. In addition, speculation about the construction of a railroad system to link California to the faraway main body of the United States only hastened the sell-off of the ranchos and the influx of Americans.

The first major influx of Americans into California was the direct result of the gold rush that took the northern part of the state by storm in the first few years of American reign. Just over a year after the Cahuenga Capitulation, and mere days before the Treaty of Guadalupe Hidalgo was signed, John Marshall discovered gold at Sutter's Mill on the American River. Word of his discovery spread quickly, and starting then, California played host to myriad people from all over the United States and Mexico, all of whom

hoped to extract some of the gold for themselves. In fact, so many people were coming to California (and the gold and other resources proved so significant) that in September 1850 the state of California was formed and admitted to the United States without having spent time as a territory, like the future states of Arizona, Oregon and Nevada would.

Once the state of California was admitted to the Union, one of the first acts of its new legislature was to divide the state into counties. On February 18, 1850, the California legislature created twenty-seven counties throughout the state, most of them in the north where the majority of people lived at that time. In very rural Southern California, only two counties were created initially: Los Angeles County and San Diego County. San Diego County was by far the largest, encompassing all of the Colorado, Imperial and Mojave Desert areas, plus the coastal areas south of San Mateo Creek. The dividing line between Los Angeles and San Diego County was a line that started where San Mateo Creek met the Pacific Ocean, went up San Mateo Creek to its source and then led straight north until it met the California/ Nevada border. To put things into perspective for Riverside County, San Mateo Creek goes through the Elsinore, or Santa Ana Mountains, and the source is a point approximately five miles south-southwest of the southern shore of Lake Elsinore. From there, the line headed north. Therefore, when California was first admitted to the Union, lands that would eventually include the areas of Riverside, Jurupa, Corona, Norco, Temescal Canyon and Elsinore were originally in Los Angeles County. All the rest of what would become Riverside County was in San Diego County.[75]

One year after creating the initial counties, the legislature enacted new laws that greatly increased the size of Los Angeles County. A small portion of Santa Barbara County was put into Los Angeles County, as was a larger portion of neighboring Mariposa County,[76] and the vast majority of northern San Diego County was all given over to Los Angeles County. At this time, the dividing line between Los Angeles and San Diego Counties was as follows:

> *Commencing on the coast of the Pacific at San Mateo Point and running thence in a direction so as to include the ranchos of Santa Margaurita and Lajuna Ternacala[77] to the rancho of San Jacinto, and along its northern line to the northeast corner.[78]*

When we try to reconcile this new configuration with present-day Riverside County, we find that the territory that would eventually include the

Central and Southern California County Boundaries

1850

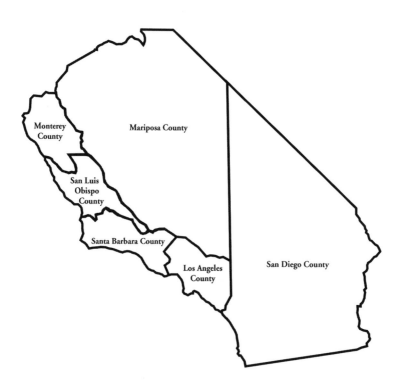

communities of Corona, Norco, Jurupa, Riverside, Moreno Valley, Beaumont and part of Banning was then in Los Angeles County, and all the others south of that line either joined or remained in San Diego County. This situation would last only a couple years, until San Bernardino County was formed.

At this point, it becomes necessary to delve a little into the founding of San Bernardino, our neighbor to the north. Although San Bernardino is

Central and Southern California County Boundaries

1852

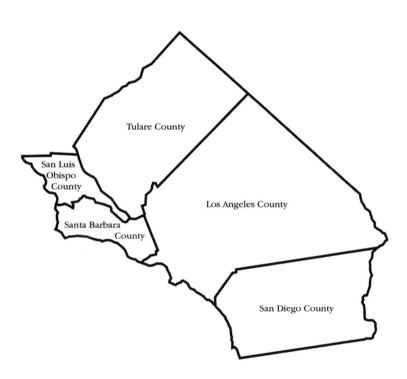

San Luis Obispo County

Tulare County

Santa Barbara County

Los Angeles County

San Diego County

not part of Riverside County, throughout the period covered by this book, San Bernardino was the major settlement in the inland area. It acted as the center for trade, as well as being both the last major settlement on the roads leading out of Southern California and the first encountered on the inbound trip. It would also be the impetus for the last county line reconfiguration in our area until Riverside County was formed.

The town of San Bernardino started as a small colony of Mormon settlers eager to establish an outpost on a southern trade route. This was believed necessary so the main stronghold of Salt Lake City could have year-round access to markets outside the United States, which in many instances was not sympathetic to the Mormon cause. In 1847, elements of the Mormon Battalion were encamped at both the Chino Rancho and the Cajon Pass as protection in the waning days of the Mexican-American War. During their encampment at Chino, Isaac Williams, the rancho's owner, indicated that he wanted to sell the Chino Rancho. When soldiers of the battalion returned to Utah, they explained the possibilities of Southern California. Eager to have a year-round trade route, Brigham Young, leader of the Mormon Church, authorized a colony to be founded near the trail in Southern California. Young believed no more than twenty people would be needed for the new colony. When the expedition began in March 1851, well over four hundred people had joined the effort to establish a colony in Southern California. Young was incensed that so many of his people wanted to "desert" the main stronghold and wrote, "I was sick at the sight of so many of the saints running to California, chiefly after the god of this world, and was unable to stop them."[79]

Those who participated in the initial trek were divided into three groups under the leadership of Jefferson Hunt, Amasa Lyman and Charles Rich. They traveled along what was known as both the Mojave Trail and the Old Spanish Trail,[80] through the Mojave Desert and into Southern California via the Cajon Pass. In May 1851, the groups arrived in the Cajon Pass and established a camp near present-day Devore. Here, Lyman and Rich paid a visit to Isaac Williams to negotiate for the Chino Rancho. When they approached him, they were informed that the rancho was no longer for sale. This did not dissuade the pair, for they then approached the Lugo family who owned the San Bernardino Rancho. The Lugos were more agreeable to the offer by Lyman and Rich. In September 1851, Lyman and Rich signed an agreement with the Lugos for the San Bernardino Rancho for $77,500, mostly on credit.[81]

The Mormon expedition began settling on its new lands almost immediately. Using today's streets as landmarks, the initial settlement was located generally along C Street between Third and Fourth.[82] Instead of an open town site, though, the first San Bernardino was more like the forts seen in old western movies. At the time the Mormons settled on their new lands, Antonio Garra, a Cupeño Indian leader, was leading a small group of his followers in what became known as the Garra Revolt. Garra had visions

of being able to drive the white man out of Southern California and was successful in convincing several other Indians to join him. Warner's Ranch in northern San Diego County was sacked, as were several immigrant trains. The Mormon settlers feared for their lives and lived in the fort for over a year until Garra and his men were captured.[83]

Once the Mormon contingency was settled on its land, and especially after Garra was captured, the Mormons began to improve the settlement. Just one year after coming to San Bernardino, Amasa Lyman described some of their improvements and gives us an insight into the first days of San Bernardino:

> [W]e erected our *Bowery*, or *Council House*, which is an adobe building, with a good shingle roof, 60 feet long by 30 feet wide…It is occupied during the week by our day school of 125 scholars…and on Sunday, after the morning service, by our Sabbath school and Bible class…One of the fashions that is so prevalent in the valleys of the mountains, has been to a very great extent adopted here; that is, the fashion of doing right, and attending to our business. The gold fever and dancing fever are diseases only known in isolated cases, and in this climate are not considered contagious.
>
> After the completion of our *Bowery*, we went to work to build a road to the forests of redwood, pine and hemlock, that adorn the mountains adjacent this place. This was accomplished with about 1,000 days' labor…Our grist mill is an adobe building with a good rock foundation, 40 feet by 27 feet with two run of stone; we expect to have one pair of stones in operation this week. Alongside the grist mill we shall erect our Store-House, or granary, which will be 100 feet by 30 feet.[84]

The year 1853 saw two important events occur at San Bernardino. The first was the official survey and recordation of the map creating the town of San Bernardino. H.C. Sherwood, who had platted Salt Lake City, surveyed and subdivided San Bernardino in a similar style. The town was one square mile, divided into a pattern of blocks of eight acres. East–west streets were given numbers from one to ten, while the north–south streets were named Far West, Navajo, Independence, California, Salt Lake, Utah, Grafton, Camel and Kirtland. The streets were bordered by irrigation ditches, and a public park was placed on the block between California, Salt Lake, Fifth and Sixth Streets.[85]

The second important event of 1853 was the creation of San Bernardino County. This was done for two reasons. First, the travel time to Los

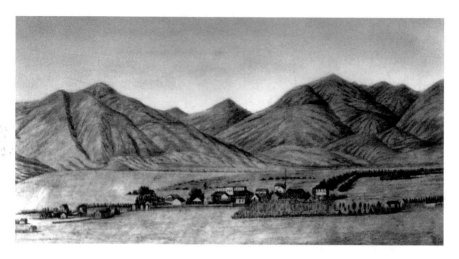

Sketch of San Bernardino in 1857. *Photo courtesy of the California Room Collection, Norman F. Feldheym Library, San Bernardino.*

Angeles, the county seat at the time, was too great. Second, the Mormons of San Bernardino were very independent and wished for their own local government. Therefore, Jefferson Hunt, who at that time was a legislator for Los Angeles County, entered an act into the state legislature carving San Bernardino County out of the eastern portion of Los Angeles County. The act was passed on April 26, 1853, and created San Bernardino County on a line described as follows:

> *Beginning at a point where a due south line drawn from the highest peak of the Sierra de Santiago intersects the northern boundary of San Diego County; thence running along the summit of said Sierra to the Santa Ana River, between the ranch of Sierra and the residence of Bernardo Yorba; thence across the Santa Ana River along the summit of the range of hills that lie between the Coyotes and Chino, to the southeast corner of the ranch of San Jose; thence along the eastern boundaries of said ranch and of San Antonio, and the western and northern boundaries of Cucaimonga Ranch to the ravine of Cucaimonga; thence up said ravine to its source in the Coast Range...[86]*

The rest of the county was simply the existing lines bordering Tulare County, San Diego County and the California/Nevada border.

Over the next few years, the Mormons at San Bernardino planted several farms, built a gristmill and constructed many other improvements, virtually

ensuring that San Bernardino would become a center of trade along the many routes that converged on it. People who came to San Bernardino, either temporarily or otherwise, usually described it in terms of the industriousness exhibited by the Mormons:

> *During the past week we paid a visit to the city of San Bernardino. We were glad to find that considerable progress had been made in city improvements since our former visit. Several new stores have been erected and the old ones improved. As yet there is no courthouse, the sessions of the court being held in a large room of Bishop Crosby's hotel; neither is there a county jail, nor much need for one. There are two schools well attended, and a third school house is being erected.*
>
> *The ranch of San Bernardino is laid off in lots of 1, 5, 10, 20, and 40 acres, the extent of the city being one mile square…The population of the ranch has increased considerably during the past six months, amounting at present to about three thousand.*[87]

This prosperity began to trouble Young and other church leaders. They feared that the "new lives" many of the colonists were enjoying, along with the success of the colony, would lead people away from the church and its central control. Young therefore began looking for a way to recall the colonists, and he found it in 1857.

Young, as governor of the Utah Territory, was rarely on friendly terms with the United States government, and therefore President Buchanan was determined to see Young ousted by a new appointee. When Buchanan sent a new governor and a contingent of the U.S. Army to enforce his order, the Mormons at Salt Lake City prepared for what appeared would become civil war. At roughly the same time this was occurring, Mormon and Indian animosities toward Americans erupted into the Mountain Meadows Massacre, wherein some 140 members of a migrant train of people coming from Missouri and Arkansas to California were brutally murdered near Cedar City, Utah. This event outraged people all over the West but especially here in Southern California, where it galvanized a small yet very vocal anti-Mormon minority. Therefore, under the auspices of needing the Saints for the impending war with the United States, and fearing for their lives due to the Mountain Meadows Massacre, Young issued a decree in late October 1857 recalling the Mormons from San Bernardino.[88]

The Mormon exodus began the next month. In the words of one historian, the Mormons "literally traded their homes for travel outfits and headed for

San Bernardino County
(1853)

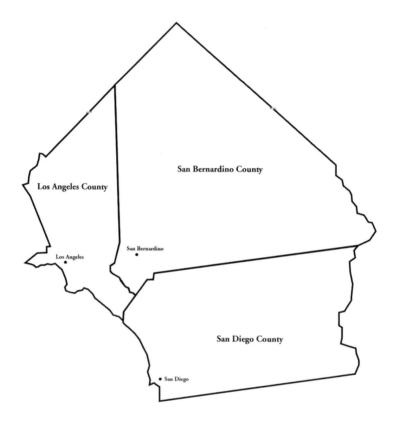

the safer environs of Utah."[89] One contemporary description gives us some idea of the haste in which the Mormons left:

> [Here are] *some items of sales recently made: one tract of 82 acres that cost $10.50 an acre, fenced with a good picket fence which cost $2 per rod, the entire tract under cultivation, with good ditches for irrigation, was sold for $500. Another tract containing 600 acres, under fence, on which there were 7,500 vines, assessed last year at $10,000, sold for $1,500. Another property containing a flouring mill, distillery, saw-mill and 300 acres of land that cost in all $75,000, sold for $6,000.*[90]

Over the next few months, only about 55 percent of the Mormon population left San Bernardino, giving an indication of the dissatisfaction and indifference that developed in the six years of San Bernardino's Mormon existence.[91] Later, several of those who heeded Young's call returned to San Bernardino, mainly because they lacked the finances or other resources to start anew in Utah.

In the meantime, San Bernardino was becoming populated with a different segment of society. In the late 1850s and early 1860s, mines in the San Bernardino Mountains and the high desert regions were being established, and San Bernardino was becoming a hub for the activities associated with mining. Lumbering also grew to be a major industry in the area at that time, and it too attracted people involved in that occupation. To paraphrase several contemporary writers, this led to a decidedly "different class" of people from the Mormons, causing lawlessness and violence in San Bernardino to increase remarkably in the post-Mormon period. W.A. Wallace, a close associate of the Mormon colony, visited San Bernardino shortly after the exodus and wrote that

> we crossed the confines of the territory once so dear to an earnest and sincere people, many of whom are now grieving for the pleasant homes their faith sacrificed. We drove through the town where, a year ago, every house was occupied, and industry had already overcome the privations of a new settlement. In those days there were no idlers—it would not pay to be idle. As we passed along, upon the right and left, few houses were occupied—many were falling to pieces. The walls are all adobe, and the rains are leaving them heaps of earth, like those we see about other deserted places. The fences are down, and the ditches filled up; lots which before were cultivated, have become open pastures for cows.
>
> In town, the first four doors I passed were open to the street; in each one I saw a table, surrounded by men playing cards for drinks, as they do in other towns. Under the old regime it was not so in this town; and it has always been a marvel to me how so many men, in every community, can live upon drinks without labor. There is plenty of liquor here, as there always was; and there are plenty of pettifogging lawyers, as there never was before, who expect to get money from the vices and misfortunes of the foolish and obstinate.
>
> I looked about for some one of the Saints whom I had once known, and who might still be lingering here, and mourning for the loss of this Zion. I soon found one, who says he bows submissively to the will of his prophet. We conversed of other days; of the old brotherly love, that continued to the

last, and ever sustained the pilgrims in their weary wanderings. He spoke, too, of the unassimilated humanity now gathered there, and which, as in other new settlements, it will take years to resolve into the quiet suavities of life. He felt no bitterness toward the newcomers; they had only seized upon the opportunity when it offered; but there was no bond of union among them except interest. The changes in San Bernardino, he said, were about as chequered as those of mortality.[92]

Obviously, San Bernardino had changed, and for the remainder of the nineteenth century, it would be a hub of commercial activity in the Inland area and also the focus of local government.

By the time Wallace visited San Bernardino, Americans farther east were preparing for what would become the Civil War. That, however, gets us a bit ahead of our story. Before we can continue discussing the changes brought about by American annexation of California, it is necessary to examine how the new émigrés viewed the lands they had acquired only a few years before.

7
THE U.S. LAND
COMMISSION AND SURVEYS

One of the first tasks the U.S. government initiated after annexing California and admitting it into the Union was to determine exactly what it had obtained for its trouble, how it could provide for the orderly division of the newly acquired lands and how the area could be brought into the economic domain of the United States. This was accomplished in a three-pronged approach. The issue of determining which lands were privately held and which could be opened for settlement was addressed by forming the U.S. Land Commission to review land titles under the old Spanish and Mexican systems. In addition, surveys were ordered for all lands within the public domain, so the newly acquired lands could be subdivided for settlement. Finally, exploratory parties were sent out to describe the area and also to determine, for instance, how a railroad could be brought from the United States to its new Pacific border.

The first of these projects to be initiated was the establishment of the U.S. Land Commission. The U.S. Land Commission was formed by Congress on March 3, 1851, and was given the task of reviewing the chain of titles for private lands in California, determining which lands were in the private domain and indicating which lands could be opened to incoming Americans. Before the Land Commission was even formed, William Carey Jones, a lawyer acting as a confidential agent of the U.S. government, came to California to research landholdings. What he discovered through his research in the archives was that land in California had been granted as ranchos, and these ranchos occupied some of the choicest lands in the

state. When Jones made his report to Congress, many were of the opinion that the large ranchos should not remain, given that the United States had just won the Mexican-American War and there were already several thousand Americans migrating to California. Supporters of this position argued persuasively that the Spanish and Mexican land titles were vague and therefore offered ample opportunities to prospective American settlers.[93]

Bearing this vagueness in mind, when the Land Commission began its work, it stipulated that all land titles in California, whether granted by the Spanish government or the Mexican government, must be brought to the commission and proven through the use of original documentation, sworn statements and witness testimony. If the commission ruled the title was in order, it would order a survey to be completed and issue a patent to the landowner or his heirs. If the title was not in order, the land would revert to the public domain, as all non-privately held land in the state did upon entering the Union. As always, the commission's ruling could be appealed to the District Court and eventually to the U.S. Supreme Court if warranted.

The U.S. Land Commission was established initially for a three-year period, although Congress later extended its life to five years. During that five years, more than eight hundred claims were heard by the commission, placing an extreme hardship on the claimants who had to produce documentation, gather witnesses who were usually friends or family members and, of course, hire attorneys. All this happened during a time when the ranchos and their owners were riding the roller coaster of prosperity and depression, with money always in short supply.

In the end, most of the claims were upheld and patents issued. However, these patents were issued only after many years of hearings, appeals, surveys and more hearings. Although the U.S. Land Commission operated from only 1851 to 1856, patents for the rancho lands within Riverside County were issued for nearly thirty years afterward, beginning in the early 1860s and continuing through the late 1880s. By the time the patents were actually issued, few of the original claimants were still alive, and the patents were issued to either heirs or others who had bought the lands in question and assumed the burden of proof. A listing of the ranchos and the persons to whom they were eventually patented is included as Appendix D.

The second government-sponsored project in the new state was a survey to answer the question of how to divide the public lands that would either be sold or given away to prospective settlers or other entities. As part of this survey, on October 4, 1852, U.S. surveyor general Samuel King awarded a contract to Colonel Henry Washington. Washington's charge was to come

to Southern California and establish the San Bernardino Base Line and Meridian, from which all lands in Southern California, and some in Central California, would eventually be surveyed (see Appendix E for a complete discussion of how land was surveyed under the Cadastral, or Township and Range, System). In the latter part of 1852, using Mount San Bernardino as his point of origin, Colonel Washington and his crew established the baseline, which was the east–west line running from the Pacific Ocean to the Colorado River. During that same time, he also established the north–south line called the meridian, which ran from the Mexican border to the Nevada border through Mount San Bernardino.

The final government project to play a role in Riverside County's development consisted of three additional surveys all seeking in some way to open California and the West to further economic expansion. In 1853, the first of these surveys came through the area. This survey was hoping to discover a feasible route for a transcontinental railroad so that the newest state could have a speedy link to the rest of the country. In that year, the U.S. War Department, under the leadership of Jefferson Davis, ordered the Pacific Railroad Survey to commence. This survey was a five-pronged initiative, with survey crews trying to ascertain routes as far north as the Canadian border and as far south as Southern California. It is this latter one with which we are concerned.

Under direct orders from Secretary of War Jefferson Davis, Lieutenant Robert S. Williamson, commander of the southern expedition, and his aide, Lieutenant John Parke, were to "ascertain the most direct practicable railroad route between Walker's Pass, or such other pass as may be found preferable, and the mouth of the Gila [River]," near present-day Yuma.[94] On May 20, 1853, Williamson and his nine-man crew boarded a steamer bound for California. They arrived in San Francisco a month later and immediately began scouting their route. The summer of 1853 saw them heading down the western edge of the San Joaquin Valley examining various routes that would lead out of the Sierra Nevada. By September, they had reached the Tejon Pass, and Williamson was becoming discouraged owing to the fact that few of the places they had seen were suitable for railroad passage. Out of desperation, he sent Lieutenant Parke on a quick scouting trip to Los Angeles, where many Angelinos told him of the San Gorgonio Pass. Parke took a quick detour to see the pass for himself and was suitably impressed. He returned to the Williamson party and related his journey and the prospects offered by the San Gorgonio Pass. Hearing this news, Williamson decided to divide his party to follow two routes. He and most of the men would

continue toward the Colorado over the Old Spanish or Mormon Trail, while Parke would lead a smaller group through San Gorgonio Pass and on to the desert. The two parties would then meet back in San Diego.

By the time Parke reached the San Timoteo Canyon inlet into Riverside County, it was November. Parke and his men, who included geologist William Blake, traveled the area and were impressed with the agricultural and settlement potential for the region. Continuing into the San Gorgonio Pass, Blake described it as an "absolute break or dislocation" in the Sierra Nevada range, and all members of the group believed it to be the best passage through which the railroad could enter California.

With Parke's descriptions, Williamson was also convinced of the use of the pass for the entryway of California's transcontinental railroad. He explained this in his final report, which was submitted to Congress toward the end of 1854. In it, he indicated that not only was the area relatively flat, requiring little in the way of blasting or tunneling, but also this southern route could be used year round, unlike the northern routes, which necessarily had to pass through snow-covered areas and could be closed from two to five months out of the year:

> *Under the supposition that a road has been constructed from the Mississippi river to the mouth of the Gila, if the question is simply how to continue that road to the Pacific, the answer is at once apparent. It would follow a nearly direct line to the entrance of the San Gorgonio Pass, the best in the Coast range; then through that pass to the San Bernardino valley; and from there to San Pedro, or some other point in its vicinity on the coast.*[95]

Over the next few years, several other reports were written about the northern routes into the West. The final reports on all the surveys were published in the later 1850s but were generally overlooked in the hectic days preceding secession by the Southern states, ultimately leading to the Civil War. In fact, it would be roughly twenty years after the initial surveys were made that Southern California would finally have its transcontinental railroad link with the rest of the United States.

The very end of 1857 saw yet another government-sponsored survey pass through what was to become Riverside County. This one occurred in the extreme eastern portion of the county when a member of the U.S. Army Corps of Topographical Engineers named Joseph Christmas Ives was charged with surveying the Colorado River as far north as could be navigated by boat. Another individual, George Johnson, was already in Yuma. He had

a steamer called the *General Jesep* and had been ferrying supplies from Port Isabel in Mexico to Yuma. He offered the ship to Ives, but Ives had other ideas. Ives had a special steamer designed and constructed in New York and brought to Port Isabel, at the Colorado River delta in Mexico. There, on December 31, 1857, Ives began his journey northward through what was then mostly uncharted territory. When he returned and published his report in 1861, Riverside County had two new place names.

On January 22, 1858, Ives and his crew had traversed the Colorado as far as the present-day Riverside/Imperial County line. Here he describes the mountains as "conspicuous by lines of serrated peaks...a range of chocolate colored mountains, from which the river emerges through a gate formed by a huge crag of vivid red rock."[96]

Throughout the rest of the work pertaining to this area, he refers to these "chocolate colored mountains" several times. He indicates that "they exhibit a rare diversity of outline, colors, and tints; and the brilliancy of the atmosphere heightens the effect of every shade and line."[97] The name Chocolate Mountains has been with us since then.

In addition to Ives's naming of the Chocolate Mountains, he illustrated a series of mountains he passed a few miles to the north along his journey. Because they were right along the river, he called them the Riverside Mountains, which can rightfully be said to be the first feature within the county to have the Riverside name. This name obviously did not correspond with the town of Riverside, which would not be established for another twelve years. However, the name Riverside Mountains has remained to this day.

Ives navigated the Colorado River as far north as Black Canyon, near present-day Las Vegas. At that point, he and his crew left the boats and entered the Grand Canyon, the first white men to explore that area.[98] Ives's report, however, came at the very beginning of the Civil War and as such was forgotten for a few years.

The last of the large-scale government surveys to traverse Riverside County was that of Lieutenant George Montague Wheeler, who for nearly ten years covered the region now known as Nevada, Arizona and eastern California, mapping and describing the area for the military. During 1876, he and his crew traveled through the Coachella Valley (which he called the Coahuila Valley) and the eastern desert on their way to the Colorado River. Oscar Loew, a chemist who accompanied the survey party, indicated in his report from 1876 that

the largest valley in the southern portion of the Mohave Desert is the Coahuila Valley, being 90 miles long, 10 to 30 miles wide, and in part below the level of the sea. Beginning with the San Gorgonio Pass, it separates the San Bernardino from the [San] *Jacinto Mountains, and widens out toward the dry-lake bottom* [present-day Salton Sea] *in its southern portion, where it is joined by the so-called "Colorado Desert," the low, hilly, barren stretch connecting this valley with the mouth of the Colorado River. Whilst the mountains near San Bernardino are clad with extensive pine forests and the lower Jacinto Mountains with a good deal of piñon, the Coahuila Valley presents a most desolating sight: its northern portions consist of a system of sand-dunes and sand-hills, whose formations are caused by the wind heaping the sand around every object higher than the soil—a bush, for instance, as the stunted acacia—while its southern portions of bare clay are covered with patches of saline efflorescences.*[99]

Upon reaching the Colorado River, he also made brief mention of what is now the Palo Verde Valley:

The extent of the bottom-lands are great enough, especially south of the Riverside Mountains, to support thousands of settlers. The climate, although very hot during four months, June to September, presents no serious drawbacks, as the inhabitants of the small town of Ehrenberg can testify.[100]

As can be seen, the first years of American rule in California were ones of discovery and preparing for what was hoped would be a great influx of Americans into California. The fact that the U.S. government took a while to accomplish this, however, does not mean that people were not coming through the region. During the early years of American rule, the Sonora Road, begun during the Mexican period, saw a tremendous influx of people coming to California in search of gold. These later migrations set the tone for some of the earliest settlements in Riverside County.

8
THE SONORA ROAD, I[101]

The lack of a railroad route to California during the early years of American rule did not impede large numbers of people from entering California. Although many people chose the more northerly Oregon Trail to travel to the gold fields of Northern California, several more chose the already trodden paths through Southern California and Riverside County in the hopes of finding their fortunes. In fact, many of the roads in use up to the time of American rule were further upgraded as the situation warranted. The transportation route foremost in this great population influx, as far as it affected Riverside County, was the Sonora Road. This road played host to thousands of Sonorans, Americans, miners, farmers and others of all walks of life traveling its length looking for a better life.

The year 1848 saw the beginning of a several-year-long seasonal migration by Sonorans and other Mexican citizens along the Sonora Road. News of the discovery of gold in Northern California brought Sonorans and others north from their homes in Mexico to the gold fields. Typically, the spring season saw vast numbers of wagon trains start from Mexico heading north, only to return in the fall. So great was this annual migration that authorities in Sonora became alarmed that many of the towns within the state were becoming virtually depopulated and vulnerable to Indian attacks. However, Sonorans using the road continued in earnest through the early 1850s. By that time, several more Americans were in the gold fields, and friction between the two groups led to many Sonorans returning to their native lands. At the same time

Sonorans were returning to Mexico, an increasing number of Americans were entering California through this southern route.

With the advent of American rule in California, events occurring farther east would result in the Sonora Road being upgraded with a subsidy for mail delivery by the U.S. government. Throughout the early days of California's statehood, three different routes were used by several companies to deliver mail. The northernmost of these started in Independence, Missouri, and headed toward San Francisco via Salt Lake City. Another one left Springfield, Missouri, and went through Albuquerque, crossed the Mojave River and then to the Tejon Pass, where it split, one route leading to Los Angeles and the other to San Francisco. This is the route that also had a side trek to San Bernardino via the Cajon Pass. This route, often called Beale's, was the one preferred by several of the mail-delivery companies. The last route was the southernmost one and went from the eastern United States to Yuma, crossed the desert much as Anza had and then went on to either the Sonora Road or, rarely, the desert route through the Coachella Valley. When it came time for the U.S. government to subsidize one company to deliver the mail year round, it was the southern route that was elected, mainly because it was not subject to closures due to snow. Therefore, at the very end of the Pierce administration, Congress voted to issue a contract for a six-year period with subsidies ranging from $300,000 per year for semimonthly service to $600,000 for semiweekly service. Of the nine bids received, John Butterfield's Butterfield Overland Mail Company[102] won the contract and began designing the exact route.

In Southern California, Butterfield initially considered using the desert route through the Coachella Valley and San Gorgonio Pass, then to San Bernardino and up the Cajon Pass and eventually to San Francisco. Residents and business owners in Los Angeles, though, protested that they were being excluded from the main route. Therefore, the route was changed to go from San Bernardino to Los Angeles. Regardless of which route was chosen, it appeared as though the new mail route would indeed go through San Bernardino. Desperately wanting to be along the new route, and fairly confident they would be, the citizens of San Bernardino petitioned their board of supervisors to survey a road from Yuma to San Bernardino so that they could present it to the Butterfield Company. For this, the board hired Dr. Isaac Smith to lead the survey, which was only supposed to go from San Bernardino southeast to the county line. However, Smith and his company went from San Bernardino through the San Gorgonio Pass, across the Whitewater River to Agua Caliente and then to Toro, eventually coming

to Dos Palmas. From there, they went nearly straight across the desert to Yuma. This action became known as the Smith Survey and was established not only to survey a route but also to look for water along the way.[103]

With the use of the Smith Survey route nearly ensured for the Butterfield line, the company sent two representatives: Warren Hall and E.G. Stevens. During the summer of 1858, this pair embarked on the route surveyed by Smith through the pass and on to the desert, where they began drilling for water and establishing stations. The watering locations were to be twenty miles apart, and in their expedition they put stations at Whitewater and Agua Caliente. Early indications seemed favorable. However, abruptly in mid-August, it was announced in the newspapers in Los Angeles and San Bernardino that the desert route through the Coachella Valley would no longer be a consideration, owing to the fact that little water was found south of Dos Palmas. Therefore, with a decision having to be made immediately, the Butterfield contractors decided to route the line along the Sonora Road through Warner's Ranch. Although this alignment ran roughly fifty miles through Mexican territory, it would be a good, all-year route with plenty of water.[104] In September 1858, Butterfield began running stages over this route, delivering mail between Tipton, Missouri (the company's main depot), and San Francisco. Along the more than 2,700-mile route, hundreds of places were designated as official stations for the Butterfield Company. These places were improved by the company, which meant there was a regular station master and a corral to keep horses.[105] Over the next few years, especially in Riverside County, these station locations became the genesis for communities and towns. For all the colorful descriptions of the "days of the stages" and the romanticizing of the Butterfield Company, though, it was relatively short-lived. The beginning of the Civil War in 1861 saw the end of the contract with the U.S. government, since a large portion of the eastern route led through states either aligned with the Confederacy or sympathetic to the cause. Before we look at the physical changes brought to Riverside County by the increased commercial use of the Sonora Road, let us examine how the Civil War affected our area.

9
THE CIVIL WAR IN INLAND SOUTHERN CALIFORNIA[106]

At the outbreak of the Civil War, the non-Indian population of Southern California was no more than twelve thousand, approximately 75 percent of whom were Southerners either by birth or ancestry.[107] Of the twelve thousand, probably no more than one hundred persons lived within the boundaries of what would become Riverside County. The sparse population of Southern California, and even California as a whole, was spared from the actual fighting that characterized the war. That is not to say, though, that there were not any war-related activities in this area.

In May 1861, just one month after hostilities began with the firing on Fort Sumter, the California legislature passed resolutions that left no doubt that California would remain loyal to the Union. This followed several efforts to bring California into the Confederacy, split off Southern California and deliver it into the Confederacy or form a separate Pacific Republic. The vote enraged many people in Southern California, who were decidedly pro-Confederacy.[108] Strongpoints of Confederate sympathy began to emerge in Southern California. One of these was El Monte, a major stop along the Sonora and other roads just east of Los Angeles. The other was San Bernardino, which was inhabited by several miners and lumbermen, almost all of whom hailed from the South, and was still believed to have a large Mormon influence.[109]

When the Civil War broke out, the old Sonora Road began to be used as a direct route from California to the seceded Southern states. Much of its traffic was Confederate sympathizers who wished to join the Confederate army.

Probably the most noteworthy figure to have used this route successfully was General Albert Sidney Johnston, arguably one of the South's best military leaders. Johnston had been commander of the Department of the Pacific in Monterey but resigned that post in favor of joining the Confederacy. In Southern California, he narrowly escaped being captured and arrested by Union troops who had been advised by Johnston's successor, General Edwin V. Sumner, that he would probably try to escape through Southern California. In sparsely populated Southern California, it was extremely difficult to patrol the entire road, and Johnston escaped arrest. Having thwarted attempts to capture him, he went on to lead Confederate troops as the commander of the Central Army of Kentucky, Department #2, where he saw action at Fort Henry and Fort Donelson. He was generally considered to be one of the Confederacy's brightest generals but was killed early in the war on April 6, 1862, at the Battle of Shiloh.

During the trying times of 1861–62, San Bernardino, the only town of significance in the Inland area, became a real concern to the Union army. While the population of San Bernardino was rather evenly split between pro-Union and pro-Confederate sympathizers, it was the pro-Confederate sympathizers who voiced their opinions louder and more openly, even to the point of almost invoking riots. On June 3, 1861, Edwin A. Sherman, the fiercely Loyalist editor of the *San Bernardino Patriot*, wrote to General Sumner about the conditions as he saw them in San Bernardino:

Secret meetings continue to be held all over this lower country, and secession and disunion are boldly avowed in our streets. Shooting continues to be the order of the day, and drunken desperadoes and Southern cutthroats damn the Stars and Stripes and endeavor to create disturbances most of the time…We have a singular population, composed of Mormons, Mormon apostates, who are even worse, gamblers, English Jews, and the devil's own population to boot, while we have only about a dozen good respectable families right in town, who are at the mercy of these desperadoes; and the secessionists of [El Monte] are only waiting the withdrawal of troops from Los Angeles before they commence operations.[110]

Sherman's remarks, as well as those of several others, including Abel Stearns, resulted in the placement of four companies of regular infantry at San Bernardino under Major William S. Ketcham. At this point, Confederate activities seem to have abated in San Bernardino itself and moved into the valleys and mountains surrounding the town.

Bear and Holcomb Valleys in particular were known as rendezvous points for Secessionists who were believed to hold almost nightly meetings, steal horses and plan for an opportunity to take control of places within Southern California, if not all of Southern California, for the Confederacy. Several people traveling through the area at the time reported seeing many well-armed and well-supplied individuals camped in the valleys. Most of these men identified themselves as miners. Although the two valleys had been used for mining in the past, there were too many men and too little residual ore being taken out of the valleys to justify the number of men.[111]

Emboldened by early Confederate victories in the east, most notably at Bull Run/Manassas in July 1861, more groups of Confederate sympathizers were seen throughout the area. Following the successful departure of General Johnston, another party tried to evade authorities and travel to the South. This one was led by Dan Showalter, an avowed Secessionist who had been a California legislator just prior to the war. Showalter and his group of several heavily armed men traversed the Sonora Road as far as the vicinity of Warner's Ranch in present-day San Diego County. There they were met and captured by a group of the First California Volunteers. Showalter and his men were taken to nearby Camp Wright, where they were held for a while until they tried to escape. After the escape attempt, they were ordered taken to Fort Yuma, from which travel in any direction without supplies was almost certain suicide.

This incident was later termed the Showalter Affair and awakened concerns in the higher ranks of the Union army in California. They began to see the necessity of closing the Sonora Road to all but official business, especially given the fact that most of the residents along the road were either sympathetic to the Southern cause or at least perceived to be. San Bernardino was upgraded to become the headquarters of the Fourth Regiment of Infantry under Colonel George Wright. Wright was quickly succeeded by Colonel James Carleton, one of whose subordinates, Major E.E. Eyre, traveled from Los Angeles to San Bernardino through the Jurupa area and along the Santa Ana River, thus having entered Riverside County.[112]

The first attempt to stop unauthorized travel across the road either into or out of Southern California came in October 1861, when Lieutenant Colonel J.R. West, under Colonel Carleton, was ordered to take three companies of infantry volunteers from Los Angeles to Yuma. Yuma was the only point of entry into Southern California for large numbers of men, and so it was of vital strategic importance.[113] West and his men traveled along the Sonora Road and, upon reaching Yuma, immediately seized all

ferryboats plying the Colorado River, established a new crossing point so that it came within range of the guns at Fort Yuma and detained all persons wishing to pass until they proved their loyalty by taking an oath of allegiance. As we will see later, the gold rushes into Arizona in 1862 and 1863 thwarted these efforts somewhat.

Efforts by Confederates to either travel to the Southern states or have the Confederate army enter California were further thwarted during the spring and summer months of 1862, when Colonel Carleton led his famous march through Arizona, New Mexico and the westernmost portion of Texas. This incursion effectively put an area one and one-third the size of the entire Confederacy under Union control within a few months. The "recapturing" of the Southwest territories effectively foiled any plans there may have been for uniting Southern California with the Confederacy but did not stop secessionist activities in California itself. With the success of Carleton's march, the remainder of the Civil War was relatively uneventful in Southern California.

Compared with events in the eastern United States or even in the larger towns and cities of Southern California, Riverside County was hardly touched by the Civil War. Given the extremely sparse population of the county at the time, it is little wonder. During this time, small bands of Confederate sympathizers traveled the Sonora Road, only to be followed by units of the regular Union army. With the exception of the passing of well-armed people of varying loyalties, the Civil War did not really touch Riverside County. In short, if one could compare life here before, during and after the war, one would not find much difference in the three.

Once the war ended, a new segment of the American population began to be seen increasingly along the road—that of displaced Southerners who were looking to start anew in California and escape the military governments established in the South after the war. In 1868, the Sonora Road entered yet another phase in its life when the mail route first used by the Butterfield Company was reopened by a government subsidy to the Wells-Fargo Company for daily mail. Again, mail-bearing stagecoaches could be seen traversing the route from Warner's Ranch through Riverside County and eventually Los Angeles. Although this new system emulated the old Butterfield Line greatly, its existence was short-lived. Soon, the mail would be delivered overland to San Francisco by a much quicker method: the transcontinental railroad.

10

THE SONORA ROAD, II

DEVELOPMENTS ALONG THE SONORA ROAD[114]

Let us now take a look at the physical effects the large burst of population had on the Riverside County portion of the Sonora Road and the settlements that ensued. The last two stops in present-day San Diego County were Warner's Ranch and then Oak Grove. From Oak Grove, the road entered Riverside County at Aguanga, a name that dated from the Spanish era for the Indian rancheria existing there. The stop for the Butterfield stage, though, was a place known in the earliest days as the "Dutchman's." This was a ranch owned by Joseph Gifthaller, described in the 1860 census as a forty-four-year-old farmer from Bavaria.[115] Gifthaller's ranch was approximately 1.75 miles west of the present-day town of Aguanga. Gifthaller's property would have been merely a changeover stop, wherein fresh horses could be traded for the weary ones.

Approximately four years later, Jacob Bergman, one of the first drivers of the Butterfield stages between Yuma and Los Angeles, decided to settle in this valley and bought the Gifthaller ranch. This stop then became known as Bergman's, and Bergman ran his ranch and maintained the station. This station lasted for many years and served as the hub for the town of Aguanga, which began to develop in the area around 1870.

The next stop, and the first major stop along the road within Riverside County, was ten miles west at Temecula. In the earliest days, travelers camped along the river in the vicinity of the Indian village that sat on a bluff

on the south side of Temecula Creek. For provisions, they probably traded with the local Indians. By the time of the Sonoran migration, Pablo Apis, grantee of the Little Temecula Rancho, had established a home and orchard in the middle of the Pauba Valley. As was the custom at that time, his home became a way station along the route. Here, Apis sold and/or traded goods and materials to travelers if he had any with which to part.

By the mid-1850s, another person had taken over the role of "shopkeeper" at Temecula. This person was John Magee, an American originally from New York. Magee settled in the valley around this time and built a small adobe home and store approximately one hundred to two hundred yards east of the Temecula Indian village. Here, Magee sold provisions to travelers, and a small community of local farmers and colonizers began to form in the area. Magee's store became the hub of the community of Temecula, sometimes called "Old Temecula" by historians. By the time John Butterfield began delivering mail on a regular basis, Magee played host to Riverside County's first post office, opened in his store on April 22, 1859.[116]

Magee continued to run the store and post office sporadically for the next few years. During the 1860s, he was joined in his endeavors by a Frenchman named Louis Wolf, who eventually took over as the main storekeeper and postmaster in Temecula. Although Wolf continually moved between San Diego, Warner's Ranch and Temecula, by 1868 he had constructed his own store at Temecula. This building was closer to the creek but still within the proximity of Magee's building, which by then had been abandoned. Here, Louis and his wife, Ramona Wolf, played host to travelers along the road, and their store became the hub of Temecula. This building was in use until Louis Wolf died in 1887, but by then the railroad had come through and displaced the community he had spent so much time nurturing. The Wolf store still stands near the present-day intersection of Highway 79 and Redhawk Parkway.

The next stop along the road was at Alamos, a descriptive Spanish name meaning "poplars" for the groves that stood around the springs at Alamos. This area became another camping ground with good water during the earliest days. In 1853, two Americans, David Cline (or Kline) and William Moody, started a ranch around the springs, generally located near the present-day intersection of Cherry Avenue and Jefferson Avenue in Murrieta.[117] In 1859, this ranch became a stop, or more rightly a "change station,"[118] along the Butterfield Road. At some point, Cline and Moody changed the name from Alamos to the Willows; the stage station was accordingly called Willow Springs Station and the springs, Willow Springs. Alamos, and later Willow

M.E. Gover sketch of the Wolf Store at Temecula, 1891. *Photo courtesy of the Ramona Pageant Association.*

Springs Station, offered a stopping place for stages and travelers some seven miles northwest of Temecula. Because of its proximity to Temecula, though, its role was minor.

Sometime in 1859, Judge Benjamin Hayes traveled the Sonora Road and gives a description of the Willow Springs Station as typical of the stations along the route:

> *Night is coming on, and we must go to Kline's, some four miles on this side of Temecula. Six miles brings us to the Willow Station. Cordially met by Mr. Clift, the road-agent...Rough supper, however; no coffee; beds on the floor. Moody is talkative, as four years ago; and kept on after he had gone to the next room; but Kline telling him I wished to sleep, he closed. A pretty good sleep before the fire; good to see once more an old-fashioned western chimney. Of course, travelers do not stay at any of the Overland Stations, unless in case of clear necessity. They let us have a sack of barley to take along...this was soaked and fed to our animals. Kline and Moody have been here 7 years, have 200 acres under fence. Report says they are worth*

The Old Hartzels Store, Temecula Valley

$20,000, made here. They formerly raised grain, found it unprofitable; too far to market. They cut a great deal of hay every season; it is excellent; four kinds of clover, besides the pin-grass. Their stock in fine condition. Kline is from Pennsylvania. He denounces interference with slavery, but says if a Pacific Republic should be formed, he will go to Oregon. He settled here supposing it would turn out to be government land; in the uncertainty about this, he has not made any very valuable improvements. His tract is claimed by Don Luis Vignes, of Los Angeles, or his assignees.[119]

Farther up the valley came the next major stop: Laguna, on the banks of the Laguna Grande. This became a major stop along the road, some eleven miles northwest of Willows. Judge Hayes described the area as follows:

At length, the sun gone, we are going down by a long and gentle slope into the valley of the Laguna, over which already hangs the shadow of night, while, in the far distance to the northeast, appear first the crimson hues of San Jacinto, and presently of San Bernardino also; we watch them with pleasure until they fade away, and their crests would be deemed only white fleeces of mist, if we did not know they were deeply laden with snow. And still, in the higher sky a faint tinge of pink in a long belt reflects itself upon

the placid lake. This is a small sheet of water, perhaps three miles broad;
brackish; now full, but went dry singularly last summer.[120]

As we saw previously, Julian Manriquez was granted the La Laguna
Rancho on June 7, 1844. However, he did little with it, and after his death,
Abel Stearns purchased it in 1852. He too did little with it, selling it to
Augustin Machado in July 1858. While Manriquez and Stearns owned the
Rancho La Laguna, travelers on the road simply camped along the Laguna's
shore, allowing their animals to graze on the acres of grass growing near
the lake and the hot springs. Augustin Machado was the first of the owners
of the rancho to actually build on it. He did this immediately upon taking
possession, building an adobe house on the northwest corner of the lake.
At this point, with the advent of the Butterfield Road, Machado's house
became a focal point of the area and a stage stop for the mail stages. It
continued under the ownership of Augustin Machado until his death in
1865. Upon Machado's death, his widow Ramona and their twelve children
maintained it until she and all but one of the children, Juan, sold their
portions in 1873. In 1874, Charles Nordhoff, a reporter for the *New York
Herald*, wrote *California for Health, Pleasure, and Residence: A Book for Travelers
and Settlers*, which has become a classic in the field of early California travel
books. This book was written as a result of his travels in the preceding few
years, and he spends one chapter telling about life on a rancho. That rancho
is the La Laguna Rancho, and his lengthy description is reproduced here as
Appendix F.

Continuing toward Los Angeles, the road led to Temescal, approximately
fifteen miles northwest of Laguna Grande. This was the home of Leandro
Serrano, who by this time had been joined by many of his children and
grandchildren, most of whom had built homes surrounding Don Leandro's.
From the time they settled in the Temescal Canyon, the Serrano family
played host to travelers moving through the area. This continued once
American rule began, with their duties increasing. Again we look to Judge
Hayes for a description of the area:

Road firm and good, gently ascending for a mile or more from the lake; then
uneven, occasionally sandy, to Temescal. Day clear and warm. Our Indian
companion kept with me as far as the rancho, where he turned down to see
his friends who occupy a few huts near the house. A fine vineyard—a large
cornfield—a large flock of sheep—many clear mountain torrents coming
down from our left, having on all of them cottonwood, sometimes a good

Later photo of the Machado House. *Photo courtesy of Lilah Knight.*

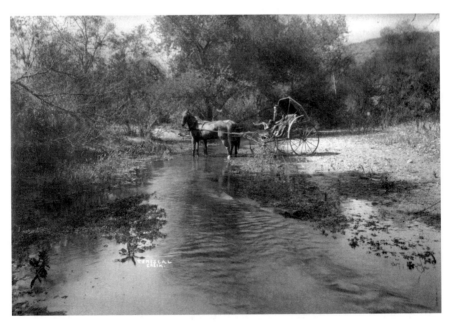

Crossing Temescal Creek in Temescal Canyon, 1890s. *Photo courtesy of the Heritage Room, Corona Public Library.*

deal of it. These torrents must be very wide sometimes. The house is on
a hill, a substantial adobe, clever people,...have been here 13 years. Very
little cultivated land from the lake to this point; on the hills, however, the
grass looks pretty. Took dinner here. They offered me a keg for a seat. The
[Serrano] *family seated themselves on the floor. Mutton boiled with corn,*
a plate of chile colorado, *and soft cheese made by themselves.*[121]

In the latest days of the Butterfield stage line, another stationmaster by the name of Jim Greenwade came to the Temescal Canyon area. Starting in about 1860, Greenwade was running a hotel in the little community of Temescal, started only a few years before as a farming and beekeeping settlement. In 1861, Greenwade established a new Temescal Station. He ran this station and catered to travelers for about eight years until he killed his six-year-old daughter and himself with strychnine in January 1869.[122]

The last stop along the Sonora Road within Riverside County was at Rincon, named because of its location on the Rincon Rancho. By 1849, this rancho had been sold by Juan Bandini to Don Bernardo Yorba, who in turn gave it to his daughter, Maria Ynez, and son-in-law, Leonardo Cota, as a wedding present. Sometime between 1850 and 1853, one of her brothers, Raimundo, built what we of today call the Yorba/Slaughter Adobe and turned it into a fine ranch and stop along the road. Raimundo believed that he was building on lands that were part of the rancho, but when the land was surveyed, it was found to be outside. Therefore, Don Raimundo homesteaded approximately three hundred additional acres to incorporate his ranch into the larger. The ranch house and property were sold in 1868 to Fenton Slaughter, hence the dual name of today.

Starting in the mid-1860s, the Yorba family began selling lands they owned. Because of this, in the vicinity of the Rincon stage stop, the small community of Rincon sprouted on the north side of the Santa Ana River where the road crossed it. Several additional people took up homesteads, and by 1870, Rincon had several dozen families living in the area, almost all of whom were farmers.

From Rincon, the next stop along the road was the Chino Ranch, in present-day San Bernardino County. Unlike Rincon, the Chino Ranch, owned by Isaac Williams, was a major stop along the way and became a station for the Butterfield Mail. From Chino, the road went through Cucamonga, El Monte and eventually into Los Angeles.

The very first westbound stage of the Butterfield line departed on September 16, 1858. On board was correspondent Waterman Lily Ormsby,

Sonora Road
Through Western Riverside County

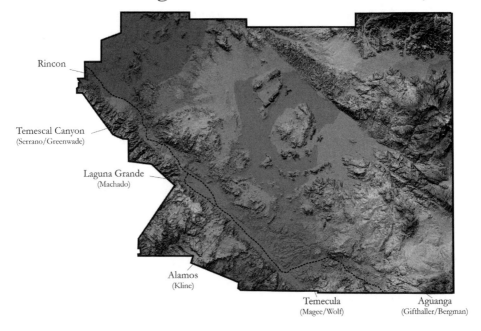

who wrote news accounts of the journey. The portions around Riverside County are recounted here, although as can be seen, he obviously did not think Southern California was living up to its potential:

In the Valley of San Felipe we saw a number of prosperous Indian ranches, where they raise corn and melons and live much like white folks. Warner's ranche is a comfortable house, situated in the valley, in the midst of a beautiful meadow, and with its shingled roof looked more like civilization than anything I had seen for many days. There were hundreds of cattle grazing on the plain, and everything looked as comfortable as every natural advantage could secure. Our road lay through some delightful oak groves—a most decided improvement on the desert—while the cool, delicious springs of water were most acceptable. The stations (through these valleys of Buena Vista), Hall's Oak Grove, Swango [Aguanga], Laguna, and Temacula [Temecula], are all at convenient distances,

and the accommodations excellent, and the road is lined with prosperous ranches. Through San Diego County the verdure was quite luxuriant, owing to the recent rains.

Our road lay through a valley in the southwest corner of San Bernardino County, having the San Bernardino Mountains on the east and the coast range on the west. The land is rich and could produce everything, but it lies almost uncultivated, being used principally for grazing. The owners prefer to grow rich without doing any work. They have plenty of meat ready at hand and can buy what they want by selling stock. Many of them buy wheat and corn, while their lands would produce abundant crops with the greatest ease. Our road leads through Chino ranche—the richest in San Bernardino County—the proprietor of which is estimated to own about $300,000 worth of cattle, yet at our breakfast, here, we had neither butter nor milk, without which the merest hod carrier in New York would think his meal incomplete. Their cattle dot the plains for miles around, and their land could produce everything; but they have not even the comforts of a Massachusetts farmer among his rocky hills.[123]

As can be seen, the Sonora Road, and especially the later Butterfield Stage Road, did much to bring people through, and settlers into, Riverside County. This route became a major immigration route into the area, and as time went on, it was natural for it to spawn several offshoots. These offshoots began to crisscross the county starting in the 1850s. At first, these side routes connected established locations or settlement or, in some cases, allowed stages on the Butterfield line to circumvent the normal route in case of inclement conditions.

BRANCHES OF THE SONORA ROAD

By the mid- to late 1850s, two branches of the Sonora Road were being used in Riverside County, both of which eventually led to San Bernardino. The first of these was a continuance of the road that mission officials had begun in order to connect Temecula with San Jacinto. This road led northeast out of the Pauba Valley, past Santa Gertrudis Spring,[124] into Diamond Valley and northeast to San Jacinto.

At San Jacinto, it joined another road that had existed since Mexican times. This one went along the foothills of the Badlands and then around

Box Springs Mountains. At that point, the road split, with offshoots leading to Jurupa and San Bernardino. This route continued in use and would later develop its own offshoots leading to San Bernardino through two other avenues: Reche Canyon and Pigeon Pass. Therefore, one could leave Temecula, go through Adobe Spring to San Jacinto and then along the Badlands to San Bernardino via one of three routes.

The second main branch of the Sonora Road left the main route near Temecula and led directly north in much the same way as today's I-215 freeway does in the region. This route then entered the San Jacinto plains and continued north until it met the San Jacinto–San Bernardino Road at Box Springs, which then continued to San Bernardino as outlined above. This side road passed by two locations: Point of Rocks and Pinacate.

In the vast, open San Jacinto Plains (generally the region between Temecula and Box Springs), there was but one stop. This was a place called Point of Rocks, which would have been in the vicinity of present-day Placentia Street where it crosses the I-215 Freeway north of Perris.[125] This served as a station used by stage companies running regular stages between Los Angeles, San Bernardino, San Diego and points east in the days leading up to the coming of the railroads. By one account, this station was in use as early as January 1868.[126]

One significant group that used the Temecula–San Bernardino Road included miners, mostly Mexican, who came to the hills on the west side of the San Jacinto Plains to extract everything from tin to gold and many other minerals. Many small mining claims and camps were established starting as early as the mid-1850s, mostly by Spanish-speaking individuals. Some familiar names, such as Trujillo and Robidoux from the Agua Mansa area, figured heavily in mining interests there. In fact, one of the main camps was called Rancho de los Trujillos, and it was mentioned frequently in the various claims filed during these years. In addition to Rancho de los Trujillos, two other communities of note began: Pinacate, meaning "stink bug," located in the hills southwest of present-day Perris, and Gavilan, meaning "sparrow hawk," which would have been to the northwest. This latter place name lives on today as the name of the hills around which the mining camp was located.

All of the aforementioned sub-roads had one location in common: the Box Springs Mountains. Near the point where the two sub-roads met was Box Springs itself, which also became a stop along both of the roads. Getting its name from the fact that the natural springs had been boxed in, probably by John Brown Sr. of San Bernardino, Box Springs was an important

Sonora Road
(With Branches)

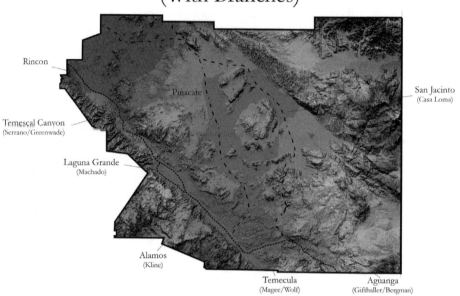

watering place on the southwest side of the hills. Much later, but at least as early as January 1875, a home and station were erected by a Captain Angus McQueen, who had homesteaded approximately twenty acres around the spring itself. This was short-lived, however, because he then sold his land to the California Southern Railroad in the early 1880s.[127]

The main Sonora Road, along with its many side routes, opened a vast area of western Riverside County to the eyes of incoming peoples. From the road, most if not all of the Aguanga Valley, Temescal Canyon, Temecula Valley, San Jacinto Plains and the Riverside Mesa could be seen, and it became only a matter of time until places along these routes would spring forth with larger and more permanent populations. However, the Sonora Road was just one of two main roads to lead through the county, the other being a desert route. This desert route saw no settlement during the migrations along the Sonora Road, but the year 1862 would drastically change its status and hence its role in the development of Riverside County.

11
BRADSHAW'S ROAD[128]

The Road to La Paz in Riverside County actually consisted of two portions of different routes: the desert portion of the Yuma Route and the Cocomaricopa Trail. For most of the time from about the 1820s to the 1850s, Anglo use of the desert portion of the Yuma Route consisted mainly of smugglers and bandits who took advantage of its lack of travelers to escape to or from California or Arizona. The heat of the desert and lack of good, reliable water sources precluded development of the route to its full potential. As we saw in the section about the Butterfield Road, several people tried to open the Yuma Route and in fact established stations at Whitewater and Agua Caliente. However, the inability to procure water south of Dos Palmas made them ultimately choose the Sonora Road. As to the Cocomaricopa Trail, it had been opened for mail by the Cocomaricopa Indians at the close of the Spanish period. When the Mexican government tried to open it, their attempt failed. From that time until the early 1860s, the road went unused as far as Anglo-American influence was concerned. Events starting in 1862 would change the scene in the eastern portions of Riverside County, and for that we must look first at our neighbor to the east: Arizona.

In January 1862, four Mexican miners left Yuma and traveled north along the Colorado River. Several miles north, at the *Arroyo de la Tenaja*, northeast of present-day Blythe, they discovered gold. Powell Weaver, whom we know from his settlement on the San Gorgonio Rancho, soon joined them and announced the discovery at Yuma. From there, several others left for the

gold fields and soon established a mining camp that would become La Paz, Arizona.[129] By early spring, Weaver had gone to Los Angeles with the news, and a gold rush ensued, taking hundreds of people from Los Angeles to Arizona. At that time, access to the area was by one of three ways, all of which were rather circuitous. There was the Mojave Route, or Mormon Road, which left San Bernardino and headed north through Cajon Pass, then east across the Mojave Desert, crossing the Colorado near present-day Needles and then heading south to La Paz. This was the shortest route but also the most dangerous, owing to the numerous Indian attacks that occurred. The second was the Sonora Road, which was the most circuitous of all. This, however, had become a military road and was being patrolled by the army for potential bands of Confederates. Also, the Sonora Road was in poor condition, owing to the tremendous rains and flooding of the previous January. That left the third route—the desert portion of the Yuma Route—as the shortest and one most traveled. This route also went through San Bernardino and then crossed the desert to Yuma, where the river was crossed if the U.S. Army allowed. From there, a prospective miner had either a seventy-mile northern trek to La Paz or a steamer trip up the Colorado River. In either case, the two routes going through Yuma were rather dangerous owing to the Colorado River's propensity to flood from March to August, making a crossing extremely hazardous.

By May 1862, it was becoming evident that the gold fields at La Paz had the potential for great riches. Many miners were returning with large nuggets of gold or a great deal of gold dust. Accordingly, on May 16, 1862, a Los Angeles resident named William Bradshaw decided to explore the possibilities at La Paz and started on the desert portion of the Yuma route. Camping one night near the Indian village of Toros, in the southern Coachella Valley,[130] Bradshaw met an Indian who befriended him and told him of a more direct route to central Arizona over the Cocomaricopa Trail.[131] The Indian agreed to take Bradshaw along the route, which led not southeast as the Yuma Route did but northeast through the pass between the present-day Orocopia and Chuckwalla Mountains on the north and the Chocolate Mountains on the south. When they had traversed the trail and arrived at the Colorado River near present-day Blythe, cutting several days off the journey, Bradshaw knew he had found a quicker, better route. With this realization, he decided to return to Los Angeles and announce the new shorter and quicker route to La Paz. However, before he did, he and William Warringer, his partner who had accompanied him on the trip, established a ferry

at Providence Point to shuttle miners and other people back and forth across the Colorado River.[132]

In mid-June 1862, Bradshaw returned to Los Angeles and told of his discovery of a new, shorter route.[133] The *Los Angeles Star* printed his description a month later, and the rush was on. By mid-summer 1862, hundreds of people were clamoring out of Los Angeles for the gold fields of La Paz, most of them taking advantage of what was termed Bradshaw's Road.

> *Ho for the Colorado—This seems to be the rallying cry of our city at the present time, and if the excitement keeps up for a short time longer at the ration of the past two weeks, there will be a great falling off in our population. At last, after many promises and much prospecting, the gold is fast flowing into our city.*[134]

With several hundred people and animals traveling along the new road in the summer of 1862, the water that existed was scarce and becoming scarcer. Temperatures in the desert could reach the 130-degree mark during the day, which would not allow a man or animal to survive very long without water. Generally speaking, as people returned to Los Angeles, they would report on the water situation along the route, and these descriptions were published in the newspapers or other bulletins. When it seemed as though travel along Bradshaw's Road was likely to be a permanent occurrence, citizens and businesses banded together to dig wells to provide a marginally regular supply of water.

With so many people traveling across Southern California, it seems only natural that stage lines would begin in earnest to help convey people from Los Angeles to La Paz. From the time of the discovery of gold until the coming of the railroad in 1877, stages frequently would be seen on Bradshaw's Road. Several stage lines operated during the roughly fifteen years before the railroad. Although it is not the purpose of this work to outline all of them, three stand out. The first of these was the Colorado Stage and Express Line, owned by David Alexander and operated by Warren Hall. Hall, who had been the superintendent of the Butterfield line between Yuma and Los Angeles, was the driver, and his assistant was Henry Wilkinson. They left the Bella Union Hotel in Los Angeles on September 6, 1862, and arrived in La Paz on the eighteenth. Along the way, Hall and Wilkinson brought along a large herd of animals, portions of which were left at relay stations they established along the way (for a list of stops along this route, see below). This line lasted only about six weeks. On October 29, Hall and Wilkinson

pulled into the Smith Ranch in the San Gorgonio Pass (see that below). They soon discovered that their strongbox, with approximately $1,200 in it, was missing and figured that the only man who could have taken it was Smith's ranch hand, a man named Gordon. When he refused to confess, Wilkinson and another man strung him up in an old oak tree, repeatedly strangling him in the hope he would confess. When he didn't, Wilkinson sent his assistant to get Hall. When Hall arrived, Gordon, who had freed himself, stabbed both him and Wilkinson to death. Although Gordon escaped, he surrendered to the San Bernardino sheriff and was eventually acquitted of murder on the grounds of self-defense. The killing of Hall and Wilkinson effectively ended the Colorado Stage and Express Line, and Alexander went on to other endeavors.[135]

In the wake of the demise of the Colorado Stage and Express Line, another one was developed. James Grant, who as we've seen was one of the first to travel the route, and John Frink, a longtime resident of the San Timoteo Canyon area, formed the La Paz Express and Saddle Train. This line, announced in February 1863, began operation the next September. This new company took not only passengers but also mail. In various permutations, it lasted until well after the Civil War.[136]

The final line of note in the area was the one established by the famous Southern California shipping magnate, railroad developer and stage line owner Phineas Banning, who in 1866 started operating a line from Wilmington through Los Angeles, San Bernardino, the desert and, finally, Yuma. Banning's colorful stagecoaches were known throughout the area, but they too were short-lived, lasting only through the summer of 1867.

The unreliable nature of water in the desert, especially east of Dos Palmas, created a need for good wells. Due to the extreme heat and lack of water, Bradshaw's Road was fit for only a few travelers at a time. When it began being used in earnest (there was little way of stopping the migration out of Los Angeles), several people began showing concern that what water there was on the road might dry up, thereby stranding many of the parties of miners or causing them to stay in Arizona once they arrived there. This of course would mean that they would not return to Southern California to spend the gold they were mining. Owing to the fact that many believed water could be found if someone would drill for it, the merchants of Los Angeles, San Bernardino and La Paz banded together and hired John Frink and James Grant to dig wells and secure good, potable water sources for both men and animals to ensure safe travel throughout the desert.[137] One of the wells they dug was the famed Chuckawalla well that will be discussed

below. Now, though, we will look at the effect the opening of the Road to La Paz/Bradshaw's Road had on the development of Riverside County and how the desert areas were made to yield that most precious of fluids: water.

STOPS ALONG THE BRADSHAW ROAD: SAN GORGONIO PASS[138]

In order to follow Bradshaw's Road through the San Gorgonio Pass, it is necessary to first go back and examine the settlement of the pass. Unfortunately, it can become rather confusing to look at all the people and places involved in early pass history; therefore, we'll take a look only at the major players in the story.

As we saw previously, Powell Weaver, Wallace Woodruff and Isaac Williams petitioned Governor Pio Pico for the San Gorgonio Rancho in 1845. This was apparently never finalized, and as they did not appear before the U.S. Land Commission with proof within the time allowed, technically the area reverted to the public domain. However, beginning in October 1853, the opportunistic Weaver began selling portions of "his" land, and thus began the early settlement of the pass.

The first person to buy was Dr. Isaac Smith, a recent immigrant from Iowa. He and his family lived in Weaver's adobe for a while until Dr. Smith established what would become known as the Smith Ranch a few months later in 1854. This area, known today as Highland Springs north of Beaumont, was a major stop through the pass for many years. Here, Smith planted several small orchards, raised grain and, most importantly, grazed a sizable herd of cattle on his 320 acres. Smith had a large family, helped mediate differences between the Mormons at San Bernardino and non-Mormons throughout the area and even eventually served in the state legislature for San Bernardino County.[139]

In December 1856, Weaver sold the 160-acre area around his own home to what ultimately became a succession of people, ending for a while with the Edgar brothers, Francis and Dr. William. Their combined holdings eventually rose to over five hundred acres of land. On their ranch, they established a vineyard and winery, which were well known for many years. Apparently, the Edgars were the first to establish fruit-growing in the pass area.

As early as 1854, Isaac Williams, the other major petitioner for the original San Gorgonio Rancho, began using lands east of Weaver's and Smith's

as a stock-grazing ranch for his main holding: the Rancho Santa Ana del Chino, or Chino Rancho. Williams's foreman, or *mayordomo*, for the area was Joe Pope, alternately called Jose. Pope built a small adobe house near a spring along the foothills north of present-day Banning for his family. In or around 1863, Pope sold the compound to Galutia S. Chapin, a prominent investor and real estate speculator from San Bernardino. He used the area to raise sheep, which seems to have been the main industry in the pass at that time. Chapin in turn sold the ranch in 1865 to another prominent figure in the early history of the pass area: Newton Noble, who made this ranch a main stopping place along the pass route. Having spent four years raising sheep and tending to the needs of travelers, Noble sold the entire area to James Marshall Gilman on May 8, 1869.[140] Gilman continued to maintain a stage stop and built an impressive home on the grounds. Gilman was a bachelor when he bought the ranch but soon married Martha Smith, one of the daughters of Isaac Smith. The Gilman's home, along with that of Dr. Smith, was alternately used as a primary stage station in the pass. During these times, the companies seesawed back and forth between using Smith's and Noble/Gilman's, although in the end, when the need for stage stations was supplanted by the railroad, it was the Noble/Gilman ranch that was used more often.[141]

Although the Smith and Noble/Gilman ranches served as the primary stops in the pass, other settlers soon came into the area to buy property or

Later photo of the Pope Adobe. *Photo courtesy of the Riverside County Regional Park and Open-Space District.*

opened their holdings to serve as stopping points for travelers and stages. Between San Bernardino and the Smith Ranch, Newt Noble, who had sold his first ranch to James Gilman, in turn bought property near the old Weaver Adobe and set up a second holding. This second ranch of Noble's became a stop, if only for a few years, until the construction of the railroad through the area in the 1870s. In addition, in San Timoteo Canyon, farther west of Noble's second ranch, was the ranch of the Frink brothers, John R. and Horace M. The Frinks had settled on government land southeast of San Bernardino as early as 1855 (see the section on San Timoteo Canyon later). In addition to ranching and farming, their early years in the canyon were kept busy freighting for Colonel Washington's baseline survey and then acting as scouts during the early years of the Bradshaw Road. Starting as early as the mid- to late 1860s, they seem to have settled in the canyon and made their place a stop for some of the many stage lines to come through that area.

In the area east of Gilman's, where the San Gorgonio Pass begins to open onto the desert, there was one stage stop. This was a ranch and home run by Frank Vandeventer. According to Chief Francisco Patencio, it was located approximately one mile north of the present-day town of Cabazon.[142] This would place it in the foothills of the mountains that make the northern boundary of both the San Gorgonio Pass and the Coachella Valley. This station started in about 1866 and changed hands in January 1875, when Antone de Crevecouer bought the property from Vandeventer, who then moved up into the San Jacinto Mountains and settled on what is today called Vandeventer Flats.

Finally, on the easternmost edge of the pass as it begins its descent into the Coachella Valley, Frank Smith, son of Dr. Smith, took over the family's ranch on the Whitewater River sometime before 1860.[143] Here, he grazed animals and raised crops and also built a small adobe structure that served as both his home and a stop along the route. The Whitewater Ranch became a very important stop to travelers. Smith constructed a ditch to carry water from the Whitewater River to the ranch and planted cottonwood trees to shade the area around his home and garden. Although the winds in the area can be fierce throughout most of the year, his place must have been a welcome sight for those who had just endured over one hundred miles of desert terrain, especially during the summer months, such as when the Bradshaw Road first opened.

Let us now recap the various stops that existed either intermittently or permanently in the San Gorgonio Pass. Depending on how far a person

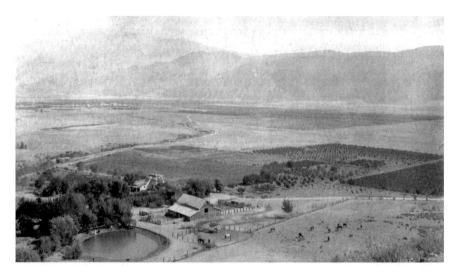

Gilman Ranch and San Gorgonio Pass, circa 1910s. *Photo courtesy of the Riverside County Regional Park and Open-Space District.*

could travel in a day, or on which stage line he was traveling, if a person or wagon train was heading east through the San Gorgonio Pass area, any of the following places could be used as stops, depending on the time: Frink's, Noble's (second) ranch, the Weaver/Edgar Ranch, the Smith Ranch, the Pope/Chapin/Noble/Gilman Ranch, Vandeventer Station (for a time) and, finally, the Whitewater River/Ranch. Even though all of these choices existed at one time or another, the main stations continued to be Smith's, the Pope/Chapin/Noble/Gilman Ranch and the Whitewater Ranch.

STOPS ALONG THE BRADSHAW ROAD: COACHELLA VALLEY[144]

The first stop out of the San Gorgonio Pass and into the Coachella Valley was that of Agua Caliente. Agua Caliente was a spring that had been called *Sexhi* by the Cahuilla who lived there. For the first decades of American rule in California, the name Agua Caliente continued to be used for the springs. In 1862, just after the opening of the Bradshaw Road, Hubert Howe Bancroft, the imminent California historian, traveled along the road and described Agua Caliente:

Agua Caliente takes its name from a large spring of warm sulphur water three or four rods to the left, as we enter the village from the west. It forms a large pool, of proper depth and temperature for bathing, for which it would be well adapted were the mud cleaned out…The proper place to camp here is one mile east of the village, where animals will not disturb the Indians' patches of corn and grain, which are unfenced, and where there is fine water and grass a few hundred yards south of the road.[145]

Agua Caliente became one of the most important stops along the road. Here, a large adobe station was built, and Jack Summers was the stationmaster for years, living at Agua Caliente well past the time the railroad had effectively negated the need for the road. According to Francisco Patencio, Summers lived on land that is now very near the downtown section of Palm Springs. He hired local Indians to raise barley for the horses, but in times when the water was not as plentiful, he would hire Indian children to gather *galleta* grass for them.[146]

The next watering place was called Sand Hole, in the vicinity of modern-day Palm Desert. This was one of the earliest stops, but one of the least used. At best, it was a sporadic, often brackish pond of water that was unreliable:

This is a muddy pool about 400 yards east of the road, and which, as it consists only of a collection of rain-water in a small clay basin, is always bad, and dries up early in the summer. It is not to be depended upon except for a few months in the spring, and then only in case of a wet winter.[147]

Generally, people continued past Sand Hole on to the next major stop: Indian Wells.

Before the Bradshaw Road, the area around Indian Wells was called *Palma Seca*, or "dry palm," for the lone palm that grew around a small spring. This spring gave rise to a small village, or rancheria. Therefore, when the stage lines initially put a station here, it was called "Old Rancheria." A few years later, the name was switched to Indian Wells because as the water dried up, the local Indians had to dig a progressively deeper well into the desert floor in search of water. A large adobe station was built there, and an agent known only as Ropely served it for many years. Later, a regular well was drilled, a good amount of water was found and Indian Wells became a good source for water on the desert.

About nine miles east of Indian Wells was another Indian village, that of Toro. Apparently named for a chief who lived there, Toro—and the

neighboring village, Martinez[148]—were sources of not only water but also mesquite, which was used for fuel, and grass and other feeds for animals. Water was not always easy to obtain, even at the springs. One of the first people to cross the new road was Mahlon Dickerson, who writes of Martinez:

> *At Martinez village where we arrived on the first of September, we had to procure water by a very tedious process. The Indians had wells some twelve or fifteen feet deep into which seeped a small quantity of water. Down into these we were compelled to go upon poles with notches cut along them for steps. The water was dipped up, a cupful at a time, poured into a bucket and carried to the surface. No more than three or four buckets could be obtained in an hour.[149]*

The next stop, that of Dos Palmas, was arguably the best-known and most-used watering hole/station on Bradshaw's Road. The spring itself, which emanates from a fissure on the San Andreas Fault, could be counted on with great regularity to provide fairly good water, although most of the times it was hot. Dos Palmas, meaning "two palms" in Spanish, was named because of the two large California fan palms that could be seen for miles in the vast, open desert surrounding the spring.[150] In 1876, Oscar Loew of the Wheeler Survey described Dos Palmas Spring:

> [It is] *a small oasis made prominent by two palm-trees that grow here in a wild state. The spring that furnishes the water for the pond at which these trees are growing, is but a few yards distant from the hut of the single inhabitant of this oasis. As far as the water of this oasis spreads, the salt grass…grows abundantly. The spring…has a disagreeable, brackish taste, a temperature of 82° F, and is odorless.[151]*

With such a good, virtually year-round supply of water, Dos Palmas Spring's importance to early travelers can hardly be understated. In fact, the spring served as a junction point for no fewer than three routes in the desert region. In addition to Bradshaw's Road, which led almost directly east from the spring, the earlier portion of the Yuma Road through the desert branched off toward the southeast, continuing across what is today the Imperial Valley and on to the Yuma crossing of the Colorado River. A third road began at Dos Palmas and led west-southwest through the Santa Rosa Mountains and then to Warner's Ranch as a back way to the desert from that portion of San Diego County. Over the next several years, as an increasing number

Road to La Paz

(Bradshaw's Road)

Western Riverside County

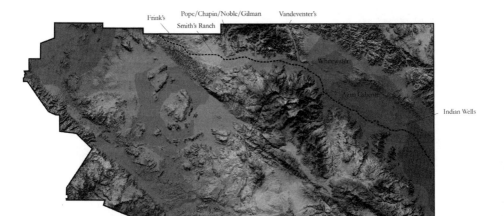

of people came through the area, additional routes led out of Dos Palmas, going to such destinations as Thousand Palm Oasis to the north.

Once the importance of Dos Palmas was defined, it was not long before a stage station was established, along with the obligatory corrals to house the horses that drove the stagecoaches when necessary. An adobe structure served as station, home for the station keeper and multipurpose building for travelers journeying by themselves or with a group or all of the various stage lines operating for the roughly fifteen years that Bradshaw's Road was in service.

Approximately ten miles east of Dos Palmas, in the pass now called Salt Creek Wash between the Orocopia[152] and Chocolate Mountains, was the first stop along the new portion of Bradshaw's Road. This was Canyon Springs (also known as Canyon Creek in the early days). The station was along the road in the wash, whereas the spring was approximately one-third of a mile to the north. Here, a swing station was established, and of course, supplies were available. Bancroft again describes the route:

> *Most of the distance the road is hard and good... The Cañon is a narrow gorge running out of Brown's Pass, or, as it is generally called, the Big*

Carl Eytel sketch of Dos Palmas. *Photo from James,* Wonders of the Colorado Desert.

Wash, to the north…There is a spring of good water on the right, going up the Cañon, one-fourth of a mile from its mouth.[153]

Approximately eight miles east of Canyon Spring the road came to the next watering place, that of Tabaseca Tank, or simply Tabaseca. This was a natural formation creating a tank in which rainwater could be collected and stored, often for a long time. While stating definitely that the name Tabaseca was Indian in nature, Jane Davies Gunther discovered no fewer than three definitions for it: *Tabbe Sakle,* meaning "yellow hammer nests"; *Ta vesh heck ke,* meaning the "home of a woodpecker"; or *Tavis Hecki,* meaning the "home of the red shafted flicker."[154] Regardless of the origin of the name, this natural tank in the desert was quite a sight for the weary traveler:

[The tank is] *a natural basin in the bed of an arroyo that issues from volcanic hills on the north slope of the Chocolate Mountains. Two very sharp prominent peaks…are conspicuous a little distance to the southeast, and the tank is almost at their base…The pool is several feet deep, is about 20 feet in diameter, and is full of gravel and rocks. The gravel is generally saturated with water, which can be obtained by digging a foot or two. The*

water is preserved for a long time, as the cliff of the waterfall shades it, and the gravel prevents animals from drawing heavily upon it.[155]

The Chuckawalla springs and well, roughly eighteen miles east of Tabaseca, was the next stop. Chuckawalla, like Tabaseca, is an Indian name. Again, it is said to have several meanings, among which is a term for the Ocotillo cactus and a small, flat lizard that roams in the area. The Chuckawalla spring was approximately two miles north of the road, while a second set, later termed Mesquite Springs, was approximately 1.75 miles southwest of Chuckawalla. These springs were used for water when the road was first opened. The well, approximately one-quarter mile north of the road, was drilled by Frink and Grant in the summer of 1863, when they also established a station. About twenty-five years after visiting the station, P.W. Dooner described it as "a station where refreshments and lodging are supposed to be furnished. The place was just about as classic in its surroundings as the jingle of its name would suggest."[156]

Approximately 17.5 miles east along the route, the next station was reached. This was Mule Spring Station. Here too a well was dug and a station established that Chief Francisco Patencio says was run by a Frenchman and his wife.[157] The well, however, was dug in the wash near where the station was and apparently either washed out or silted up often. Overall, Mule Springs apparently was not a reliable source of water. This could be dangerous, as it was halfway between Chuckawalla Station and the Colorado River.[158]

From Mule Spring Station, Bradshaw's Road came out of the mountains and began to enter the Palo Verde Valley. Here, on the western edge of the Palo Verde Mesa, was the last stop along the road before reaching the Colorado River. This was the Willow Springs Station, approximately fifteen miles northeast of Mule Spring Station and just northeast of the present-day intersection of Eighteenth Avenue and Stephenson Boulevard southwest of Blythe. An adobe building was constructed, which apparently was the only one on the true portion of Bradshaw's Road. Therefore, after 1900, it acquired the more popular name of Adobe Station. Willow Spring itself is described as a sink created by an eddy or whirlpool in one of the several channels of the Colorado River. The eddy apparently excavated a hole, the elevation of which was actually deeper than the water table, thus making a spring.[159] This would have been a welcome sight if the traveler had been unsuccessful at Mule Springs.

Finally, the Colorado River crossing at Providence Point was reached, having traveled approximately nine miles northeast from the Willow

Chuckawalla well site today. *Courtesy of the author.*

Ruins of Mule Springs Station today. *Courtesy of the author.*

Road to La Paz
(Bradshaw's Road)
Eastern Riverside County

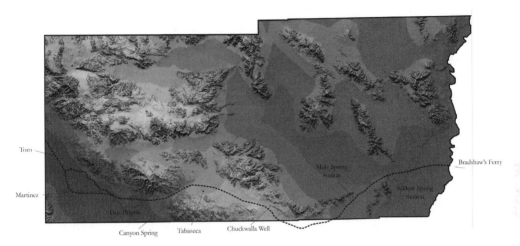

Spring Station. Here, on June 16, 1862, Bradshaw and his partner, William Warringer, established what became known as the Bradshaw Ferry in order to take passengers across the river. Very soon after, Bradshaw installed his brother Isaac as manager of the ferry service. The ferry itself was generally a crude boat pulled across the river by means of a rope stretched from the California side to the Arizona side, as we see in this description by early traveler Mahlon Dickerson Fairchild:

> *Traveling about thirty-five miles from our last halting place,[160] the sight of the Colorado River gladdened our eyes. We had reached Bradshaw's ferry… The ferry was established by William Bradshaw, a former member of several of Fremont's expeditions. A rude boat capable of carrying wagons and a limited number of animals, attached to a rope spanning the stream, the current being the propelling power, comprised the affair. The rates for ferriage were not exorbitant and it was of great convenience.[161]*

As a sidelight, across the Colorado River lay a little town variously named Olive, Olive City or Olivia, Arizona. The town had been named for Olive Oatman, a legendary figure in Arizona history. Early in 1851, Royce

Oatman, his wife and their seven children (including Olive) were traveling west to California. In March of that year, they camped in what would become known as Oatman Flats in present-day Mariposa County, Arizona. One night, the family was ambushed by local Indians who killed six of the family members, including the parents. One brother, Lorenzo, was spared by playing dead. Two sisters, Mary Ann, who was eleven at the time, and Olive, who was sixteen, were captured and sold into slavery. Mary Ann died in captivity, but five years later, in February 1856, a healed Lorenzo rescued his sister Olive. At the time of her rescue, Olive Oatman could barely speak English, was severely tattooed and was in ill health due to long exposure to the sun. Word quickly spread about the Oatman saga, and later, many places were named in their honor.[162]

Within a few years of the opening of the Bradshaw Road, Herman Ehrenberg, a well-accomplished and respected German engineer, explorer and miner, established the town of Mineral City, just south of Olive City. In 1866, while traveling along the Bradshaw Road, Ehrenberg camped for a night at Dos Palmas Spring. A few days later, his murdered body was found by other passersby who buried it and spread the news. The death of Ehrenberg came as a blow to many of the miners in the Southwest, including his good friend Mike Goldwater, grandfather of famed Arizona senator Barry Goldwater. Mike Goldwater was instrumental in causing the dual towns of Olive City and Mineral City to be renamed to Ehrenberg in his honor. Today, Ehrenberg, Arizona, is the first town approached when one leaves Riverside County heading east.

Like the Sonora Road, Bradshaw's Road saw a tremendous number of people traveling on it throughout Riverside County. However, unlike its counterpart to the west, Bradshaw's Road did not lead to any true settlements.

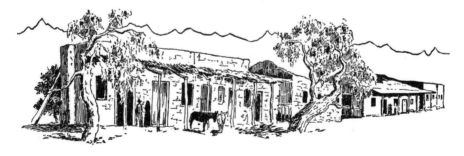

Carl Eytel sketch of Ehrenberg, Arizona. *Photo from James,* Wonders of the Colorado Desert.

There are two reasons for this. First, Bradshaw's Road throughout most of Riverside County lies in desert regions, which at the time were unable to support a settlement of several dozen individuals. True, people did live along the road, but they were usually single stationmasters who tended one of the several rest stops along the way. The second reason why Bradshaw's Road would not have lent itself to settlement has to do with the type of person using it. The Sonora Road was used by people whose purpose was to come to the area, either temporarily or permanently. The main focus of Bradshaw's Road was to take miners from Los Angeles to La Paz and back. The users of Bradshaw's Road had only one purpose in mind—that of mining in Arizona. True, other uses such as the mail stages took Bradshaw's Road, but again, the fact that it went mainly through desert lands kept any true town sites from being established along it (for a full description of an early trek along Bradshaw's Road, please see Appendix G).

12
OTHER SETTLEMENTS

SAN TIMOTEO CANYON

San Timoteo Canyon is a fairly small, flat canyon stretching from present-day Redlands southeast to Beaumont. In looking at it and the development patterns taking place during the early American period, it seems natural that this canyon would start to see an influx of people very early in the overall history of the county. The canyon's proximity to both San Bernardino and the San Gorgonio Pass, its position along the desert portion of the Yuma Route and Bradshaw's Road and the abundance of water provided by San Timoteo Creek all worked together to ensure a prominent place in the early development of the area.

American settlement began to some extent in the eastern portion of the San Timoteo Canyon, when Louis Robidoux purchased the San Jacinto y San Gorgonio Rancho from Santiago Johnson in April 1845. Although Robidoux used it primarily for pasturing cattle, his purchase apparently did stimulate additional settlement. By 1851, Dudley Pine had homesteaded land just west of the grant, and within a few years, a man named Zina Ayers had established his holdings in the region, planting a vineyard and orchard. Another to settle in the immediate area was Duff Weaver, who is better known as being the brother of Powell Weaver of the San Gorgonio Rancho.[163]

American settlement of the canyon grew in 1855 when the Frink brothers, John and Horace, settled on government land around the area that is today's

El Casco Lake.[164] By the time they settled in the area, both brothers had already witnessed a great deal of early western history, John having been a scout with Kit Carson and Horace having been at Sutter's fort to witness the discovery of gold while also being a scout for General Fremont and Commodore Stockton.[165] Together, the brothers established what became known as the Frink Ranch, consisting of a sizable adobe home, several other buildings and, of course, pastureland and farms. As the Frinks were involved in freighting, and their home was the most substantial in the canyon, starting in the mid- to late 1850s, the Frink Ranch became the main stop along the various roads that traversed the canyon.[166]

By late 1855, there apparently was sufficient population in the canyon for San Bernardino County to designate the canyon as a school district, forming the San Timoteo School District. Immediately, a small adobe schoolhouse was built, and instruction began.[167] Over the next several years, as an increasing number of people traveled through the area and settled nearby, the San Timoteo Canyon area of the county would play host to a whole series of farmers and settlers who maintained a small but coherent community (but not a town per se) in the area.[168]

TEMESCAL TIN MINES[169]

The history of the development of the Temescal Tin Mines in western Riverside County begins with a well-known figure in California history: Daniel Sexton. A member of the famed Rowland-Workman party of 1841, Sexton settled in Southern California and tried his hand at several occupations, namely farming, lumbering, mining and many others.

According to legend, sometime in 1857 or 1858, he was called to the bedside of his dying father-in-law, Chief Solano, who revealed to Sexton the location of an area rich in a precious metal used as a medicine by the Indians. The area Solano described was just east of Temescal Canyon, near the ill-defined boundaries of the Temescal Rancho and the El Sobrante de San Jacinto Rancho. After Solano's death, Sexton joined with Fenton S. Slaughter of the Yorba/Slaughter Adobe. Together with an Indian guide, the pair began to explore the area, thinking it might be rich in silver or even gold.

Upon arriving at the location, the Indian guide became excited and led them directly to the place that had been used for so many years before by

the Indians. Sexton and his partner proceeded to remove some samples from the location for assaying analyses. These analyses soon showed that the area was rich in tin. While tin was not on the minds of Sexton and Slaughter, it soon became evident that this was indeed a rare find, since tin was virtually unknown in North America and had to be imported, usually from Wales. Once they saw the potential worth of their find, they began to seek funding to exploit the resources near Temescal.

Throughout the late 1850s, the pair managed to acquire more investors, one of whom was Benjamin Wilson, who formerly owned a portion of the Jurupa Rancho. In September 1860, a mining district was formed after a sale of stock that had occurred the previous March. Luckily for him, Sexton apparently liquidated his interest during this time, probably to continue his wanderings.[170]

The mining district, however, was short-lived, as another player entered the field at that time. This person was Abel Stearns, a famous person in early California history who at one time was one of the largest landowners in Southern California. Acting as a representative for Josefa Montalba de Serrano, Leandro Serrano's widow, Stearns was able to call into question the tin mining district's legal rights to the property. He acquired rights to the property through moving, or "floating," the boundary of the Rancho Temescal. The fact that the U.S. Land Commission had rejected Serrano's petition for the rancho apparently did not dissuade Stearns. By late 1860, Stearns was in control and, over the next five years, did a minimal amount of mining on the property. Although it took him a while, by 1865, he had accumulated enough ore to send to Wales to be processed.[171]

Stearns's shenanigans with the property lines finally caught up with him late in 1867, when the U.S. Supreme Court ruled that the Serrano's "grant" of the Temescal Rancho could not be proven and therefore did not exist. At the same time, the court formally recognized the El Sobrante de San Jacinto Rancho, giving it to Jose Antonio Aguirre and extending the western boundary roughly twenty-seven miles, which incorporated all of the tin mining property in question. This decision forced Stearns out. While he bitterly opposed the decision, he became reconciled to losing what seemed to be a valuable asset.

Now that Stearns was gone, and it seemed as though the problems with land ownership were resolved, another new group came to the area hoping to exploit what seemed to be a worthwhile investment. This group, called the San Jacinto Tin Company, acquired the El Sobrante de San Jacinto Rancho in 1868, just a few months after the Supreme Court decision. Taking its name

from the rancho upon which it was located, the San Jacinto Tin Company had its headquarters in San Francisco and was composed of many people who had vast experience in the field of mining. One of these was its vice-president, L.L. Robinson, who either owned or directed several gold and silver mines in the western United States.

From late 1868 through 1888, the San Jacinto Tin Company produced some tin in varying periods of activity. The first tin ingot to be extracted from the area came in 1868 and produced calls for widening the mining efforts. However, with the previous land ownership problems still plaguing the operation, it was difficult to find many serious investors and hence much money. In addition, even though the tin ore produced in the Temescal Tin Mines was of excellent quality and pureness, it apparently did not occur in great quantities, was very hard to extract and thus made each bar of tin a very labor-intensive process. Realizing they needed an influx of capital, in 1874 the San Jacinto Tin Company decided to exploit the colonizing boom that was just beginning in Southern California at the time. They developed a plan to subdivide some of their northernmost lands into a colony along the Santa Ana River. This colony, dubbed the Santa Ana Colony, did not last long under the direction of the San Jacinto Tin Company.

In 1888, having weathered yet another controversy over land ownership, this one involving fraud charges, the San Jacinto Tin Company sold its holdings to an English firm, hoping to do even better than the Americans before. This firm, the San Jacinto Syndicate, Ltd., consisted of a large group of London-based investors led by Colonel Ned Robinson and Sir John Stokes. Much hype surrounded the new holdings of Temescal, and mining began again in earnest. By the spring of 1891, the mine had produced several ingots of tin. In April of that year, when President Benjamin Harrison toured Southern California, his train stopped near the mines, and the president's picture was taken with a tin-ingot monument some twelve feet high.

Undoubtedly, this helped to bolster the investment money that continued to arrive from England. Called the "American Cornwall," the Temescal Tin Mines continued to produce high-quality tin for the next few years. Throughout these years, though, an increasing number of mining experts predicted that either the Temescal mines had reached their end or were very near to it. It therefore became more difficult to raise money due to these predictions. Workers were laid off by the score, and by mid-1893, mining functions had ceased at Temescal.

It was soon discovered that while the area had some very rich deposits of tin, those deposits were few in number and certainly not enough to warrant

The Temescal Tin Mines. *Photo courtesy of the Heritage Room, Corona Public Library.*

spending large amounts of money on improvements such as tunnels, reduction machines and milling equipment. Although the amount of tin produced at the Temescal Tin Mines was substantial when compared to tin production in the rest of the United States, when compared worldwide to such countries as England, Bolivia and Australia, the amount produced at Temescal was minuscule. However, during the 1880s and 1890s, there was great pandemonium in the British financial circles, with scams of one sort or another appearing almost daily. It was not too difficult, therefore, to find investors willing to part with some money to invest in a scheme that had the potential to become a serious threat to the dominance of the English tin market if all of the vastly inflated propaganda had been true.

CALIFORNIA SILK CENTER ASSOCIATION

Although the Temescal Tin Mines were in operation at various times over a roughly thirty-year period, their influence on the overall history of the county is slight. Ironically, though, one venture to the northeast of the mines would have a definite lasting effect, although the venture never grew beyond the initial planning stages.

In the mid-1860s, Californians were beginning to look to silk production as another potential boom industry. The man behind much of this speculation was a Frenchman named Louis Prevost, who had immigrated

to the San Jose area of Northern California from France. He was born in
Reux in Normandy on August 9, 1807. Raised in the silk business of his
native France, he wished to see his adopted country compete in the very
popular silk trade. When he arrived in San Jose in 1852, he believed that
he had found the perfect location for growing the essential commodity in
sericulture: mulberry trees. He planted twenty-five thousand trees, raised
them and imported what proved to be bad silkworm eggs from China. After
unsuccessfully trying three separate shipments, he burned the majority of
his trees.[172]

Before destroying his last trees, though, he did acquire healthy eggs from
his native France. These proved to be a big success, and subsequent attempts
with more trees and eggs proved equally successful. His business increased
greatly until the early 1860s, when it gained further momentum due to an
epidemic that all but decimated silk culture in Europe. Because of his great
success, Prevost expanded his operation southward, by starting a mulberry
tree nursery near Los Angeles.

By this time, California was already in the throes of a silk boom,
brought about in 1866 by the state legislature enacting bounties for the
production of silk. The bounty law, which empowered the state to pay
the enormous sums of $250 for each five thousand planted mulberry
trees and $300 for every one thousand silk cocoons, was making quick
converts of people to the art of sericulture. This in turn led to the
speculative planting of thousands of trees, most of which were planted
in unbearable conditions and would never see a silkworm cocoon. At a
time when one thousand cocoons could net a mere $2 on the silk market,
the state was obviously headed for financial trouble.

With the Los Angeles nursery established, Prevost saw firsthand the many
trees being planted purely on speculation. He believed that speculation
merely for the state-sponsored bounty, with no means of processing the silk,
would result in the demise of the sericulture industry. He therefore began to
develop a scheme to alleviate this problem and hopefully show the world that
California was an excellent location for sericulture. Under his direction, he
would establish a colony of people interested in silk production somewhere
in Southern California. Investors in the colony scheme would oversee the
planting of mulberry trees, the construction of an irrigation system for them
and the importation of silk eggs. Within a few years, they would be able to
produce what would be, in his opinion, some of the finest silk in the world.
To assist in this venture, he would train Indian women in the delicate task
of unraveling the fragile, single-thread cocoons. Convinced his idea had

little chance of failing, he began looking for someone he could convince to back the proposition financially. He found such a person in Thomas Wells Cover, who had come to California in 1868 from the mining districts of Montana. Having made a rather substantial fortune in mining, Cover came to California seeking a means to invest his money. Prevost approached Cover about his plan, and Cover agreed to supply the capital that was so desperately needed.

The colony venture, thought Prevost and Cover, was sure to be a success. The two men immediately began to search for both colonists/investors and potential sites for the colony. Two factors weighed heavily in any decision they were to make. First, any land they acquired had to be suitable for the necessary mulberry trees that would hold the cocoons. Second, it needed a secure water source to irrigate the trees. In addition, the area had to be close to Los Angeles, the only city in Southern California through which they could export their end product. They found a potential home for their colony on the eastern portion of the Jurupa Rancho and the government lands directly south of the rancho, a two-day trip east of Los Angeles. This area appealed to them for a number of reasons. First, it was very close to the Santa Ana River, from which they could take water almost year round. Cover, who had spent many years in Montana planning and working with canals for mining purposes, felt that the area could possibly be irrigated by a canal from the river. Second, the site was only about sixty miles from Los Angeles.

Because the site met their qualifications, it was soon decided to secure the land for a colony venture. The first order of business would be to affix the water right. On June 17, 1869, under the name of the "Silk City Land Association," Prevost and Cover, joined by colonists Thomas Garey (of later Southern California fame), George J. Clark, Henry Hamilton, J.H. Stewart, S.D. Potter, Dudley Pine, J.S. Bright, Louis D. Combe and Moses Martin, submitted a formal application to the San Bernardino Water Commissioner, asking

> to obtain the right of water from a point ¼ of a mile below the crossing of the Santa Ana River by the Temecula Road [roughly the present-day La Cadena Road] lying immediately south of the Agua Mansa, thence around the base of the mountain [the present-day La Loma Hills in Colton] through the most eligible route…for the purpose of irrigating 9 or more Sections of land.[173]

The Early American Period

Starting just a few days later, on June 21, 1869, twenty-seven people filed Possessory Claims over a twelve-day period with the San Bernardino county recorder for a total of 4,320 acres of the government land or just under seven sections (square miles) of land. The claims filed were for land extending between the southernmost boundary of the Jurupa Rancho and the northernmost boundary of the Hartshorn Tract (present-day Jurupa Avenue and Arlington Avenue, respectively) and stretched from Pachappa Hill, which for many years stood as a natural boundary marker, to the area around the present-day Riverside Airport.[174] On December 27, 1869, apparently acting for himself, Tom Cover purchased approximately 2,600 acres of the Jurupa (Robidoux) Rancho to the north.[175] In addition, on April 22, 1870, the association purchased for $7,924.71 what was said to be 3,169.88 acres of land of the Jurupa Rancho from Alfred Robinson, acting as trustee for Abel Stearns.[176] All together, this gave the group possession of nearly 10,100 acres of land.

With water rights secured and the land and investors needed to start the colony, it seemed as though the dream of mass-producing silk in Southern California was about to come to fruition. At this point, though, the fortunes of the fledgling colony came to an abrupt halt. In late July 1869, only about a month after the possessory claims were filed, Prevost contracted typhoid fever. Two weeks later, when his condition worsened, he was removed to his estate in San Jose, where he succumbed to the fever on August 16. When news of Prevost's death reached the colonists, they came to the stark realization that they were left without the one individual who knew anything about sericulture. Not only that, but the state was also realizing that the bounties it had adopted three years earlier were about to bankrupt it.

The idea of founding a sericulture colony was therefore abandoned. Because Cover had been the financier for the venture, he became the de facto leader of the colonists. They elected to liquidate the assets of the colony, empowering Cover to sell the land for $60,000. Although the subsequent records are scarce, it seems as though Cover at first had few takers for the property that was still in many people's minds too far inland to be of any use or value. However, the group of investors was willing to hold out so that the members could get a substantial return on what they had invested.

In what seems an unlikely move given the circumstances, the remaining investors incorporated as the "California Silk Center Association, Prevost Selection,"[177] on November 19, 1869. The articles of incorporation indicated $250,000 in capital stock and that the corporation had been formed "for the purpose of irrigation for mining and manufacturing purposes, the

waters of the Santa Ana River to be conducted by means of a canal to their property."[178] This incorporation may have been done to protect the investors in the sale of the land, solidify their water right or both. In any case, the purpose of the association—that of irrigating for mining and manufacturing purposes—was vastly different from their initial purpose.

With the demise of the silk venture yet incorporation of the Silk Center Association, Cover began searching in earnest for someone to purchase his lands. At the time, it was felt that with the completion of the transcontinental railroad and the movement to bring another main line through Southern California, the investors would be able to get a handsome return for their lands if they could wait. When most of the investors returned to their respective homes, Cover went to the most likely place to find buyers: Los Angeles. It was in Los Angeles that he would meet up with a party led by John North and negotiate a deal for the land that would eventually become Riverside.

The first one hundred years of non-Indian occupation of the lands that eventually would become Riverside County were a time of varying needs and roles. Spanish and Mexican occupation was primarily interested in populating the land in order to maintain control while keeping foreigners from overtaking the area. American occupation revolved more around resource exploitation—mining, timbering, et cetera. From 1772 to 1870, very few residents took up lands within the area. That would change drastically over the next fifty years, as the immigrant roads were used to a greater degree and then the railroad brought a huge influx of people cheaply and easily.

APPENDIX A
LISTING OF ANZA'S PLACE NAMES WITH CORRESPONDING PRESENT-DAY PLACE NAMES

Puerto de San Carlos = Coyote Canyon
This was where Anza entered Riverside County.

Laguna de Principe = Dry Lake

Cañada de San Patricio = Bautista Canyon

Arroyo de San Jose = San Jacinto Valley
Apparently, Anza considered the entire area stretching from the present-day San Jacinto Valley to the Santa Ana River as the Arroyo de San Jose.

Laguna de San Antonio de Bucarelli = Mystic Lake

Rio Santa Ana = Santa Ana River
This name was already in place when Anza came through.

Appendix B
Captain José Romero's Letter to Don Antonio Narbona, January 16, 1824

Excerpted from Justin G Turner's "The First Letter from Palm Springs: The José Romero Story." Historical Society of Southern California Quarterly *57, no. 2 (Summer 1974): 123–34.*

In an official letter of July 7, 1823, I sent you an account by special messenger via Loreto, charging that Government to forward the report I addressed to you so that it would reach your hands. In it I give you an account of all my journey, along with the Diary of the incidents of said passage. In another of the 19th of August last past, I reported to you through the same Loreto arrangement, that the Lord Governor of Alta California, Don Luis de Argüello, had called me to come to the Capital at Monterey to confer with the said Governor regarding my task.

And having discussed everything, we agreed that with forty men of this Province of Alta California in charge of the Lieutenant of the Presidio of San Diego, Don Jose Maria Estudillo, I would return to my province. And having departed from that capital in the month of October, I waited until the 15th of December, when, having joined the forty auxiliaries I started on the José Cocomarcopa Trail, as you had advised me during my stay at your headquarters.

And having traveled a ways, guided by a Christian Indian from the Mission of San Juan Capistrano, he gave us another, opposite direction to the road we should have taken. And after traveling for three days without water for the horses, we decided to turn back, because all the horses were in

no condition to travel any further, and we knew not what lay ahead of us; for not even the guide knew where he was, thus we had to turn back to a place where we arrived after three days. After having lost a number of horses for lack of water, which for drinking we did not reach for six days, although on the second day of our return it rained some, with which the animals were able to moisten their mouths a little, and got to drink some after six days, as I have related.

And finding myself at this place amid villages of friendly heathens named Cahuillas, I have availed myself of one of them to take this report to you, paying him for his trouble so that by this means and by that of the Cocomaricopas, you may be informed of our lot, for not having received any answer from you, I fear that none of my reports have reached you, much less, do you know of our whereabouts.

By means of the same bearer of this, I am sending word to José Cocomaricopa to come with his people by the March moon, and I am retiring to the Mission of San Gabriel to replenish my horses and to join Captain Don Pablo de la Portilla of the Mazatlan Squadron, who is stationed with one hundred men at the Presidio of San Diego and is planning to retire next April. And I hope that you will exert your influence so that, by speeding the arrival of José Cocomaricopa, we may have some one to guide us in returning to our province. And in case he does not come I will still make my return with the said Captain, either via the lower Rio Colorado through all the Nations, which is where they robbed us, or by way of the trail of the old expeditions.

But if the said Captain has other plans, I cannot set out unless the Indian Cocomaricopa comes with his people; for these trails are very scarce of water and the horses cannot endure this and this would mean we would perish from thirst.

The bearer of this has instructions to await an answer, which I would appreciate your sending as soon as possible. For in this land they have had three years of drought and all of the horses are dying from malnutrition. This is the cause of our having been delayed on this trip, and having had to turn back in order to rest our horses.

All of which I report to you for your superior information and final decision.

May God keep you many years,
Watering place of the planting fields of the Cahuillas, January 16, 1824.
José Romero

APPENDIX C
LOUIS ROBIDOUX'S LETTER TO MANUEL ALVAREZ, GIVING ROBIDOUX'S ACCOUNT OF THE BATTLE OF CHINO

Excerpted from Oral Messmore Robidoux's Memorial to the Robidoux Brothers *(Kansas City, MO: Smith-Grieves Company, 1924), 219–21.*

California, May 1st, 1848

Sr. D. Manuel Alvarez:

My dear sir and friend, whom I esteem...From the beginning of hostilities between the two nations I was a prisoner of war. On the 25th of September, 1846, we met in my house and my neighbor's Don Benjamin Wilson's (18 strangers), to defend ourselves at any cost, because the shout of insurrection had already resounded everywhere, and rumor was that they would spare not the life of any stranger. The day after our meeting we went to the ranch of Chino, which is 6 leagues distant from my house; Don Juan Rowland was one of our warriors, and also four or five other additional strangers whom we met at said ranch. Our intention was to continue as far as the town of Los Angeles, if possible, in order to join the small American force which was stationed there, but the enemy did not relish this reunion, we were attacked the next day, that is on the 27th of September, by a force superior to ours, to which we had to surrender at discretion after a struggle of an hour. The enemy assaulted the house in which we were fortified with so much furor and valor that, in the twinkling of an eye, as they say, set it on fire on every side with so much celerity that we had no alternative but to surrender or be burned alive. We did that to our regret. From that moment I lost my liberty.

The enemy numbered 200 men; we, with little ammunition and victuals, our opponents with plenty of war material, and the camp was theirs. We were then presented to the general, D. Jose Ma. Flores, a military officer of the Mexican army, a man of superior attainments and courage, although many say he is a coward and a tyrant; but, according to my way of seeing, I believe in good faith, that he has during the whole period of the insurrection, acted with prudence, and that he has behaved as a good soldier. It seems to me that every man who embraces the military calling sees after a name and riches, etc., etc.

This same Flores whom I have just praised had made up his mind to send us as far as the Capital of Mexico for the purpose of giving more weight to his exploits, or still better, to the drafts he had issued upon the government. But everything was frustrated, as you will see further on. There was at the time a party which always spied him, embarrassed his plans, and opposed, when necessary, his individual views. This same party, realizing that our departure was against the general interest of the Californios and for fear also of reprisals from the Americans, formed an opposition against him and continued the plan, with the aid of us, the prisoners, that is, with our money, of turning him down from the position, a thing that happened on the eve of the day when we were about to start for the Capitol. This intrigue relieved us from a very long walk, and perhaps saved our lives. Sometime after he was allowed to again assume the command, but on condition that the prisoners would not have to go out of California. Before this happened, we had received orders to prepare to go out of the Territory and that we should make some determination of our property as well as of our families.

This command fell upon us like a bolt of lightning from heaven. A very great sorrow took hold of us all, so much so that Don Juan Rowland frequently said, "cut off a leg from me and let me stay with my family." But his clamor was useless, no heart was softened in our behalf; it was the same as if we had spoken to the rocks; for my part I always remembered the poor Texans and their sufferings who went afoot from New Mexico to the Capital, the half of whom died on the road, such being my information, as much on account of the ill treatment they received as for lack of food. But fortune, or rather the Supreme Being, who always remembers His good children when He is implored, determined otherwise and turned to naught the calculations of the ambitious who thirst after fame and riches at the cost of human life and blood.

APPENDIX D
MEXICAN RANCHO LAND GRANTS OF RIVERSIDE COUNTY, CALIFORNIA

Adapted from W.W. Robinson's The Story of Riverside County *(N.p.: Title Insurance and Trust Company, 1957).*

JURUPA (Rubidoux):

Granted:	September 28, 1838, by Governor Juan B. Alvarado to Juan Bandini
Patented:	December 8, 1876, to Louis Rubideau
Area:	6,749.99 acres (the smaller part of the 7-square-league grant to Bandini)

JURUPA (Stearns), partly in San Bernardino County:

Granted:	September 28, 1838, by Governor Juan B. Alvarado to Juan Bandini
Patented:	May 23, 1879, to Abel Stearns
Area:	25,509.17 acres (the larger part of the 7-square-league grant to Bandini which totaled 32,259.16 acres)

EL RINCON, partly in San Bernardino County:

Granted:	April 8, 1839, by Governor Juan B. Alvarado to Juan Bandini
Patented:	November 14, 1879, to Bernardo Yorba
Area:	4,431.47 acres

APPENDIX D

SAN JACINTO VIEJO:

Granted: December 21, 1842, by Governor Pro Tem Manuel Jimeno
 (Casarin) to Jose Antonio Estudillo
Patented: January 17, 1888, to the heirs of Jose Antonio Estudillo
Area: 35,503.03 acres

TRACT BETWEEN SAN JACINTO AND SAN GORGONIO:

Granted: March 22, 1843, by Governor Manuel Micheltorena to
 Santiago Johnson
Patented: August 13, 1872, to Louis Rubideau
Area: 4,439.57 acres

LA LAGUNA (Stearns):

Granted: June 7, 1844, by Governor Manuel Micheltorena to Julian
 Manriquez
Patented: September 3, 1872, to Abel Stearns
Area: 13,338.80 acres

PAUBA:

Granted: First on November 9, 1844, by Governor Manuel Micheltorena
 to Vicente Moraga and second on February 4, 1846, by
 Governor Pio Pico to Vicente Moraga and Luis Aranes
Patented: January 19, 1860, to Luis Vignes
Area: 26,597.96 acres

TEMECULA:

Granted: December 14, 1844, by Governor Manuel Micbeltorena to
 Felix Valdez
Patented: January 18, 1860, to Luis Vignes
Area: 26,608.94 acres

POTRERO DE LA CIENEGA:

Granted: April 5, 1845, by Governor Pio Pico to Juan Forster, one
 of three mountain "Potreros of San Juan Capistrano" (two
 being in Riverside County, the third in Orange County)
Patented: June 30, 1866, to Juan Forster
Acreage: 477.25 acres

POTRERO EL CARISO (or CARIZO):
Granted: April 5, 1845, by Governor Pio Pico to Juan Forster, one
 of three mountain "Potreros of San Juan Capistrano" (two
 being in Riverside County, the third in Orange County)
Patented: June 30, 1866, to Juan Forster
Acreage: 167.51 acres

LITTLE TEMECULA:
Granted: May 7, 1845, by Governor Pio Pico to Pablo Apis
Patented: January 8, 1873, to Maria A. Apis, et al.
Area: 2,233.42 acres

SAN JACINTO NUEVO Y POTRERO:
Granted: January 14, 1846, by Governor Pio Pico to Miguel de Pedrorena
Patented: January 9, 1883, to Thomas W Sutherland, guardian of
 Victoria, Isabel, Miguel and Helen Pedrorena, minor children
 of Miguel de Pedrorena and of Maria Antonia Estudillo de
 Pedrorena, his wife
Area: 48,861.10 acres

SANTA ROSA (Moreno):
Granted: January 30, 1846, by Governor Pio Pico to Juan Moreno
Patented: October 10, 1872, to Juan Moreno
Area: 47,815.10 acres

SOBRANTE DE SAN JACINTO:
Granted: May 9, 1846, by Governor Pio Pico to Maria del Rosario
 Estudillo de Aguirre
Patented: October 26, 1867, to Maria del Rosario de Aguirre
Area: 48,847.28 acres

LA SIERRA (Sepulveda):
Granted: June 15, 1846, by Governor Pio Pico to Vicente Sepulveda
Patented: April 28, 1877, to Vicente Sepulveda
Area: 17,774.19 acres

LA SIERRA (Yorba):
Granted: June 15, 1846, by Governor Pio Pico to Bernardo Yorba
Patented: February 4, 1875, to Bernardo Yorba
Area: 17,786.89 acres

Appendix D

Unofficial Ranchos

Temescal Rancho
San Gorgonio Rancho

APPENDIX E
THE TOWNSHIP AND RANGE SYSTEM OF SURVEYING

E ver since the western "frontier" of the United States has been what is presently the state of Ohio, the U.S. government has relied on the Township and Range method of surveying lands. This system is based on two main lines being set up: the baseline, which runs east to west, and the meridian, which runs north to south. From these two main lines spanned a series of townships, both north and south of the baseline and east and west of the meridian.

A township is an area of thirty-six square miles, six miles on a side. Each of the thirty-six square miles is in turn called a section. The sections are numbered in a zigzag pattern, since that is how they were laid out when initially surveyed. The diagram below shows a surveyed township:

6	5	4	3	2	1
7	8	9	10	11	12
18	17	16	15	14	13
19	20	21	22	23	24
30	29	28	27	26	25
31	32	33	34	35	36

Each numbered section is one square mile, which is equal to 640 acres. These sections were in turn divided, usually by quarters, to arrive at parcels of 160, 40 or 10 acres, although several other subdivision possibilities were made. Typically, when a person homesteaded a parcel, it was for 40 acres, or a quarter-quarter section, so that his legal description may read, "The northeast quarter of the southwest quarter of Section 1, Township 6 South, Range 4 West, San Bernardino Baseline and Meridian."

The baseline and meridian were lines set up by Colonel Washington. The baseline can be followed today by the street in San Bernardino that is named for it; likewise, east of Hemet is Meridian Road, which also takes its name from its survey function. In reading a description of a parcel, one needs the section number, the township number and the range number. Township numbers were based on how many townships either north or south of the baseline the particular township in question lay. In the example above, "Township 6 South" meant the area starting thirty miles south of the baseline (since there were five townships above it, 5 x 6 = 30). Likewise, the range number was measured east or west of the meridian. Again, in the above example, "Range 4 West," started eighteen miles west of the meridian. To put things in perspective, the above example delineates the eastern portion of the present-day city of Canyon Lake.

APPENDIX F
CHARLES NORDHOFF'S DESCRIPTION OF THE LA LAGUNA RANCHO

Excerpted from Chapter 13 of Nordhoff's California: A Book for Travelers and Settlers *(New York: Harper and Brothers, 1874), 148–54.*

On my way from San Bernardino, I stopped overnight at a large Mexican rancho, the Laguna. Laguna means lake; the house stands, in fact, at one end of a large fresh-water lake, with mountains towering up on all sides. The sheet is about four miles long and three wide; it has a border of perhaps half a mile of arable land on the side which I passed over.

We got to Senor M.'s house an hour before sunset, and received at once a grave permission to unsaddle our horses and remain overnight. An Indian came up to take away the horses, which were turned into a pasture lot to shift for themselves; receiving a little barley in the evening and next morning. As for myself, I looked around with some curiosity, for this was the first time I had had an opportunity to see how the old Californians of wealth live.

Senor M. is reputed to possess 40,000 acres of land. He told me that he had sold last fall 1800 young colts at six dollars per head. He owns several thousand sheep; as to cattle, he could not tell till after the *rodeo* how many there were. The *rodeo* is the annual gathering of cattle, when the owners in a large district drive all the stock into one great plain, and each with his vacqueros, picks out his own cows, withdraws them into a separate herd, brands the calves which innocently follow their mothers, and then turns the whole mass adrift again, or in some cases drives them home to his own land.

Senor M. is therefore a person of substance; he is a man above middle height, a little corpulent, forty-five years of age, a little grizzled, and grave with all the gravity of the Spaniard. He politely invited us into the house; but seeing my inclination to remain out-of-doors, where a magnificent sunset was making rosy the western mountain tops, he gravely and silently brought out chairs for us. As for himself, he leaned up against the house, and looked at my curiosity with mild contempt.

I offered him a rather good cigar, whereupon he became a little communicative. He had worked hard, he said, but he was now getting old, and took it easy.

"Could he find a grizzly bear for me in the mountains?"

"Well, yes, he could; but be was not fond of grizzly bears; one had come down among a flock of his sheep, a mile off, the night before, but the herder had driven it off; it was a bad beast; he used to hunt them when he was younger; but now"—and he shrugged his shoulders.

"Yes, he had Indians"—seeing me look at several who were skylarking about the place, catching each other with lassos—"they are useful people; not good for much"; he added, "but quiet"; be paid them fifteen dollars a mouth; and they bought what they needed at his store.

You must understand that in California parlance a man "has" Indians, but he "is in" sheep, or cattle, or horses.

I remarked that the Laguna was a lovely piece of water.

"Yes," he said, "it will do," with another shrug. He had had a boat, but nobody took care of it, and it rotted away. A flock of wild ducks took advantage of this circumstance to sail about under our noses, at such a prudent distance from the shore as made it mere murder for me to shoot them, for I should have had to swim out to get what I had shot.

I looked into his garden, where he had half an acre of young grape-vines, two or three dozen young apple and orange trees, and a small orchard of young English walnuts, set out much too close together. I undertook to admire this moderate collection in horticulture, whereupon at last the grave Spaniard relented a little.

"Yes," he said, with a mild shrug, "it is very well; the garden is growing; it is not much; but I am *muy contente*"—well satisfied. "What do I want more?" he asked, with a kind of grave scorn; "I am well; I have enough; I owe nobody money; if any body comes to buy of me he must bring me the money in his hand"; here Don M.'s countenance looked a little implacable. "I am not afraid to die," he added; "only I don't want to be sick. *Muy contente*," he repeated, in his gentle and careless

voice, several times, to impress it upon my ears, which are unaccustomed to Spanish.

Presently, a fire being made upon the hearth in the sitting-room, and night falling upon us in that noiseless way with which the dark comes on in this country, where no chirruping or humming insects are heard, we walked in and sat down.

And now you shall hear how this contented man of great wealth lived. The house was of adobe, which, as you know, is a sun-dried brick. It was an oblong, and contained three rooms. The front room was the store or shop, where he dealt out calicoes, sugar, coffee, and other dry goods and groceries, besides grape-brandy, to his Indians and any others who chose to come. The next room, which had no windows, contained two beds, in which his three young boys slept. It contained, also, the materials for the family sewing and a closet. The third room, which held Senor M.'s bed and a fire-place, was also our dining-room; and here, presently, a coarse but clean cloth was spread, and three women and a little girl began to lay the table and serve the supper.

At one side of the house a small room had been built on for a kitchen; opposite to that was a capacious store-room, in which hung "*carne seco*," jerked beef, from the rafters—bloody sheets of meat which looked unfit to eat, but which make a savory stew; while on the floor two or three young lambs were confined, which by-and-by succeeded in getting out, and came bleating into the dining-room—a quite startling spectacle to us, but evidently indulged playthings.

Beyond the house itself, about fifteen feet distant, was a clay oven for baking bread, covered over with raw bull's hide, the hairy side downward, intended to keep the top dry in case it should rain; and beyond this, a few feet farther off, marking the boundary of what Western people call their "yard," was a range of open shanties, which, on riding up, I had innocently taken for cattle sheds. Here, close to the house, the Indians lived.

Later in the evening, hearing singing and the droning *tum-ti tum-ti* of a stringed instrument, I walked out, and saw how they live. Half a dozen men were sitting around a wood fire, which had been made in the centre of the open shed. They sat on wooden blocks or lounged on the earthen floor; they talked in Indian or in Spanish, as it happened, and at intervals one broke in with a snatch of song, which was taken up by the rest, and swept, not unmusically, through the air, slowly rising and falling away, until there remained only the *tum-ti tum-ti* of the musician, whose instrument was composed of a corn-stalk about thirty inches long, stretching a single string made of lambs' entrails.

"They are poor creatures," said Senor M., with a shrug of his shoulders; "poor creatures, but quiet; not good for much, but useful."

"But where do they sleep?" I asked.

He pointed to a door, which opened into a lightly inclosed [*sic*] shed, which I had imagined to be the chicken-house. In the farther end, truly, the chickens were at roost, but the larger part was floored with poles, on which barley-straw was spread, and here the Indians slept—if they slept—of which, later, I had occasion to entertain some doubts.

Outside of the yard near the house was the wood-heap; near it lay a beef's head, skinned and gory; everywhere except immediately about the house was what we should call careless disorder and litter.

When supper was served, two benches were drawn up to the table, and we three men sat down and helped ourselves to the stew of meat and onions, to excellent bread—but no butter—to a dish of black and red beans, to some fried potatoes, and to coffee or tea as we preferred. Presently came in two boys of thirteen and eleven, and to them was added, in a few minutes more, their mother, stout and healthy-looking, as is the habit of the Californian Spanish women. She took one end of the table and drew a chair to her side for a lad of eight years, her youngest, who ate out of her plate, drank coffee out of her cup, and was indulged with sundry hugs and kisses during the meal. Later dropped in a young woman—a poor relation, probably—and a little girl who held the same situation. After the manner of poor relations, they spoke in whispers, sat uneasily on their chairs, and finished their meal sooner than the rest of us.

I presently discovered that two of the lads could speak a little English; and after supper they got out their reading-books and slates, and astonished and pleased me by their precision in reading and the readiness of their ciphering. They had, I found, a teacher or tutor, a young Spaniard, to whom our host paid seventeen dollars a month—"and of course a horse and whatever he needs here," he added. This young man had been educated in one of the public schools in this part of the country; and he told me that the youngsters, his pupils, were very quick with their lessons. What is odd, is that while they could read in English with perfect readiness and correctness, they did not understand more than half the words which they pronounced, and could give me but a broken account of their lesson. A very intelligent young teacher; whose school near San Bernardino I visited, told me that it was too often the custom in the public schools to teach the Spanish children to spell and read merely by rote, and that they are so quick at learning as to satisfy an indolent or careless teacher, without understanding much English.

I find that the Spaniards very generally in this Southern country send their children to the public schools; and they have everywhere the reputation of being very quick to learn. In several schools which I have visited, American and Mexican children attend together, but, for the most part, while the American children acquire Spanish, the others retain only their own tongue. In many cases it is necessary to carry on the school in Spanish; the teacher very commonly, in these Southern counties, understands both languages; and it is not unusual for the children to talk at play in Spanish during the recess, and returning to the school-room to sing together, and with surprising readiness, "My Country, 'tis of Thee," or some other American song.

To return to our supper: my host lit his cigar before he left the table; and, indeed, he did not wait until I had done with my own supper; and we smoked while the table was cleared away. The principal vacquero, a Sonoranian, as they here call the natives of the Mexican province of Sonora—they call a person from Texas a Texanian—came later for his supper; and meanwhile we talked about the schooling of the boys, who were very ingenuous and kindly though evidently much-indulged youngsters.

"Yes," their father said, "they shall be taught; they learn well; I have enough for them; they shall not work with their hands, as I did; they shall labor with their heads. When they are larger I shall send them to a school; and when they are young men I mean to put them into a Jew store, where they will quickly learn how to trade. I mean to make men of them," he said, with pride.

You will laugh at his way of making men of them; but, after all, he had reason for it. Twenty years ago the countrymen of this man owned the whole of California; the land, the cattle, the horses, and sheep were theirs. To-day the majority of them are poor; in fact, very few retain even a part of their old possessions. They were not business men; they liked to live free of care; and they found it easy to borrow money, or to obtain any thing else on credit. They know nothing of interest; even Senor M. to-day probably buries his coin or hides it away in some secure place. As for the most of his fellow land-owners in the old time, they squandered their money; they borrowed at two, three, and five per cent a month; they were ready to have their notes renewed when they fell due, and to borrow more on top of them; and it is said of them that it was perfectly safe to lend them money, for they would pay, if to pay ruined them.

Of course it did ruin them. One great land-holder in Los Angeles County, when his settling day came, was confronted, among a multitude of other

accounts, with a bakers bill (with interest) for $18,000. He paid all, but his children are poor people to-day.

On the other hand, the country merchants with whom they chiefly deal are Jews. They abound all over California, and are justly respected as a highly honorable, fair-dealing, and public-spirited class; and their thrift and prosperity strikes men like Senor M. as something very admirable and enviable.

The style of living I have described, poor and simple as it looks to us, is that usual among the old Spanish or Californian population. Their food is chiefly beef, "*carne seco*" or dried beef, beans, tortillas; which are wheaten or corn cakes, in shape like Scotch scones, and coffee. Senor M. being a careful man, had a cow—I mean a milch cow. His house had a wooden floor; but in Santa Barbara the last Mexican lieutenant-governor lived in an adobe house with an earthen floor, and he was a man of wealth and intelligence. Earthen floors were almost universal in the old times, and are still quite common.

Curious tales are told of the improvidence of the old Californians in their last days. When the Americans from the East rushed into the country on the discovery of gold, cattle suddenly became valuable for their meat; before then only their hides were sold; and I have myself, in 1847, in Monterey, seen a fat steer sold for three dollars to the ship's butcher, who later sold the hide for a dollar, thus receiving the whole carcass for only two dollars. The Yankee demand for beef made the cattle owners suddenly rich, and they made haste to spend what they so easily got. Saddles trimmed with solid silver, spurs of gold, bridles with silver chains, were among the fancies of the men; and a lady in Santa Barbara amused me by describing the old adobe houses, with earthen floors covered with costly rugs; four-post bedsteads with the costliest lace curtains, and these looped up with lace again; and the senora and senoritas dragging trains of massive silk and satin over the earthen floors. It must have been an odd mixture of squalor and splendor.

An adobe house, no matter what is the wealth or condition of the Californian who lives in it, is simply a long range of rooms. It is one story high, has a piazza roof in front, an earthen floor, usually no ceiling, a tile roof, and each room, or all but one in houses where there are grown and unmarried daughters, has a door opening on the verandah.

One room, at the end of the long row, has no outward door, and only a narrow window. In this room it was customary for respectable people in a town like Los Angeles to lock up their unmarried but marriageable daughters about sunset, to preserve them from the temptation of young men—a custom which, curiously enough, did not prevent weddings.

To return to the Laguna: outside of the palings which inclosed the house, the Indian quarters, the little orchard, and a pasture-field, roamed cattle and horses at their own sweet will. At night twenty or thirty horses were driven into a large corral, from which the vacqueros chose their riding-beasts the next morning. We smoked and talked until nearly nine o'clock, by which time this excellent family gaped so fearfully that I proposed to retire, and was immediately shown into the store, where a mattress was spread for each of us on the floor, our own blankets, and overcoats serving us for covers. Ventilation, I found, the roof afforded; and it was nearly twelve before the Indians, our neighbors, ceased their chattering and singing. They began again at four; and by five—before daylight—I arose and found these uneasy spirits sitting around the fire talking.

We breakfasted a little before seven, and then went out on the great common to see two vacqueros lasso a wild bull. They very neatly separated the animal from the herd, drove it at full tilt toward us, and, when it threatened to run us down, whizz went the riata, and, though I looked with all my eyes, I saw nothing except that the animal stopped in mid-career, and tumbled over as though it was shot. Thereupon the vacquero coolly got off his horse, first winding the end of the riata about the pommel of his saddle, and then I saw the most curious part of the whole business. The horse, a mere pony, stood with his fore legs planted firmly, and a very knowing look in his eyes. Presently the bull began to struggle; he managed by a sudden motion to raise himself half erect; but the horse quietly took a step backward, tightened the rope, and down went the bull, helpless. This was repeated several times, till I did not know which most to admire, the horse, or the man who had so thoroughly taught it.

Appendix G
George Wharton James's Description of Bradshaw's Road from the Colorado River to Dos Palmas

Excerpted from James's Wonders of the Colorado Desert *(N.p., 1906), 425–28).* NOTE: James refers to Bradshaw's Road as the Chuckwalla Road.

Leaving the river now, with canteen filled, we are soon on the Chuckwalla road. At night we sleep on the roadside, with a fine camp-fire of palo verde wood to keep us warm through the night. What a lonely road this is! It is a true desert road. Dipping into a wide valley flanked by blue mountains, on the far horizon a group of saw-toothed mountains stand which seem to remain at the same distance all day, though we trudge bravely along. Now we are wading through deep sand, then on hard gravel, while the surrounding country is covered with black, igneous rock as if it had recently been scorched by a fearful fire. There is no animal life in sight, save an occasional lizard. The signs of death are everywhere in the bones of horses and cattle, and the dried-up horns of mountain-sheep. Yonder lies a roughly made pack-saddle telling its own story of a straying burro, and possibly of the wandering prospector following on and on to his death. The noon hour is passed and there is no sign as yet of the Chuckwalla well. Surely we cannot have passed it. The road is well marked and we were assured that it would certainly lead to water, so we push on. Soon a change in the appearance of the country delights us. It is less barren and desolate. A trifle of green vegetation appears, to be more common later on; palo verde trees chopped with an axe are a good sign; and then a rock-wall and a tumbled-down rock-cabin appear at the foot of the hill before us, and on our arrival we find

a rock-walled well, half hidden by mesquite bushes. This is the long-desired Chuckwalla well.

Here there comes over us the sadness of the desert. There are times when the desert seems to stir body and soul to joyful existence which finds expression in quickened steps and the lifting of the voice in song—to the amazement of the lizard and curious horned toad. But over certain localities there seems to hover the spirit of sadness and the soul is touched by the somber chords of past events that are still vibrating in the air. On the low hill, opposite the well, are two graves, covered with rocks to keep the coyotes from getting to the bodies. There are no crosses, no headboards,—they are nameless graves. And yet we seem to know the whole story. The mind instinctively goes back to the days when wagons were banded together to be prepared for the attacks of bad Indians and worse white men and Mexicans, for the legends of the Chuckwalla trail are filled with stories of surprises, conflicts, and cruel deaths.

Before leaving the well we fill up our canteens to the very muzzle for forty miles' stretch before us. Forty long, weary, desolate miles—at least the first large portion of it is desolate, and though we draw upon their contents often, the canteens grow very heavy to the shoulders before that long stretch is over. At last we rise to the crest of the plateau, and joy! there before us rises the blue line of the glorious San Jacinto Mountains, seventy miles away. As the night sinks, a roadside camp-fire is made and we sleep the sleep of the healthily weary. No need of an alarm-clock to awaken us; we are up before the sun and as rapidly as we can, though it seems slowly enough, we begin to descend the long mesa, and cross the wide sand-wash that leads us into the Salton Basin. Sandstone formations of fantastic shape attract the eye and tell of the power of atmospheric agencies, fierce wind and sand storms and the dashing of cloudbursts and mountain torrents. For this is a region where the elements often battle. It is nothing rare in the rainy season—which is generally in August or early September if it occurs at all—for a torrential rainfall to flood this country in a couple of hours and send masses of water, scouring out gullies and washes, down into the Salton Sink, there to be evaporated in a few short hours or days.

Soon we reach the approach to Canyon Spring, but it is closed to us, not by an angel with a flaming sword, but by a dead horse, whose fly-covered carcass blockades the narrow entrance and forbids our reaching the water. But our canteens still contain a little of the precious fluid, and the dead creature suggests that perhaps the water has earned its reputation of being arsenical, as well as bitter and nauseating with alkali…Our canteens hang

empty on our shoulders. There is no more danger of thirst, for in the morning, only a few miles farther on, are palms rising out of the desert, telling of the presence of an oasis where there is an abundance of water. It is Dos Palmas, well-loved spot of desert teamsters and prospectors; the old stagestation, where two springs supply an abundance of good water so that animals and men can drink all they desire without fee. Without this fine supply of water it seems as if the Chuckwalla trail, with its long weary miles, could never have been traveled for here barrels and canteens for animals and men were filled thus assuring the needful supply. A small shack, which serves as bedroom, parlor, sitting-room, dining-room, kitchen, hall, reception and smoking room, stands close by the spring, which is surrounded by beautiful trees, carrizo, grass, and flowers to which it gives life.

NOTES

Chapter 1

1. The exception to this pattern is the Halchidoma people, who lived in what is now the Palo Verde Valley and did practice some agriculture along the Colorado River.

2. Bolanos named California for the island homeland of Amazons, ruled by Queen Califia, about whom he read in a novel.

3. The first expedition missed Monterey Bay but discovered San Francisco Bay on November 2, 1769.

4. Many early accounts credit Fages with "discovering" the Cajon Pass. While it is true that he was the first European immigrant to do so, the pass had been used as a trading route by Indians between Southern California and the Great Basin Region for centuries.

5. Tubac is currently located in southern Arizona, south of Tucson.

6. Right before the expedition was to start, Anza was introduced to Sebastian Tarabal, a runaway Indian who fled from San Gabriel and had come all the way to Sonora via an overland route. Anza asked Tarabal to accompany him as a guide, but in the field, Tarabal proved inconsistent and ineffectual in that capacity. It has later been postulated that Tarabal spent most of his original journey lost and that it was only by sheer luck that he arrived in Sonora. At Sonora, he was captured by the Yumans and taken to Tubac, where they hoped to receive a reward for him.

7. These diaries lay almost forgotten for 150 years, until Dr. Herbert Eugene Bolton of the University of California spent several years reviewing them and retracing Anza's steps on horseback. Many of his travels through Riverside County occurred in the early 1920s and, according to him, resulted in the renaming of the Cahuilla Plains to the Anza Valley, as it is known today. Before Dr. Bolton's work, many writers (including Beattie and Guinn) assumed that Anza's party

had traveled through the Coachella Valley, the San Gorgonio Pass, into the San Bernardino Valley, and then to San Gabriel. This was shown otherwise in Dr. Bolton's research and the publication of his monumental, five-volume *Anza's California Expeditions* in 1930. All of the references to Anza's diaries are taken verbatim from Dr. Bolton's work.

8. For a complete list of Anza's place names compared with modern-day ones, see Appendix A.

9. Bolton, *Anza's California Expedition*, vol. II, 88–90.

10. Ibid., 90–91.

11. While the Anza Valley was named for Juan Bautista de Anza, Bautista Canyon and Creek were not. They were named much later to honor Juan Bautista, a long-time leader of the Cahuilla Indians.

12. Bolton, *Anza's California Expedition*, vol. II, 91–92.

13. Ibid., 92–93.

14. Ibid., 93–94.

15. Ibid., 94–95.

16. A quick glance at a map of Southern California's missions will show that a third mission, that of San Juan Capistrano, was also very close to the boundaries of Riverside County. However, while the fathers at San Juan Capistrano verbally laid claim to lands within Riverside County, most notably the Temescal Canyon, it seems nothing was ever done on their part to secure this claim. Therefore, when Mission San Luis Rey was established, mission officials there filled the void.

Chapter 2

17. Gould, "Indians and Pioneers," 233–34.

18. Harley, "Two Asistencias?" 14, 57. Harley does indicate that the precise date is conjecture. May 20 is St. Bernardine's day, which makes that date seem logical but does not verify it conclusively.

19. Ibid., 15. These buildings at San Bernardino were not the "Asistencia" we know today. The original San Bernardino Rancho buildings were approximately one and a half miles west-northwest of the present-day Asistencia, on Barton Road. The current location of the Asistencia was not used until the late 1820s, when Father Sanchez, as priest at San Gabriel, recommended the use of what became known as "Barton" hill for the mission's building. While on the subject, it must be noted too that San Bernardino was never an asistencia. Although later writers have referred to the present-day structure as either the San Bernardino "Mission" or "Asistencia," neither is correct. In his exhaustive research on the subject, Dr. Harley explains that while the building is commonly called the "Asistencia," it was little more than what was termed an "estancia," or rancho with a chapel-type of structure but with no regular service conducted on-site. There were later proposals to upgrade the

San Bernardino Rancho to either an asistencia or even a full mission, but neither of those was enacted.

20. According to the online edition of the *Catholic Encyclopedia*, Saint Gorgonius was a "Martyr, suffered in 304 at Nicomedia during the persecution of Diocletian. Gorgonius held a high position in the household of the emperor, and had often been entrusted with matters of the greatest importance. At the breaking out of the persecution he was consequently among the first to be charged, and, remaining constant in the profession of the Faith, was with his companions, Dorotheus, Peter and several others, subjected to the most frightful torments and finally strangled. Diocletian, determined that their bodies should not receive the extraordinary honours which the early Christians were wont to pay the relics of the martyrs (honours so great as to occasion the charge of idolatry), ordered them to be thrown into the sea. The Christians nevertheless obtained possession of them, and later the body of Gorgonius was carried to Rome, whence in the eighth century it was translated by St. Chrodegang, Bishop of Metz, and enshrined in the monastery of Gorze. Many French churches obtained portions of the saint's body from Gorze, but in the general pillage of the French Revolution, most of these relics were lost. Our chief sources of information regarding these martyrs are Lactantius and Eusebius. Their feast is kept on 9 Sept. There are five other martyrs of this name venerated in the Church. The first is venerated at Nice on 10 March; the second, martyred at Antioch, is commemorated on 11 March; the third, martyred at Rome, is honoured at Tours on 11 March; the fourth, martyred at Nicomedia, is reverenced in the East on 12 March; while the fifth is one of the Forty Martyrs of Sebaste, whose feast is kept 10 March." http://www.newadvent.org/cathen/06651b.htm.

21. On December 5, 1827, Father Jose Sanchez, while compiling the Mission San Gabriel's valuation, wrote the following in regards to the extent of that mission's lands: "At a distance of about fifteen leagues is...Jorupet, [Jurupa] while the distance to San Bernardino is about twenty leagues. In the same direction is the place called San Gorgonio, about twenty-seven leagues distant." Engelhardt, *Mission San Gabriel*, 141.

22. For most of the period covered by the present work, the area we know as the Salton Sea was simply a great salt flat, possessing almost pure, edible salt. This depression held sea water at one time and had been part of the Gulf of California. At some point in time, the shifting sands deposited by the Colorado River closed the southern end of the depression and formed a large inland sea. This sea evaporated, leaving the salt behind. As the Colorado River continued to shift, every few centuries it would turn westward and fill the depression, only to shift again years later to the Gulf of California. Thus, an intermittent sea was created. Evidence of this sea is outlined on the rocks throughout the southern portion of the Coachella Valley. Throughout the 120 years covered by the present

work, though, the area was simply a dry salt flat. It would not be until 1906 until the Salton Sea, in its present form, would be created.

23. Guinn, "Las Salinas," 169.
24. McAdams, "Early History," 55–56.
25. Engelhardt, *Mission San Gabriel*, 141.
26. In looking at a map of this route, one observes that this is not a direct route to San Bernardino—the more efficient route would be to head east from the Pomona area through the San Bernardino Valley and then into San Bernardino itself. However, it must be remembered that travelers at that time had to rely on good sources of water and feed for their draft animals. Many early accounts refer to the "Cucamonga desert," indicating that water there was not as plentiful as it was along the Santa Ana River. Keeping these points in mind, it becomes clear why the earliest travelers would have opted for the Chino Hills–Santa Ana River–San Bernardino route as the preferable one.
27. Garner, *Arcadia*, 3.
28. Lasuén, *Writings*, 225.
29. McCown, "Temekun," 8.
30. The original Indian name for the San Jacinto Rancho area was Jaguara.
31. Harley, "Two Asistencias?" 19. This rather late date seems correct given San Jacinto's distance from the mission.
32. Gunther, *Riverside County*, 136.
33. Brigandi, personal communication, January 19, 2001.
34. Ellerbee, "History," 13. *Cienega* is a word meaning "swamp," "marsh" or "spring."
35. Marsh, *Corona*, 19.
36. As none subsequently was, Pala remained an asistencia.
37. Father Jose Sanchez, quoted in Engelhardt, *San Luis Rey Mission*, 44–45. The enramada of which he spoke was the Casa Loma, the home of the mayordomo of the San Jacinto Rancho.
38. The building to which they would have come at San Bernardino was not the "Asistencia" we know of today but the original San Bernardino Rancho building ,approximately one and a half miles west-northwest of the present-day asistencia on Mission Road.
39. Father Jose Sanchez, quoted in Beattie, "San Bernardino Valley," 17.

Chapter 3

40. Turner, "First Letter," 127.
41. Ibid., 132.
42. This diversion from the original Anza trail had been mentioned by Santiago Argüello, an early San Diego landowner and mission official who came through the area in 1825 while searching for Indian horse thieves.

43. These two acts were earlier attempts to decide how to manage lands in California and also the situation with the Indian neophytes.

44. Clelend, *From Wilderness to Empire*, 127.

45. The petition process for a rancho was fairly straightforward, and although the process was adhered to rather strictly in the beginning, toward the mid-1840s, when it appeared as if Mexico would cede its northern provinces to the United States, the process moved more quickly.

Chapter 4

46. Much of the information regarding the individual ranchos is taken from Beattie and Beattie, *Heritage of the Valley*; Brigandi, *Temecula*; Gunther, *Riverside County*; Hudson, *Lake Elsinore Valley* and *1000 Years*; and McAdams, "Early History."

47. See the section on the Temecula Rancho for earlier petitions for rancho lands within the county.

48. The most common unit of measurement in Spanish and Mexican California was the league, which was approximately 2.63 miles. Therefore, a square league encompassed approximately 6.92 square miles, or roughly 4,428 acres of land.

49. Patterson, *Landmarks*, 17. Juan Bandini had an alternate name for his home and Jurupa land: San Juan del Rio. In a later court case, he stated that he wanted to call his entire holdings, both the Jurupa and Rincon Ranchos (see below), San Juan del Rio, meaning St. John of the River. Gunther, *Riverside County*, 472. Although Bandini may have referred to the area as such, obviously it never became established.

50. Gunther, *Riverside County*, 439.

51. Hughes, *History of Banning*, 154–55; McAdams, "Early History," 52–53.

52. McAdams, "Early History," 55–56.

53. Bird, "San Gorgonio Pass," 177.

54. Expediente No. 521, quoted in Gunther, *Riverside County*, 471.

55. Brigandi, *Temecula*, 22.

56. Engelhardt, *San Luis Rey Mission*, 119–20.

57. Vignes is better known for being one of the first large-scale winemakers in Southern California. He had an expansive vineyard in Los Angeles.

58. Parker, *Historic Valley of Temecula*, 6. The modern-day reader should be aware of the original name for this small canyon. It was originally called Nigger Valley (or sometimes Nigger Canyon), and virtually all references to this area published before 1970 use this term. Named for Jim Hamilton, a mixed-race settler in the canyon in the late 1800s, Nigger Valley kept its name until 1970, when the U.S. Geological Survey required that all offensive place names and other geographical references be changed. At that time, Nigger Valley became Butterfield Valley. Sometime in the late 1860s, Jim Hamilton was forced to move from his valley when legal challenges over the Pauba Rancho found that he was on land that belonged to it. He settled in what

is today the Anza Valley, which for a time was called the Hamilton Plains. Hamilton Creek, and later Hamilton School, were similarly named for him.

59. Parker, *Historic Valley of Temecula*, 5–6.

60. Gunther, *Riverside County*, 381.

61. Brigandi, *Temecula*, 24.

62. Expediente 545, quoted in Gunther, *Riverside County*, 382.

63. Expediente 319, quoted in Gunther, *Riverside County*, 468.

64. Bowman, "Prominent Women," 155.

65. Expediente 543, quoted in Gunther, *Riverside County*, 286.

66. New Mexicans were certainly not strangers in Southern California at that time. As far back as 1829, a trade route had been opened between Santa Fe and Los Angeles over the Old Spanish Trail. This route entered California near today's city of Needles, traveled west along the mountains and then came down the Cajon Pass to the San Bernardino Valley, where it continued west to Los Angeles.

67. Bell, *Reminiscences of a Ranger*, 62.

68. Harley, *Story of Agua Mansa*, 22.

69. Sidler, "Great Flood," 52. To put this into perspective, 360,000 cubic feet would fill a box the size of a football field seven feet high. Traveling water is measured in cubic feet per second; therefore, that volume of water was passing any one point along the river every second.

70. Hayes, *Pionner Notes*, 270–71.

Chapter 5

71. Only three days before, Varela and about twenty men under his command had attacked the adobe building in Los Angeles where Lieutenant Gillespie and his men were quartered. This attack was the starting point of the Mexican-American War.

72. Isaac Williams was married to one of Lugo's sisters. Therefore, the two leaders of the standoff at Chino were brothers-in-law.

73. Palomares owned the San Jose Rancho in the vicinity of present-day Pomona.

74. Ramon Carrillo played a role in many aspects of California's history during this period of time. He fought against the Bear Flag revolt in 1846 and was accused of killing two Americans there. That accusation may have been a deciding factor on whether to spare the lives of the American prisoners. After the Battle of Chino, Carrillo helped to escort the Americans to Los Angeles. He was afterward quoted as saying, "They say that I am an assassin. I will prove to the world that I am not." Later, Carrillo would be implicated in the murder of John Rains, the well-respected owner of the Cucamonga Rancho. Beattie and Beattie, *Heritage of the Valley*, 156. For an excellent account of the events surrounding the Cucamonga Rancho, John Rains and Ramon Carrillo, please see Esther Boulton Black's *Rancho Cucamonga and Doña Merced*.

Chapter 6

75. Coy, *Genesis of California Counties*, 141, 221–22.
76. Mariposa County at this time was divided into Mariposa, Tulare and Los Angeles Counties.
77. Laguna Temecula, as misspelled here, was a seldom-used name for Laguna Grande, or Lake Elsinore, as we know it today.
78. Coy, *Genesis of California Counties*, 221.
79. Brigham Young, quoted in Beattie and Beattie, *Heritage of the Valley*, 171.
80. Due to this Mormon migration, the trail would later be known as the Mormon Trail or Road.
81. Beattie and Beattie, *Heritage of the Valley*, 182.
82. Ingersoll, *Century Annals*, 132.
83. Garra was captured by Juan Antonio and some two dozen of his men.
84. Amasa Lyman, letter to the editor of the *Deseret News*, July 20, 1852, as quoted in Carter, "Mormons in San Bernardiono," 7.
85. Sherwood, "Plan of San Bernardino."
86. Coy, *Genesis of California Counties*, 216.
87. *Western Standard*, December 27, 1856, as quoted in Carter, "Mormons in San Bernardiono."
88. Beattie and Beattie, *Heritage of the Valley*, 287; Lyman, 1996, pp. 361–64.
89. Lyman, *San Bernardino*, 368.
90. *Los Angeles Star*, December 5, 1857.
91. Lyman, *San Bernardino*, 414.
92. W.A. Wallace, letter to the *San Francisco Alta California*, as quoted in Beattie and Beattie, *Heritage of the Valley*, 305.

Chapter 7

93. The formation of the Land Commission was heavily endorsed by Northern California residents, many of whom had virtually overrun the ranchos in that region by squatting on property while seeking gold. As the burden of proof was placed on the Mexican grantee of the rancho and not those who had established residence through other means, it seems a foregone conclusion that the odds were stacked heavily against the Mexican landowner. The years of litigation that followed the findings of the Land Commission bore this out.
94. Williamson, "Report of Explorations," Introduction.
95. Ibid., 41.
96. Ives, "Report Upon the Colorado River," 50.
97. Ibid.
98. Ives, however, was nowhere near as enamored with the Grand Canyon as later explorers would be. He indicates in his journal that the Grand Canyon "looks like the Gates of Hell. The region…is, of course, altogether valueless. Ours has

been the first and will undoubtedly be the last, party of whites to visit the locality. It seems intended by nature that the Colorado River along the greater portion of its lonely and majestic way, shall be forever unvisited and undisturbed." http://dav4is.8m.com/Celebrity/IVES260.html, accessed December 23, 2002.

99. Oscar Loew, "The Mohave Desert," in Wheeler, "Annual Report," 218.

100. Oscar Loew, "Bottom Lands of the Lower Colorado," in Wheeler, "Annual Report," 219.

Chapter 8

101. Today, the Sonora Road is generally referred to as the Southern Emigrant Trail. The terms Southern Emigrant Trail and Bradshaw Trail denote a misunderstanding among modern researchers. To the people of the 1800s, these well-worn dirt paths were roads, not trails. Just because they do not have concrete/asphalt surfacing or allow high-speed travel does not make them simple trails. Therefore, these routes will be referred to as roads in this work.

102. Oftentimes, the Butterfield Overland is romanticized as the sole project of John Butterfield. In fact, the Butterfield Overland was aligned rather closely with Wells-Fargo & Company and controlled by stockholders in New York.

103. Beattie and Beattie, *Heritage of the Valley*, 340–41.

104. Although not part of Riverside County's past, the route Butterfield chose leading from San Antonio, Texas, to Warner's Ranch had been in use since the previous year by James Birch's famed "Jackass Mail." Therefore, the road for mail purposes had already been used up through Warner's Ranch when Butterfield came through; he simply continued northwest along the Sonora Road instead of heading southwest into San Diego as Birch's "Jackass Mail" had.

105. Although the stages could travel several miles in a day, the individual horses could not. Therefore, each station had a supply of horses that would be exchanged for ones that had just made a certain journey.

Chapter 9

106. Much of the information for this section comes from Beattie and Beattie, *Heritage of the Valley*, and Cooney, "Southern California," 1924.

107. Cooney, "Southern California," 55.

108. It must be remembered here that the vast majority of the population of California at the time was in the northern part of the state, especially in the gold field areas. While Confederate sympathy ran relatively high in Southern California, the fact that there were hardly any people here made the voices of the Southern Californians relatively quiet.

109. Because they had tried to distance themselves from the rest of the United States, the Mormons in California were believed to be Confederate sympathizers during the Civil War. Although it is true that they did not exactly support the United

States, they also did not support the Confederacy. In fact, their sympathies lay more with themselves, and they simply hoped to be left alone.

110. Beattie and Beattie, *Heritage of the Valley*, 359.

111. Ibid., 379–86.

112. Ibid., 385.

113. At this time, both the Arizona and New Mexico Territories were within Confederate hands, so the threat of an eastern incursion of the Confederate army was real.

Chapter 10

114. Much of the information for this section comes from Beattie, "Development of Travel" and "Reopening the Anza Road"; Beattie and Beattie, *Heritage of the Valley*; Brigandi, *Temecula*; Clarno, "Early American Development" and *Elsinore-Temecula Valley*; Conkling and Conkling, *Butterfield Overland Mail*; Gunther, *Riverside County*; and Zimmerman, "History of the Elsinore Region."

115. Bergman, *Jacob Bergman*, 13.

116. Salley, *California Post Offices*, 212.

117. Brigandi, *Temecula*, 40.

118. A change station was simply a place where the driver of the stage could change out his horses for fresh ones. As such, the Butterfield line had to maintain an enormous herd of horses, most of them staying at various stations and only going from five to twenty miles at one time.

119. Hayes, *Pioneer Notes*, 220–21.

120. Ibid., 219–20.

121. Ibid., 65.

122. Accounts of Greenwade paint him as a hell-raiser in San Bernardino. His father-in-law was the famed Uncle "Billy" Rubottom of Spadra, which today is part of Pomona.

123. Ormsby, *Butterfield Overland Mail*, 111–12.

124. Santa Gertrudis Spring would be renamed Adobe Spring during this time.

125. Gunther, *Riverside County*, 399.

126. Ibid., 399.

127. Ibid., 69–70.

Chapter 11

128. Generally speaking, today the overland route between Dos Palmas and the Colorado River is known as the Bradshaw Trail. According to Francis Johnston, who did extensive research on the route for his book *The Bradshaw Trail*, the name "Bradshaw Trail" apparently was not used for the route during the time we are studying, despite the fact that it does appear on one contemporary map. The only citations he could find using Bradshaw's name referred to it as the "Bradshaw

Route," or occasionally "Bradshaw's Road." Johnston, *Bradshaw Trail*, 115. Therefore, in attempting to keep the present work as contemporary as possible, I will use the terms Bradshaw's Road and Route.

129. The area was actually close to Pot Holes, Arizona. This was soon renamed in honor of Our Lady of Peace to Laguna de la Paz, or simply La Paz.

130. This is now part of the present-day Toro-Martinez Indian Reservation.

131. Accounts vary as to the Indians who befriended Bradshaw. Some accounts indicate that it was one Maricopa Indian who either guided him or gave him a map. Others indicate that Bradshaw met none other than Old Chief Cabazon, who told him of the route, and a Maricopa Indian who guided him. Regardless, some Indian(s) told him of the old Cocomaricopa Trail

132. It would appear as though Bradshaw, having seen probably one too many gold rushes go bust, decided to find his "gold" in ferrying people across the mighty Colorado River.

133. There is some dispute as to whether Bradshaw was the first American to actually "discover" the route. James Grant, a San Bernardino businessman, announced in the *Los Angeles Southern News* on July 13, 1862, that he had discovered a new route to La Paz: "About four weeks ago, I left [San Bernardino] for the purpose of securing a more direct route to the newly discovered gold diggings on the Colorado River, about one hundred and thirty miles north of Yuma. In this I have been very successful, and on the morning of the 12th instant I intend starting from this place with fingerboards, etc., to be placed along the road for the benefit of the traveling public." The next day, in the *Los Angeles Star*, Bradshaw published his discovery, and actually named places along the route—San Bernardino, San Gorgonio Pass, White River (Whitewater), Agua Caliente, Toro Indian Village, Martin's House, Lone Palm, Dos Palmas, Canon Creek (Canyon Springs), Tabisaca (Tabeseca Tank) and Chu-cul-wallah (Chuckawalla Spring). Because Bradshaw clearly delineated the route to anyone reading the paper, the new route was named in honor of him Johnston, "Stagecoach Travel," 619–20.

134. *Los Angeles Star*, May 24, 1862.

135. Johnston, *Bradshaw Trail*, 133–35.

136. McAdams, "Early History," 191–92; Ross, *Gold Road*, 40.

137. Lest the reader believe that this pooling of resources by the merchants of Los Angeles was done with only the best interests of the traveling miners in mind, it must be remembered that Los Angeles was about the only major town in Southern California at the time—where else would the gold miners spend all that hard-earned gold but in the stores, saloons and other business establishments in Los Angeles?

138. Much of the information for this section comes from Brumgardt, "Pioneer by Circumstance"; Gunther, *Riverside County*; Hughes, *History of Banning*; Hoyt, "History of the Desert Region," "Bradshaw Road" and "Bradshaw's Road"; McAdams, "Early History"; and Johnston, "Stagecoach Travel" and *Bradshaw Trail*.

139. During his tenure in office, Smith introduced a bill in 1858 appropriating money to dig wells along the desert. This was done in the hope that the Butterfield Company would place its proposed mail route through the pass. Unfortunately, both wells were dry, which was one of the reasons Butterfield chose the Sonora Road route.

140. Brumgardt, "Pioneer by Circumstance," 149–51.

141. Johnston, *Bradshaw Trail, passim*; McAdams, "Early History," *passim*.

142. Patencio, *Stories and Legends*, 61.

143. The records apparently indicate that he took over the ranch, meaning, of course, that sometime beforehand, Dr. Isaac Smith had procured the land. If birth records prove correct, Frank would have been only sixteen, which, while unusual, would not have been unheard of at that time. Stocker, "Whitewater Story," 7.

144. Much of the information for this section comes from Gunther, *Riverside County*; Hoyt, "History of the Desert Region," "Bradshaw Road," and "Bradshaw's Road"; and Johnston, "Stagecoach Travel" and *Bradshaw Trail.*

145. Bancroft and Cowan, "Guide to the Colorado Mines," 8.

146. Patencio, *Stories and Legends*, 60. *Galleta* grass (*Pleuraphis jamesii* or *Hilaria jamesii*) is a low-growing, coarse grass that grows generally in small bunches.

147. Bancroft and Cowan, "Guide to the Colorado Mines," 8.

148. Martinez is also called "Martin's House" in many early accounts of the area.

149. Bancroft and Cowan, "Guide to the Colorado Mines," 13.

150. The name, however, was a fairly recent acquisition when Bradshaw's Road opened. Jose Maria Estudillo, of the Romero Expedition, gave a good account of the springs but did not mention the palms. They must have begun growing there sometime between Romero's visit in 1824 and the opening of Bradshaw's Road in 1862.

151. Wheeler, "Annual Report," 196.

152. For lack of a better name, the original miners in the area called the Orocopia Mountains the Dos Palmas Mountains. It was not until 1905, when the Oro Copia Mining Company began gold mining in the area, that the name of the outfit was combined and given to the mountains.

153. Bancroft and Cowan, "Guide to the Colorado Mines," 9–10. Brown's Pass was named for early prospector Hank Brown.

154. Gunther, *Riverside County*, 519–20.

155. Brown, "Salton Sea Region," 248–49.

156. Dooner, "From Arizona to California," 32.

157. Patencio, *Stories and Legends*, 62.

158. If one reads the various accounts of Mule Springs Station in Gunther's article on it (*Riverside County*, 341–43), one sees that some people saw plenty of good water and others saw absolutely nothing. In addition, those who saw no water could not even find traces of the well, owing to the fact that it had been put in the wash and covered when water flowed through.

159. Ross, *Gold Road*, 198.

160. Fairchild had obviously missed the Willow Spring.

161. Mahlon Dickerson Fairchild, as quoted in Bancroft and Cowan, "Guide to the Colorado Mines," 16.

162. Rau, *Ordeal of Olive Oatman, passim.*

Chapter 12

163. Strickland, "Brief History," 7. Dudley Pine apparently saw the beginnings of several ventures within what would become Riverside County. Not only was he one of the first to settle within San Timoteo Canyon, but he was also one of the many investors in the California Silk Center Association (see that later in this chapter) and stayed to help in the establishment of Riverside.

164. United States Department of the Interior, Bureau of Land Management/ Government Land Office Records, BLM Serial No. CACAAA 081278: December 27, 1876 (John R. Frink).

165. Strickland, "Brief History," 8.

166. Frink, "Early Days," December 18, 1936.

167. The present San Timoteo Schoolhouse, on San Timoteo Canyon Road between Fisherman's Retreat and El Casco Lake, is a later incarnation of this first school. Built in 1882, the present structure is a Riverside County landmark, as well as being listed on the National Register of Historic Places. The original name for it was the El Casco School.

168. Christian, *Historic San Timoteo Canyon*, 122; Gunther, *Riverside County*, 488.

169. Most of the information for this section is taken from Chaput, "Temescal Tin Fiasco," and Gunther, *Riverside County*.

170. Chaput, "Temescal Tin Fiasco," 3.

171. Ibid., 7.

172. Thrapp, 1989, 249–50. Most of the information for this section was taken from Gunther, *Riverside County*; Klose, "Louis Prevost"; and Thrapp, 1989.

173. San Bernardino County Water Commissioner Records Book B, June 18, 1869, 3.

174. Gunther, *Riverside County*, 93–94.

175. San Bernardino County Deed Book 5, 234.

176. San Bernardino County Agreements Book A, 77–80.

177. The term "selection" here is a contemporary usage. The *Oxford English Dictionary* defines selection in this sense as "a piece of land selected or taken up through 'free-selection.'" Free-selection, in turn, is an Australian term meaning "to take up land under government." Therefore, when the incorporation spoke of the "Prevost Selection," it was talking about that area that the association, under Louis Prevost's supervision, had acquired through the colonists' possessory claims of government lands.

178. Gunther, *Riverside County*, 93.

BIBLIOGRAPHY

Baker, Patricia. "The Bandinis." *Historical Society of San Diego Quarterly* (Winter 1969).

Bancroft, Hubert Howe, and Robert Ernest Cowan, eds. "Guide to the Colorado Mines." *California Historical Society Quarterly* 12, no. 1 (March 1933): 3–10.

Bean, Lowell John, and William Marvin Mason. *The Romero Expeditions, 1823–1826*. Palm Springs, CA: Palm Springs Desert Museum, 1962.

Beattie, George William. "Development of Travel Between Southern Arizona and Los Angeles as it Related to the San Bernardino Valley." *Historical Society of Southern California Annual Publication* 13 (1925): 228–58.

———. "Diary of a Fort Yuma Ferryman." *Historical Society of Southern California Annual Publication* 14, no. 2 (1929).

———. "Reopening the Anza Road." *Pacific Historical Review* 11, no. 1 (1933): 54–71.

———. "San Bernardino Valley Before the Americans Came." *California Historical Society Quarterly* 12, no. 2 (June 1933): 111–24.

———. "San Bernardino Valley in the Spanish Period." *Historical Society of California Quarterly* 13, no. 3 (1923): 10–28.

———. "Spanish Plans for an Inland Chain of Missions." *Historical Society of Southern California Publication* (1929).

Beattie, George William, and Helen Pruitt Beattie. *Heritage of the Valley*. Oakland, CA: Biobooks, 1951.

Bell, Major Horace. *Reminiscences of a Ranger, or Early Times in Southern California*. Los Angeles: Yarnell, Caystell & Mathes, 1881.

Bergman, Coral R. *Jacob Bergman of Aguanga: The Real Story*. Warner Springs, CA: Coral R. Bergman, 1996.

Bibb, Leland E. "The Location of the Indian Village of Temecula." *Journal of the San Diego Historical Society* 13, no. 3 (Spring 1969).

Bibliography

————. "Pablo Apis and Temecula." *Journal of the San Diego Historical Society* (Fall 1991).

Bird, Jessica. "The San Gorgonio Pass." In *History of Riverside County*, edited by Elmer Wallace Holmes, 174–217. Los Angeles: Historic Record Company, 1912.

Blake, William P. "The Cahuilla Basin and Desert of The Colorado." In *The Salton Sea*. Carnegie Institution of Washington Publication #193, 1914.

————. "Lake Cahuilla, the Ancient Lake of the Colorado Desert." *National Geographic Magazine* 38 (1907): 830. Bolton, Herbert Eugene. *Anza's California Expeditions*. Berkeley: University of California Press, 1930.

Bowman, J.N. "Prominent Women of Provincial California." *Historical Society of Southern California Quarterly* 39, no. 2 (June 1957): 149–66.

Brackett. R.W. *The History of the San Diego Ranchos*. San Diego, CA: Union Title Insurance and Trust Company, 1951.

Brigandi, Phil. Personal communication, various dates as cited in text.

————. *Temecula: At the Crossroads of History*. Encinitas, CA: Heritage Media Corporation, 1998.

Brown, John S. "Routes to Desert Watering Places in the Salton Sea Region, California." U.S. Geological Survey Water-Supply Paper No. 490-A. Washington, D.C.: Government Printing Office, 1920.

————. "The Salton Sea Region, California." U.S. Geological Survey Water-Supply Paper No. 497. Washington, D.C.: Government Printing Office, 1923.

Brumgardt, John R. *From Sonora to San Francisco Bay: The Expeditions of Juan Bautista de Anza, 1774–1776*. Riverside, CA: Riverside County Historical Commission Press, 1976.

————. "Pioneer by Circumstance: James Marshall Gilman and the Beginnings of Banning, California." *Historical Society of Southern California Quarterly* 62, no. 2 (Summer 1980).

Bynum, Lindley, trans., ed. "The Record Book of the Rancho Santa Ana del Chino." *Historical Society of Southern California Quarterly* 16, no. 1 (1934): 5ff.

Byrkit, Jim, and Bruce Hooper. *The Story of Pauline Weaver, Arizona's Foremost Mountain Man*. Flagstaff, AZ: Sierra Azul Press, 1993.

Caballeria, Reverend Father Juan. *History of the San Bernardino Valley from the Padres to the Pioneers, 1810–1851*. San Bernardino, CA: Times-Index Press, 1902.

Callizo, Joe, and Robert R. Smith. *The Pope Family*. Napa, CA: Napa County Historical Society, 1985.

Carter, Kate B., comp. "The Mormons in San Bernardino." Salt Lake City: Daughters of Utah Pioneers, lessons for March 1961, March 1961.

The Catholic Encyclopedia. http://www.newadvent.org/cathen/06651b.htm.

Chaput, Donald. "The Temescal Tin Fiasco." *Historical Society of Southern California Quarterly* 67 (1985).

Christian, Peggy. *Historic San Timoteo Canyon*. Morongo Valley, CA: Sagebrush Press, 2002.

BIBLIOGRAPHY

Clarno, Robert M. "Early American Development of the Elsinore-Temecula Valley, 1846–1893." Master's thesis, University of California, Riverside, 1954.

———. *The Elsinore-Temecula Valley: Its Mission and Ranchos.* Elsinore, CA: self-published, 1954.

Cleland, Robert Glass. *From Wilderness to Empire.* New York: Alfred A. Knopf, 1944.

———. "Transportation in California Before the Railroads, with Especial Reference to Los Angeles." *Historical Society of Southern California Quarterly* 11, no. 1 (1918): 60–67.

Conkling, Roscoe P., and Margaret B. Conkling. *The Butterfield Overland Mail.* Glendale, CA: Arthur H. Clark Company, 1947.

Cooney, Percival J. "Southern California in Civil War Days." Historical Society of Southern California Quarterly 13, no. 1 (1924): 54–68.

Coy, Owen Cochran. *The Genesis of California Counties.* Sacramento: California State Printing Office, 1923.

Crafts, E.P.R. *Pioneer Days in the San Bernardino Valley.* Los Angeles: Kingsley, Moles, and Collins Company, 1906.

Desborough, Christina Feer. "Rincon's 100 Years—1839–1939." Privately printed by author, 1981.

Dooner, P.W. "From Arizona to California in the Early '70s." *Historical Society of Southern California Quarterly* 3, no. 3 (1895).

Ellerbe, Rose L. "History of Temescal Valley." *Historical Society of Southern California Quarterly* 11, no. 3 (1920): 12–20.

Engelhardt, Father Zephyrin. *Mission San Gabriel.* San Gabriel, CA: Mission San Gabriel, 1927.

———. *Missions and Missionaries of California.* San Francisco: James H. Barry Company, 1908.

———. *San Luis Rey Mission.* San Francisco: James H. Barry Company, 1921.

Forbes, Jack D. "The Development of the Yuma Route Before 1846." *California Historical Society Quarterly* 43, no. 2 (June 1964): 99–118.

Fowler, Mrs. Frank H. "The San Jacinto Valley." In *History of Riverside County*, edited by Elmer Wallace Holmes, 218-252. Los Angeles: Historic Record Company, 1912.

Frink, William H. "Early Days of San Timoteo Valley." *Redlands Daily Facts*, December 18, 19, 21 and 22, 1936.

Gabbert, John. *History of Riverside City and County.* Riverside, CA: Record Publishing Company, 1935.

Garner, Walter T. *Arcadia and the Forgotten Guapa.* Riverside, CA: Jurupa Mountains Cultural Center, 1967.

Gerstbacher, Emily. *Temecula History: A Chronology.* Temecula, CA: Friends of the Temecula Library, 1994.

Gould, Janet Williams. "The Butterfield Stage Station at Laguna Grande." *Historical Society of Southern California Quarterly* 18, no. 2 (June 1938): 46–49.

BIBLIOGRAPHY

————. *A History of California and an Extended History of Its Southern Coast Counties*. Los Angeles: Historic Record Company, 1907.

————. "The Indians and Pioneers of Corona and the Temescal Valley." *Historical Society of Southern California Quarterly* 30 (September 1948): 243.

————. "The Old Temescal Road." *Historical Society of Southern California Quarterly* 51, no. 3 (September 1959): 257–60.

Guide to the Historical Landmarks of Riverside County, California. Riverside, CA: Riverside County Historical Commission, 1993.

Guinn, James M. *Historical and Biographical Record of Southern California*. Chicago: Chapman Publishing Company, 1902.

————. "Las Salinas: The Salt Pits." *Historical Society of Southern California Annual Publications* 7, nos. 2–3 (1907–1908): 169–75.

————. "The Sonoran Migration." *Historical Society of Southern California Annual Publications* 8, nos. 1–2 (1909–1910): 31–36.

Gunther, Jane Davies. *Riverside County, California Place Names*. Riverside, CA: Rubidoux Printing Company, 1984.

Hague, Harlan H. *The Road to California: The Search for a Southern Overland Route, 1540–1848*. Glendale, CA: Arthur H. Clarke Company, 1978.

————. "The Search for a Southern Overland Route to California." *California Historical Society Quarterly* 55, no. 2 (Summer 1976): 152.

Hall, Charlot. *First Citizen of Prescott, Pauline Weaver, Trapper and Mountain Man*. Prescott, AZ: Prescott Museum Press, 1929.

Hanna, Phil Townsend. *The Dictionary of California Land Names*. Los Angeles: Automobile Club of Southern California, 1946.

Harley, Dr. R. Bruce. "The Agua Mansa History Trail." *San Bernardino Museum Quarterly* 43, no. 3 (Summer 1996).

————. "The Agua Mansa Story." *San Bernardino Museum Quarterly* 39, no. 1 (Winter 1991).

————. "By the Gentle Water: Agua Mansa and San Salvador Parish, 1842–1893." *Readings in Diocesan Heritage* 3 (1991).

————. "Did Mission San Gabriel have Two Asistencias? The Case for Rancho San Bernardino." *San Bernardino County Museum Association Quarterly* 36, no. 4 (Winter 1989).

————. "The Rancho San Jacinto Chapel." Readings in Diocesan Heritage 1, Dioscese of San Bernardino, San Bernardino, California: 1989.

————. *The Story of Agua Mansa, Its Settlement, Churches, and People*. San Bernardino, CA: Diocese of San Bernardino, 1998.

Hayes, Benjamin Ignatius. *Pioneer Notes from the Diaries of Judge Benjamin Hayes*. Los Angeles: Benjamin Hayes, 1929.

History of San Bernardino and San Diego Counties. San Francisco, CA: Elliott, Wallace W. & Company, Publishers, 1883.

Holmes, Elmer Wallace. *History of Riverside County*. Los Angeles: Historic Record Company, 1912.

Hoyt, Franklin. "The Bradshaw Road." *Pacific Historical Review* 21, no. 3 (August 1952).

———. "Bradshaw's Road to the La Paz Diggin's." *Desert Magazine* (February 1956): 4–8.

———. "A History of the Desert Region of Riverside County from 1540 to the Completion of the Railroad to Yuma in 1877." Master's thesis, University of Southern California, Los Angeles, June 1948.

Hudson, Millard. "The Pauma Massacre." *Quarterly Publications of the Historical Society of Southern California* 7 (1906): 13–21.

Hudson, Tom. *Lake Elsinore Valley: Its Story 1776–1977*. Lake Elsinore, CA: Laguna House, 1978.

———. *1000 Years in the Temecula Valley*. Temecula Chamber of Commerce, Temecula, California: 1981.

———. "The Pauba and Santa Rosa." *Lake Elsinore Valley Sun*, June 21, 1956.

Hughes, Tom. *History of Banning and San Gorgonio Pass*. Banning, CA: Banning Record Print, 1938.

Ingersoll, Luther A. *Century Annals of San Bernardino County, 1769-1904*. Los Angeles: Ingersoll Publishers, 1904.

Ives, Lieutenant Joseph Christmas. "Report Upon the Colorado River of the West, Explored in 1857 and 1858…" 36th Congress, 1st Session, House Executive Document No. 90. Washington, D.C.: 1861.

Jackson, Helen Hunt. *Ramona*. Boston: Little, Brown & Company, 1900.

James, George Wharton. *The Old Franciscan Missions of California*. Boston: Little, Brown & Company, 1915.

———. *Through Ramona's Country*. Boston: Little, Brown & Company, 1908.

———. *Wonders of the Colorado Desert*. Boston: Little, Brown & Company, 1906.

Johnston, Francis J. *The Bradshaw Trail*. Riverside, CA: Riverside County Historical Commission Press, 1977.

———. "San Gorgonio Pass: Forgotten Route of the Californios?" *Journal of the West* 8, no. 1 (January 1969).

———. "Stagecoach Travel Through San Gorgonio Pass." *Journal of the West* 9, no. 4 (October 1972).

Klose, Nelson. "Louis Prevost and the Silk Industry at San Jose." *California Historical Society Quarterly* 43 (December 1964).

Kurz, Don. *Robidoux Rancho on the Jurupa, 1847–1972. The History of Rubidoux and the Jurupa Area*. Riverside, CA: privately published by the author, 1972.

Lasuén, Fermín Francisco de. *Writings of Fermín Francisco de Lausén*. Washington, D.C.: Academy of American Franciscan History, 1965.

Los Angeles Star

Lyman, Edward Leo. *San Bernardino: The Rise and Fall of a California Community*. Salt Lake City: Signature Books, 1996.

Marsh, Diann. *Corona: The Circle City*. Carlsbad, CA: Heritage Media Corporation, Carlsbad, 1998.

McAdams, Henry E. "Early History of the San Gorgonio Pass Gateway to California." Master's thesis, University of Southern California Graduate School, Los Angeles, June 1955.

McCown, B.E. "Temeku: A Page from the History of the Luiseno Indians." Papers of the Archaeological Survey Association of Southern California, Los Angeles, 1955.

McKenney, J. Wilson. "Gold Builds a Road." *Desert Magazine* 1, no. 2 (December 1937).

Mendenhall, W.C. "The Colorado Desert." *National Geographic Magazine* 20 (1909): 681–701.

Nordhoff, Charles. *California: A Book for Travelers and Settlers*. New York: Harper and Brothers, 1874.

Ormsby, Waterman Lily. *The Butterfield Overland Mail*. Edited by Lyle H. Wright and Josephine M. Bynum. San Marino, CA: Huntington Library, 1942.

Painter, Charles Cornelius Coffin. *The Condition of Affairs in Indian Territory and California. A Report by Prof. C. C. Painter, Agent of the Indian Rights Association*. Philadelphia: Indian Rights Association, 1888.

Parker, Horace. *The Historic Valley of Temecula: The Early Indians of Temecula*. Librito No. 1. Balboa Island, CA: Paisano Press, 1965.

———. *The Historic Valley of Temecula: The Temecula Massacre*. Librito No. 4. Balboa Island, CA: Paisano Press, 1971.

———. *The Historic Valley of Temecula: The Treaty of Temecula*. Librito No. 2. Balboa Island, CA: Paisano Press, 1967.

Patencio, Chief Francisco. *Stories and Legends of the Palm Springs Indians*. Palm Springs, CA: Palm Springs Desert Museum, 1943.

Patterson, Tom. *Landmarks of Riverside and the Stories Behind Them*. Riverside, CA: Press-Enterprise Co., 1964.

Peck, L.B. "Elsinore." In *History of Riverside County*, edited by Elmer Wallace Holmes, 288–294. Los Angeles: Historic Record Company, 1912.

Rau, Margaret. *The Ordeal of Olive Oatman: A True Story of the American West*. Greensboro, NC: Morgan-Reynolds, Inc., 1997.

Rhodes, Edwin. *The Break of Day in Chino*. Chino, CA: self-published, 1951.

Robidoux, Oral Messmore. *Memorial to the Robidoux Brothers*. Kansas City, MO: Smith-Grieves Company, 1924.

Robinson, W.W. *Land in California*. Berkeley: University of California Press, 1948.

———. *The Story of Riverside County*. Riverside, CA: Riverside Title Company, 1957.

———. *The Story of San Bernardino County*. San Bernardino, CA: Pioneer Title Insurance Company, 1958.

Ross, Delmer G. *Gold Road to La Paz: An Interpretive Guide to the Bradshaw Trail.* Essex, CA: Tales of the Mojave Road Publishing Company, 1992.

Salley, Harold E. *History of California Post Offices, 1849–1976.* La Mesa, CA: Postal History Associates, Inc., Printed by Heartland Printing and Publishing Company, 1977.

San Bernardino County Deed Books.

Sidler, W.A. "The Great Flood of January 22, 1862." In "The Agua Mansa Story," compiled by Dr. R. Bruce Harley, 49–53. *San Bernardino Museum Quarterly* 39, no. 1 (Winter 1991).

Standart, Sister M. Colette. "The Sonora Migration to California, 1848–1856: A Study in Prejudice." *Historical Society of Southern California, Quarterly* 53, no. 3 (Fall 1976).

Stocker, Vera McPherson. "The Whitewater Story." *San Bernardino County Museum Quarterly* 20, nos. 3–4 (Spring and Summer 1973).

Strickland, Gary. "Brief History of San Timoteo Canyon." Typescript of lecture given to the Redlands Area Historical Society, November 2000.

Turner, Justin G. "The First Letter from Palm Springs: The Jose Romero Story." *Historical Society of Southern California Quarterly* 56, no. 2 (Summer 1974): 123–34.

Tyler, Sergeant Daniel. *A Concise History of the Mormon Battalion in the Mexican War, 1846–1847.* 1881. Reprint, Chicago: Rio Grande Press, Inc., 1964.

Waitman, Leonard B. "The Watchdogs of San Bernardino Valley: Chief Juan Antonio and Lorenzo Trujillo." *San Bernardino Museum Quarterly* (1970).

Wang, Peter Heywood. "The Mythical Confederate Plot in Southern California." *San Bernardino County Museum Association Quarterly* 16, no. 4 (Summer 1969).

Wheeler, George M. "Annual Report on the Geographical Surveys West of the One-Hundredth Meridian in California, Nevada, Utah, Wyoming, New Mexico, Arizona and Montana." Appendix JJ of the Annual Report of the Chief of Engineers for 1876. Washington, D.C., 1876.

Whelan, Harold A. "Eden in Jurupa Valley: The Story of Agua Mansa." *Historical Society of Southern California Quarterly* 55 (1973).

Williamson, Lieutenant R.S. "Report of Explorations in California for Railroad Routes." In *Reports of Explorations and Surveys to Ascertain the Most Practicable and Economical Route for a Railroad from the Mississippi River to the Pacific Ocean Made under the Direction of the Secretary of War in 1853–4.* Vol. 5, *Explorations and Surveys for a Railroad Route from the Mississippi to the Pacific Ocean.* 33rd Congress, 2nd Session. Washington, D.C., 1856.

Wilson, Benjamin David. "Benjamin David Wilson's Observations in Early Days in California and New Mexico." *Annual Publications of the Historical Society of Southern California* (1934): 74–150.

Wright, Ralph W., ed. *California's Missions.* Los Angeles: California Mission Trails Association, Ltd., 1950.

Zimmerman, Dorothy G. "The History of the Elsinore Region, Riverside County, California." Master's thesis, University of Southern California, Los Angeles, June 1934.

INDEX

Index

Y

Yorba, Bernardo 41, 94, 131, 133
Yorba, Jose Antonio 25, 51

ABOUT THE AUTHOR

S teve Lech is a researcher, author and lecturer on the history of Riverside County, California. A native Riversider, his interest in local history dates back more than thirty-five years. He began working for Riverside County in 1986 and since that time has enjoyed exploring many aspects of the history of the county. One of the avenues on which his research took him was the fascinating story of how Riverside County came into existence both geographically and politically. This led to his first self-published book, *Along the Old Roads*, which has been described as the definitive history of Riverside County's settlement and formation. Other works include *Riverside in Vintage Postcards*, *Resorts of Riverside County*, *Riverside's Mission Inn* (coauthored with longtime friend and Jurupa-area historian Kim Jarrell Johnson) and *Riverside, 1870–1940*, all of which were published by Arcadia Publishing. In 2011, Steve self-published his sixth book, this one entitled *More Than a Place to Pitch a Tent: The Stories Behind Riverside County's Regional Parks*, and in 2012, he self-published another entitled *For Tourism and a Good Night's Sleep: J. Win Wilson, Wilson Howell, and the Beginnings of the Pines-to-Palms Highway*.

Together with Kim Jarrell Johnson, Steve currently coauthors a local history column entitled "Back in the Day" for the *Press-Enterprise* newspaper. He has been a docent with the Mission Inn Foundation for more than twenty years and has been president of the Riverside Historical Society for several years. In 2008, he was awarded the Individual Achievement Award for Outstanding Contributions to Local History by the Riverside County Historical Commission, and in 2009, he was recognized by the City of Riverside's Cultural Heritage Board with an Individual Achievement Award for Outstanding Contributions to Local History.

Visit us at
www.historypress.net